6-20-12

LAFOURCHE PARISH PUBLIC LIBRARY

0 0533 0059 0514 6

W9-BYZ-258

T 8

LAFOURCHE PARISH PUBLIC LIBRARY

1812

A Nation Emerges

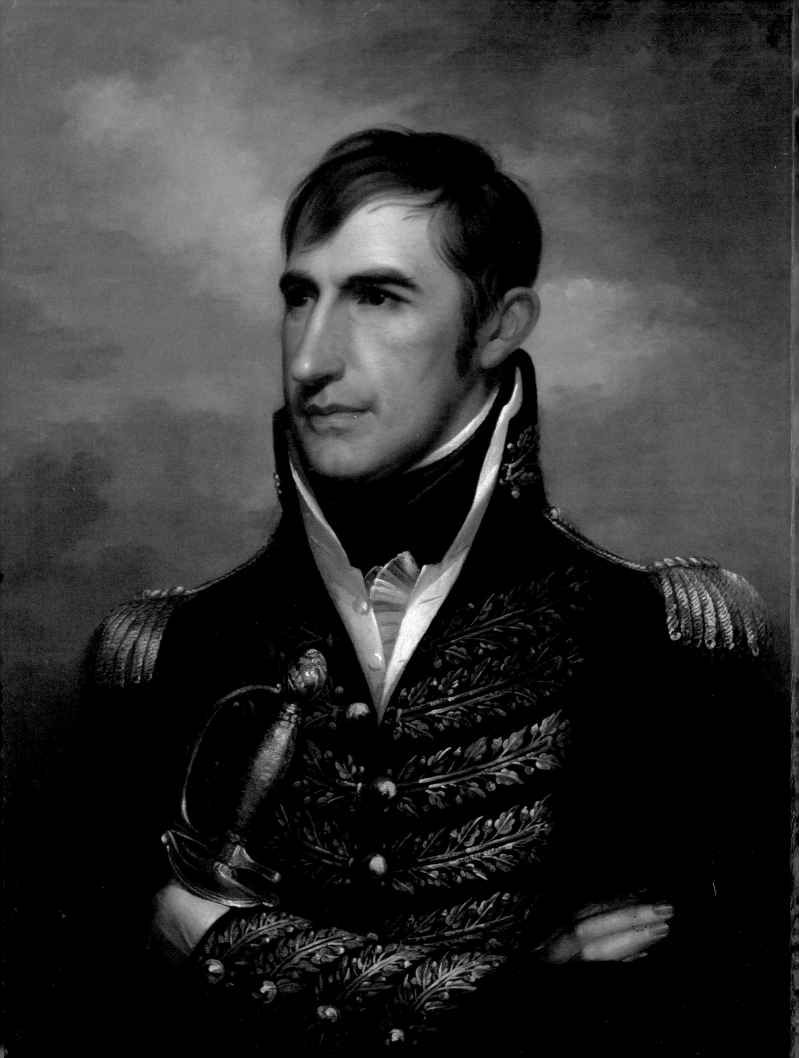

1812 *A Nation Emerges*

Sidney Hart
Rachael L. Penman

With essays by

Donald R. Hickey

J. C. A. Stagg

Published for the National Portrait Gallery

Published in cooperation with
ROWMAN & LITTLEFIELD PUBLISHERS, INC.

Smithsonian Institution
Scholarly Press

Lafourche Parish Public Library
Thibodaux, LA

Published to accompany an exhibition at the
National Portrait Gallery, Smithsonian Institution
June 15, 2012–January 27, 2013

Published by
SMITHSONIAN INSTITUTION SCHOLARLY PRESS
P.O. Box 37012, MRC 957
Washington, D.C. 20013-7012
www.scholarlypress.si.edu

In cooperation with
ROWMAN & LITTLEFIELD PUBLISHERS, INC.
A wholly owned subsidiary of The Rowman & Littlefield Publishing Group, Inc.
4501 Forbes Boulevard, Suite 200, Lanham, Maryland 20706
www.rowmanlittlefield.com

Estover Road
Plymouth PL6 7PY
United Kingdom

Frontispiece: William Henry Harrison by Rembrandt Peale, cat. 23

Copyright © 2012 by Smithsonian Institution

All rights reserved. No part of this publication may be reproduced, stored in a retrieval system, or transmitted in any form or by any means, electronic, mechanical, photocopying, recording, or otherwise, without the prior permission of the publisher.

Library of Congress Cataloging-in-Publication Data

Hart, Sidney.
 1812 : a nation emerges / Sidney Hart, Rachael Penman ; with essays by Donald R. Hickey, J. C. A. Stagg.
 p. cm.
 Published to accompany an exhibition at the National Portrait Gallery, Smithsonian Institution, June 15, 2012-Jan. 27, 2013.

 Includes bibliographical references and index.

 ISBN 978-1-935623-09-0 (hardcover : alk. paper)
 1. United States--History--War of 1812--Exhibitions. 2. United States--
 History--War of 1812--Art and the war--Exhibitions. I. Penman, Rachael. II. Hickey, Donald R.,
 1944- III. Stagg, J. C. A. (John Charles Anderson), 1945- IV.
 National Portrait Gallery (Smithsonian Institution) V. Title.

 E354.H37 2012

 973.5'2--dc23 2011045067

Printed in the United States of America

♾ The paper used in this publication meets the minimum requirements of the American
National Standard for Permanence of Paper for Printed Library Materials Z39.48–1992.

The *1812: A Nation Emerges* book and exhibition are made possible by the generous support of HISTORY® and TD Bank Group.

Additional support provided by Mr. and Mrs. Peter L. Malkin; the Abraham and Virginia Weiss Charitable Trust, Amy and Marc Meadows; and Jack H. Watson Jr. Gifts in kind provided by Ben Zaricor.

Contents

FOREWORD

The National Portrait Gallery's special exhibitions devoted to American history and biography are essential contributors to the museum's strategic vision. In the past, the National Portrait Gallery has created shows and books commemorating national milestones such as the bicentennial of the American Revolution, the framing of the Constitution, and the Smithsonian Institution's 150th anniversary. Several years ago, we recognized that 2012–15 marks yet another important anniversary: the bicentennial of the War of 1812. This book offers persuasive evidence that the war merits attention in our own time because of the enduring changes it wrought in national life.

The exhibition *1812: A Nation Emerges* opened almost 200 years to the day from the moment when a new, fragile republic chose to declare war against the mighty British Empire. It is perhaps only a modest exaggeration to say that in the course of that conflict, America completed its struggle for independence. The battles of the War of 1812—scattered throughout the land mass of a largely unsettled continent and fought in dramatic one-on-one battles on the oceans and the Great Lakes—were small scale by even the contemporary standards of the Napoleonic Wars, of which they were a part. But the ramifications of that conflict would shape the destiny of North America.

Britain gave up its occupation of what was then called the Northwest Territory, opening it for American settlement, but the war's outcome also dashed American dreams of conquering Canada. Canadians continue to celebrate their status as "victors."

Native Indian nations, which had largely aligned with Great Britain,

suffered most severely and irrevocably. Abandoned after the war by their British allies, they could no longer protect their ancestral homelands against the relentless pressure of westward expansion and land hunger. Traditional Native settlements were disrupted, relocated, and often reduced nearly to the point of extinction.

Among other major consequences was the growth of political support for a standing army in the United States and a navy of sufficient size to protect the country's national interests and exert its influence in the Western Hemisphere. The United States celebrated a new generation of military heroes, three of whom succeeded to the presidency on the strength of their wartime exploits: Andrew Jackson, William Henry Harrison, and Zachary Taylor.

For a time, the states became more unified in outlook during the brief postwar Era of Good Feelings. Symbols of national identity that originated in the War of 1812, including "The Star-Spangled Banner" and the mythical persona of Uncle Sam, embodied that sense of unity and pride. Congressional leaders and a succession of presidents also found agreement on an agenda of support for internal improvements—the turnpikes, canals, and railroads that began to knit together all regions of the country.

Both national and international in scope, *1812: A Nation Emerges* is a reminder that the Napoleonic Wars were the proximate cause and the geographic context for the struggles in North America. Its international character is evident in the objects loaned by institutions such as the British National Portrait Gallery, the McCord Museum of Canadian History, the Canadian War Museum, the National Gallery of Canada, the National Maritime Museum in London, and private collectors in Ireland. The National Portrait Gallery's own collections provided a strong nucleus, with works such as Gilbert Stuart's *Thomas Jefferson*, Charles Bird King's *John C. Calhoun*, John Wesley Jarvis's *John Randolph*, Henry Inman's *Tenskwatawa*, Rembrandt Peale's *William Henry Harrison*, and numerous other portraits.

Beyond the narrative of the war itself and its causes and aftermath, this book and exhibition also confirm the exceptional caliber of art and artists during that era. So many talented artists on both sides of the Atlantic created

portraits and battle depictions that breathe life into the classic textbook descriptions of the war. It is a joy to see them assembled in one place for the first, and possibly the only, time.

The National Portrait Gallery expresses its deep appreciation to HISTORY®; TD Bank Group; Mr. and Mrs. Peter L. Malkin; the Abraham and Virginia Weiss Charitable Trust, Amy and Marc Meadows; and Commission Chair Jack H. Watson Jr. for their generosity. In addition, we are grateful to James Madison's Montpelier and the United States Navy's Naval History and Heritage Command for their partnership. This project was conceived and guided by the National Portrait Gallery's senior historian, Dr. Sidney Hart, who served as lead curator, with very able and diligent assistance from Ms. Rachael L. Penman.

Martin E. Sullivan
Director, National Portrait Gallery

James Madison's America

J. C. A. Stagg

On April 6, 1817, James Madison (fig. 1.1) left Washington to return to Montpelier, his home in the Virginia Piedmont. With the exception of a brief appearance at the Virginia state constitutional convention in Richmond in 1829, his departure was to be his last public act in a career that had stretched, with few interruptions, from 1776 to 1817. To start his journey into retirement, Madison took a steamboat down the Potomac River to Aquia Creek, where he picked up a carriage that would convey him to his final destination. During the river voyage, one of his traveling companions, the writer and future secretary of the navy James Kirke Paulding, recalled that the former president was "as playful as a child; talked and jested with every body on board, & reminded me of a school Boy on a long vacation."[1]

As Madison boarded the steamboat, it is quite likely he cast his mind back to the time when he had first passed through this country. That was in the summer of 1769, when, in the company of his tutor and a slave, he set out on horseback from Montpelier through a predominantly wooded landscape until he took a ferry across the Potomac River to Georgetown, then in the British colony of Maryland. Continuing northward, Madison went through Rock Creek Gorge, observing some of the locations in which he would reside as secretary of state and president after 1801. He may have passed close by the town of Bladensburg, Maryland, from which he and his administration would be driven in August 1814 (cat. 60) in the events that led to the destruction of the nation's capital by the British army. From there he went to Philadelphia, the largest city in the American colonies and the second largest in the British Empire, before making the final leg of his ride to the College of New Jersey at Princeton, from which he would graduate in 1771. In 1769, Madison's ride took at least ten days, if not more; in 1817, the journey, admittedly a shorter one, took only two. During the years in between, Madison lived through a remarkable series of transformations, both in the circumstances of his life and in the nation in which he would serve as the fourth president.

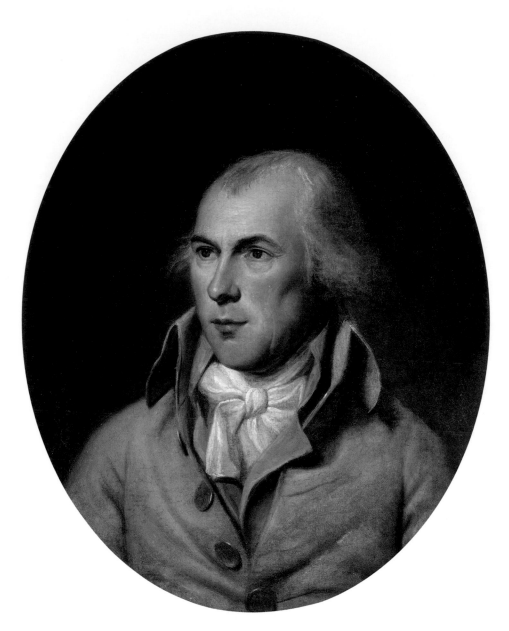

Fig. 1.1. *James Madison* by
Charles Willson Peale (1741–1827), oil
on canvas, 1792. Gilcrease Museum,
Tulsa, Oklahoma

No one individual, even one as powerfully situated as Madison, was
responsible for all the changes that had occurred in the United States by
1817. Nor can it be fairly asserted that the War of 1812 itself—the climactic
event of Madison's two terms in the White House—necessarily contributed
very much to them either. Most of the factors that transformed Madison's
world were beginning to work their effects even before the establishment
of American independence, and they would continue to do so long after
Madison's death in 1836. The numbers and geographical mobility of
the American people increased enormously. Those same people were also
integrated into a federal system that facilitated both the territorial expansion
of the nation and the ability of its citizens—the free ones, at least—to enjoy
the fruits of a capitalist economy in an extended marketplace. Finally, changes
were wrought by war, first the war for independence between 1775 and 1783

and then the War of 1812, which many Americans, Madison particularly, regarded as essential to preserve the gains that had been made after 1783.

And one of the most important cultural changes that occurred in the making of the United States was the decline of the colonial established churches, a phenomenon that coincided with the spread of evangelical religion and the rise of a democratic and egalitarian ideology that became the yardstick by which all customs and institutions would be measured. Nevertheless, Madison contributed in varying ways to all of these agents of transformation, even as he was transformed by them himself.

As is well known, Madison's main contributions to the making of the United States occurred in the 1780s and 1790s when, by virtue of his legislative skills and his study of history and politics, he played decisive roles in two major American developments. One was the establishment of freedom of conscience as a foundational American political principle, first in his native Virginia and then on the national level in his role as the leading framer of the Bill of Rights. The other was his contribution to replacing the failing Articles of Confederation with a more coherently structured federal system that would enable a stronger national government to consolidate the gains won by the achievement of independence. To protect the latter accomplishment, Madison had also taken a prominent part in organizing the Democratic-Republican Party to oppose what he regarded as the misguided policies of the Federalist administrations headed by George Washington and John Adams in the 1790s. By so doing, he helped stabilize domestic politics to the extent of making it possible for Americans to experience a peaceful transfer of power from one political party to another following the presidential election of 1800. As a member of Congress, both under the Articles of Confederation and the federal Constitution before 1797, and while serving as secretary of state and as president after 1801, Madison also played a leading role in creating the national domain as it was defined by such international agreements as the 1783 Treaty of Paris and the Louisiana Purchase of 1803. He had, moreover, further expanded that domain by his annexation of much of the Gulf Coast of Spanish West Florida in 1810.

All of these were significant accomplishments, in which Madison and most of his contemporaries took great pride. As Madison himself remarked at his first inaugural in March 1809: "Under the benign influence of [its] Republican institutions," the nation had enjoyed "an unrivalled growth of [its] faculties and resources." The evidence could be seen in "the improvements of agriculture; in the successful enterprizes of commerce; in the progress of manufactures, and the useful arts; in the increase of the public revenue, and the use made of it in reducing the public debt; and in the valuable works and establishments every where multiplying over the face of [the] land."[2] There was only one problem—the inability to conduct an effective foreign policy of neutrality during the Napoleonic Wars. In the years

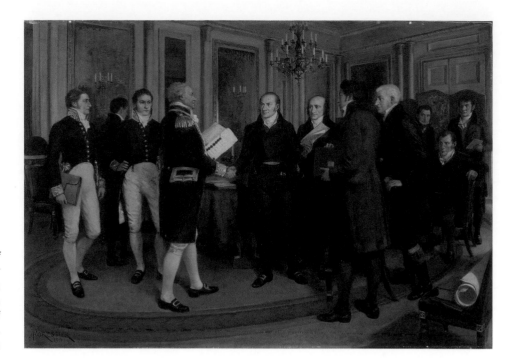

Fig. 1.2. *The Signing of the Treaty of Ghent, Christmas Eve, 1814* by Sir Amèdée Forestier (1854–1930), oil on canvas, 1914. Smithsonian American Art Museum, Washington, D.C.; gift of the Sulgrave Institution of the U.S. and Great Britain

after 1803, the two leading European belligerents, France and Great Britain, had waged unrelenting war on American overseas trade, seizing vessels, cargoes, and seamen almost at will as they tried to thwart any advantages their enemies might derive from having access to the trade and resources of the United States. The problem was serious. At first, Thomas Jefferson's administration had resorted to policies of commercial restriction, the Non-Importation Act of 1806 and the Embargo of 1807 to 1809, to secure a better deal for American trade short of going to war. These measures were controversial at best and unsuccessful at worst. Their failure threatened to undermine the nation's ability to manage both its domestic and foreign affairs. By 1810 the U.S. government seemed weak and ineffectual—almost as much as it had been during the American Revolution—and the political divisions between the Federalists and Democratic-Republicans had become so intense as to threaten to tear the republic asunder. Indeed, some of the Federalists had become so disillusioned with the Madison administration and its policies that they discussed leaving the Union altogether.

For Madison, the climax of these developments came in the summer of 1811, when he learned that Great Britain would continue to violate American neutrality for as long as it took to end Napoleon's domination of the continent of Europe, a prospect nowhere in sight at the time. That statement also meant that the former mother country would continue to disparage American sovereignty and neutrality to the point that the republic could eventually lose the ability to chart its own course in the community of nations. In response, Madison resolved that a "second war for independence" was now the only option open to him and that the goal of this war would be to obtain treaty guarantees, as a matter of international law, for American

rights and interests. Those guarantees would be obtained through the conquest of Great Britain's Canadian colonies. Congress declared war on June 18, 1812, and over the next thirty-two months American forces launched no fewer than ten invasions of Canada. Almost without exception, the invasions failed, often disgracefully and miserably. By the end of 1814, the United States had reached the limits of its capacities as a war-making state. The Treasury was empty, there were not enough men in the armed forces to continue carrying the war to the enemy, and the Americans held only two British posts in Canada: Fort Malden, opposite Detroit, and Fort Erie, on the Niagara Peninsula. The British, on the other hand, held much of the District of Maine and had attacked the nation's capital, burning the White House and all of its other public buildings, except the Patent Office. Yet when news of a peace reached Washington in February 1815, Madison proclaimed it as "highly honorable to the United States," and many Americans went on to celebrate it as a significant victory.[3]

Why? Were Americans justified in claiming that the War of 1812 had accomplished any important results that changed the nation or improved its standing in the international community? The Treaty of Ghent (fig. 1.2) recorded no such tangible gains. It was an empty document that made no mention of the problems Madison had sought to remedy by war, and its articles were largely concerned with the details of restoring peace and providing ways to deal with unresolved disputes in the postwar era. Rather, the reasons why Americans celebrated the peace reflected the circumstances surrounding its arrival. These included having lived through a dangerous British offensive in the summer and fall of 1814 and confronting the prospect of disunion, as presented by the assembly of the New England Federalist states in the Hartford Convention (cat. 84). That the arrival of the peace was preceded by the news of Andrew Jackson's destruction of a British army at the Battle of New Orleans (cat. 82) therefore provided the occasion for a moment of collective cathartic relief. When the outcomes of recent events could have been so much worse, the survival of the republic intact meant that it retained the potential to realize all the benefits of independence that Madison had outlined in his first inaugural address. It was, moreover, of enormous importance that Madison's wartime measures had not included attempts to curtail or to suppress the civil liberties of his political opponents (as President John Adams had attempted to do by supporting the 1798 Alien and Sedition Acts during the Quasi-War with France). That act of executive restraint strengthened the political freedoms of all American citizens for the future. These circumstances constituted the most important political and psychological benefit of the war. All but its most bitter opponents remarked that after February 1815, Americans began to talk and think about their nation with a renewed sense of unity and purpose. Carried to extremes, that reaffirmation of the nation's identity could become

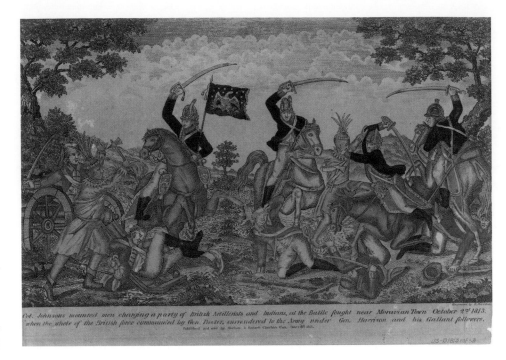

Fig. 1.3. *Battle Fought Near Moraviantown* (Battle of the Thames) by Ralph Rawdon (1790–1860), engraving, 1813. Anne S. K. Brown Military Collection, Brown University Library, Providence, Rhode Island

an aggressive, almost belligerent, American patriotism, and as early as 1816 aggrieved British tourists in the United States could be heard complaining of having to endure such boastful claims that Andrew Jackson was a finer general than the Duke of Wellington and that American naval commanders were more than a match for the officers of Lord Nelson's navy.

Yet the consequences of the war were more than psychological. Although the Americans had not won the war in any military sense, neither were the British the victors, and the future security and prosperity of their colonies in Canada were to remain a hostage to the goodwill of the United States. Throughout the nineteenth century (in the 1840s, 1860s, and 1890s), further crises occurred in Anglo-American relations that could have resulted in war. That they did not do so owed something, at least, to the difficulties both nations had encountered between 1812 and 1815. The War of 1812, in short, proved that for Great Britain and the United States, the risks of war could not be allowed to trump the benefits of peace. There were, nevertheless, real losers in the War of 1812, and their losses produced great gains for the United States. The defeated parties in the war were to be found among the Indian nations on the country's northwestern and southern frontiers, some of whom had hoped that by fighting the Americans after 1812, they could relieve the pressures on their communities that were being exerted by the westward expansion of white settlement. These Indians lost not only their wars but also much of their territory, which they were compelled to cede to the United States as indemnities for peace (fig. 1.3). Those outcomes, to all intents and purposes, removed the Indian nations in the trans-Appalachian West as serious obstacles to further American expansion, thereby consolidating U.S. control over the heartland of the North American continent.

But what of Madison himself? The War of 1812 changed the fourth president inasmuch as he and his administration realized that new priorities were necessary to address the difficulties of mobilization that they had encountered between 1812 and 1815. As a consequence, starting as early as March 1815 and continuing through the sessions of the Fourteenth Congress (1815–17), Madison called for the reorganization of the U.S. Army and Navy to ensure that they were larger and better administered than they had been in 1811. The problems of future war financing were provided for by the chartering of a Second Bank of the United States in 1816. Madison had opposed the establishment of the First Bank of the United States in 1790 on constitutional grounds, but by 1816 he was prepared to regard his objections as overruled by the lessons of history and the needs of the federal government (fig. 1.4). The problem of the national debt incurred to wage war between 1812 and 1815 was dealt with by raising the tariff to provide more revenue. The higher duties also provided a measure of protection for many of the new industries that had emerged between 1807 and 1815 as a response to the Democratic-Republican policies of commercial restriction and war. As the invasions of Canada had often been hobbled by serious logistical problems that were the consequence of a defective transportation network, the war also focused attention on the need for internal improvements, particularly the construction of roads and canals. In his last year as president, Madison was even prepared to consider federal funding for internal improvements, although he vetoed a bill for that purpose shortly before he left office in March 1817. There he acted not so much on constitutional grounds as on his awareness that the bill in question would not accomplish the national benefits that such legislation should require. But by being willing to endorse the expansion of federal power in these ways, Madison also narrowed the partisan divide between the Federalist and Democratic-Republican parties after 1815. In that sense, he helped lay the foundation for the so-called Era of Good Feelings.

Events were to prove that not all of these developments and policies were entirely successful or even very long-lived. The expenditure of federal revenues for many of these purposes, for example, was much reduced in the 1820s as a result of the Panic of 1819. For those reasons, the effects of the War of 1812 did not transform the nation in the ways that the Civil War and World War II would. Rather, in some respects the War of 1812 was not unlike World War I, another conflict that was forced on the United States in response to the efforts of a European belligerent to flout U.S. neutrality to the point of driving it from the high seas altogether. And even if Madison had not defeated Great Britain by 1815 in the way that Woodrow Wilson was to defeat Germany, that difference did not greatly matter. The postwar republic was unquestionably a stronger and more confident nation than it had been in 1811, and it was also evident that the world was becoming a safer place for the United States than it had been at any time between 1776 and 1815. In part, that was a consequence of the War of 1812, but it was also

In Senate of the United States
December 3d 1816.

The following written message was received from the President of the United States by Mr. Todd his secretary.

Fellow Citizens of the Senate and of the House of Representatives.

In reviewing the present state of our Country, our attention cannot be withheld from the effect produced by peculiar seasons; which have very generally impaired the annual gifts of the Earth, and threaten scarcity in particular districts. Such, however, is the variety of soils, of climates, and of products within our extensive limits, that the aggregate resources for subsistance, are more than sufficient for the aggregate wants. And as far as an economy of consumption, more than usual, may be necessary, our thankfulness is due to Providence for what is far more than a compensation, in the remark-able health which has distinguished the present year.

Amidst the advantages which have suc-ceeded the peace of Europe and that of the United States with Great Britain, in a general invigoration of Industry among us, and in the extension of our commerce, the value of which is more and more disclosing itself to commercial na-tions; it is to be regretted, that a depression is experienced by particular branches of our manufactures, and by

Fig. 1.4. President James Madison's annual message to Congress, December 3, 1816 (page 1). National Archives, Washington, D.C.

a bonus that accrued to the United States from the fact that Europe was to remain largely at peace for the next century. But when all of these matters are taken into consideration as a whole, it was perhaps not altogether surprising that John Adams—who was certainly no great admirer of James Madison—should have observed on the eve of the fourth president's retirement that his administration had "acquired more glory than all his three Predecessors, Washington Adams and Jefferson, put together."[4] And although there might have been a touch of exaggeration in that remark, it certainly helps us understand why Madison, when he embarked on his steamboat ride in April 1817, was as "playful as a child" and behaved like a schoolboy about to go "on a long vacation."

Notes

1. Ralph Ketcham, ed., "An Unpublished Sketch of James Madison by James K. Paulding," *Virginia Magazine of History and Biography* 67 (1959): 435.

2. James Madison, first inaugural address, March 4, 1809, in *The Papers of James Madison: Presidential Series*, ed. Robert A. Rutland et al. (Charlottesville: University of Virginia Press, 1984), 1:16.

3. Madison's proclamation of the peace was printed in the *Daily National Intelligencer*, February 18, 1815.

4. John Adams to Thomas Jefferson, February 2, 1817, in *The Adams-Jefferson Letters: The Complete Correspondence Between Thomas Jefferson and Abigail and John Adams,* ed. Lester J. Cappon (Chapel Hill: University of North Carolina Press, 1959), 2:508.

THE WAR OF 1812: A MILITARY HISTORY

DONALD R. HICKEY

The War of 1812 against Great Britain began on June 18, 1812, when President James Madison signed a bill that Congress had passed by a narrow vote—79 to 49 in the House and 19 to 13 in the Senate. The vote indicated significant opposition to the decision, mainly from Federalists but also from some Democratic-Republicans (Jeffersonians). The war was a direct outgrowth of a larger conflict that raged in Europe. Great Britain and France had been at war almost continuously for two decades, first in the French Revolutionary Wars (1793–1801) and then, after a short interval of peace, in the Napoleonic Wars (1803–15).

Both European belligerents encroached upon American rights, but Britain, which was Mistress of the Seas, committed the greater offenses. The British threatened American sovereignty with the Orders in Council, which restricted neutral trade with the European continent, and with impressment, which was the forcible removal of seamen from American merchant vessels. Between 1807 and 1812, the British seized some 400 American merchant vessels for violating the Orders in Council, and between 1803 and 1812 they impressed some 6,000 Americans (although they claimed the right to impress only British subjects).

The United States sought to force the European belligerents to show greater respect for American rights with a series of trade restrictions adopted between 1806 and 1811. When these measures failed to do the job, President Madison (cat. 9) asked Congress to put the nation "into an armor and an attitude demanded by the crisis."[1] Under the leadership of Kentucky War Hawk and Speaker of the House Henry Clay (cat. 10), Congress responded with a series of war preparations. When the British still refused to make concessions on the maritime issues in dispute, the United States declared war.

In the language of the day, the purpose of the war was to secure "Free Trade and Sailors' Rights." But since the United States lacked the naval power to challenge the Royal Navy on the high seas, the young republic targeted British Canada. The conquest of Canada was supposed to be easy.

After all, the United States had a huge population advantage—7.7 million to 500,000 in 1812—and those living in Canada, particularly the recent American immigrants and the French residents, were not expected to offer much resistance. Most Democratic-Republicans anticipated what critic John Randolph of Roanoke (cat. 12) called "a holiday campaign." With "no expense of blood or treasure on our part—Canada is to conquer herself— she is to be subdued by the principles of fraternity."[2] Events would soon prove otherwise.

The United States launched a three-pronged invasion of Canada in 1812, but such was the state of the American military establishment, with aging and incompetent leaders and untrained soldiers, that the results were disastrous. In the Old Northwest, Brigadier General William Hull (cat. 24) cut a road through the Black Swamp in Ohio to reach the Detroit frontier but lost his nerve when he learned that Mackinac had fallen to a British force on July 17, thus exposing his northern flank to hostile Indians. Fearing an Indian massacre, he surrendered his entire army on August 16 to an Anglo-Indian force under the leadership of Major General Isaac Brock (cat. 25) and the Shawnee leader Tecumseh (cat. 27). Before surrendering, Hull had ordered the evacuation of Fort Dearborn (in present-day Chicago), and Indians killed many of the soldiers and civilians once they left the fort. The fall of Mackinac and Detroit, coupled with the Fort Dearborn massacre, left the British and their Indian allies ascendant in the region.

Farther east, on the Niagara frontier, the news was not much better. There, a large army was assembled under the leadership of Major General Stephen Van Rensselaer of the New York militia. On October 13, a mixed force consisting mostly of regulars crossed the river, precipitating the Battle of Queenston Heights. The Americans established a position on the heights but had to surrender when the British (aided by their Indian allies under Mohawk leader John Norton, cat. 31) counterattacked because the New York militia, standing on its right to serve only in American territory, refused to cross the river to reinforce them. Although Major General Brock was killed in the counterattack, the United States nonetheless had lost a second army.

Nor was there much to cheer about at the eastern end of New York, where a large American force under Major General Henry Dearborn belatedly advanced along the western shore of Lake Champlain to the Canadian frontier. There, as on the Niagara, the militia refused to leave the country, and after a confused skirmish at Lacolle Mill on November 20, Dearborn ordered an end to the campaign. A contemporary later described Dearborn's campaign as a "miscarriage, without even [the] heroism of disaster."[3]

The one bright spot for the young republic was in the war at sea. American privateers took a large number of British merchant vessels as prizes of war, and U.S. warships won a string of duels against their counterparts in the Royal Navy. Most impressive was the performance of the nation's heavy

frigates, which were the most powerful ships of their class in the world. In separate engagements, the U.S. frigate *Constitution* defeated two British frigates, the *Guerrière* and the *Java*, and the *United States* captured the British frigate *Macedonian* (cat. 46) and brought it home as a prize of war. Although these naval victories had little strategic significance, they boosted American morale and outraged and perplexed the British, who in twenty years of warfare with France and her allies had rarely tasted the sting of defeat on the high seas.

The United States launched another three-pronged attack against Canada in 1813 but was successful only in the West. Initially, however, the British retained the initiative there. Major General William Henry Harrison (cat. 23), who had succeeded Hull, spent the latter part of 1812 rebuilding the Northwestern army and stockpiling supplies. In January of 1813, one of his subordinates, Brigadier General James Winchester, exceeded his orders by marching a force to Frenchtown (now Monroe, Michigan) on the River Raisin, where he was defeated on January 22 by an enemy force under the command of Colonel Henry Procter. The following day, drunken Indians massacred some thirty of their American captives, and thereafter the cry "Remember the Raisin!" echoed throughout the American West.

Procter invaded Ohio the following spring but enjoyed little success. He besieged Fort Meigs from May 1 through May 9 but had to withdraw when his Indian allies and militia started drifting away. The only bright spot for Procter was the capture of the bulk of a relief force that had arrived from Kentucky on May 5. Once again, however, Indians killed some of the captives, although it would have been worse had Tecumseh not intervened. Procter besieged Fort Meigs for a second time from July 21 to 28, but once again the fort refused to submit. Hoping for a consolation prize, Procter attacked Fort Stephenson in modern-day Fremont, Ohio, on August 1–2 but was rebuffed.

Thereafter, the tide of war in that area shifted. Master Commandant Oliver H. Perry (cat. 50) built a small squadron that on September 10 defeated a British squadron under Commander Robert H. Barclay in the Battle of Lake Erie (fig. 2.1). Perry prevailed because after most of his guns and men had been knocked out of action on his flagship, he transferred his command to a sister ship and then pounded the British into submission. Perry added to his reputation with a terse after-action report to Major General Harrison: "We have met the enemy, and they are ours."[4]

Having lost control of Lake Erie, Procter (who was now a major general) was unable to supply his troops and Indian allies on the Detroit River. Hence, over the vigorous protests of Tecumseh, he ordered a withdrawal to the east. About fifty miles from Detroit, Harrison, who had about 3,000 men, including 1,000 mounted Kentucky volunteers under Colonel Richard M. Johnson (cat. 28), caught up with Procter, who had only about 700

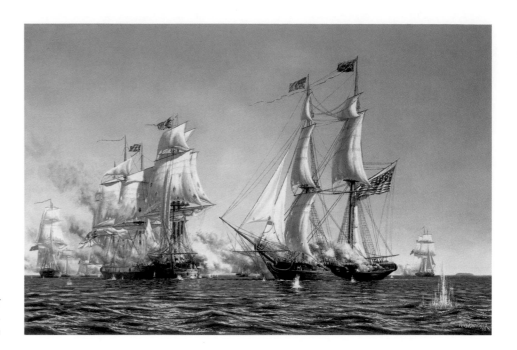

Fig. 2.1. *Perry Breaks the Line* by Peter Rindlisbacher, oil on canvas, 1993. Private collection

troops and perhaps 500 Indians. Johnson's mounted men blew through Procter's two thin lines, and most of the British surrendered, although the major general managed to escape. The Indians fought on longer but melted away when they learned that Tecumseh had been killed, probably by Johnson, even though the colonel had been wounded four times. The American victory in the Battle of the Thames (fig. 2.2) broke British power in the Old Northwest, and many (although not all) of Britain's Indian allies then made peace with the United States.

American operations farther east also had a promising start. In a successful amphibious operation on April 27, 1813, U.S. troops captured the provincial capital of York (now Toronto), although Brigadier General Zebulon Pike (cat. 26), the famed explorer, was killed along with a large number of his men when the departing British blew up their magazine. Furious over these losses, the Americans looted and burned York's public buildings. In this they were aided by some locals who came in from the countryside.

In another amphibious operation on May 27, the United States captured Fort George at the mouth of the Niagara, forcing the British to withdraw from all their positions along the river. But thereafter American fortunes steadily declined. Two American forces that sallied forth from Fort George were defeated, the first at Stoney Creek on June 5–6 and the second at Beaver Dams on June 24. At Stoney Creek, two American brigadiers, William Winder and John Chandler, were captured; at Beaver Dams, the entire American force surrendered. Thereafter, the Americans were bottled up in Fort George, with the British and their Indian allies maintaining a loose siege.

By December of 1813, most of the American regulars had been transferred east, and with the term of service of many militiamen expiring, Brigadier

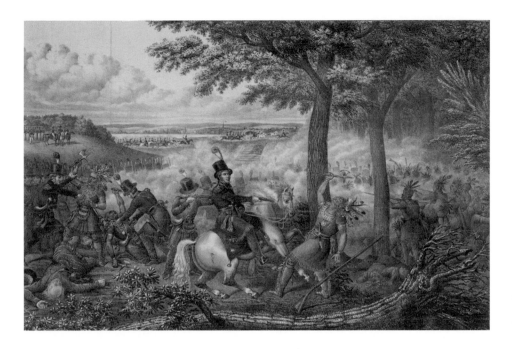

Fig. 2.2. *Battle of the Thames* by John Dorival (active 1826–1838), lithograph, c. 1833. Prints and Photographs Division, Library of Congress, Washington, D.C.

General George McClure decided to evacuate Fort George. As he left, he ordered the nearby town of Newark (now Niagara-on-the-Lake) burned. Lieutenant General Gordon Drummond, who then held the British command on this front, was so furious that after capturing Fort Niagara on the American side of the river he ordered all nearby towns, including Buffalo, put to the torch. Thus, by the end of the year the British controlled the front, and settlements on the American side of the river were in ruins.

At the other end of Lake Ontario, American forces under Brigadier General Jacob Brown beat back an amphibious assault on Sackets Harbor on May 29. But this was the only bright note in an otherwise disastrous campaign in the region. The principal American operation, which called for a two-pronged assault on Montreal, ended in failure. One army, under Major General Wade Hampton, which headed north from Plattsburgh, was turned back by a much smaller force of French Canadians and Indians under the command of Lieutenant Colonel Charles de Salaberry (cat. 34) at Châteauguay on October 26. A second army, under Major General James Wilkinson (cat. 17), which approached down the St. Lawrence River, was defeated in the Battle of Crysler's Farm on November 11. With this twin defeat, Wilkinson, who had the overall command, ended the campaign and went into winter quarters.

Americans had a lot less to celebrate in the war at sea in 1813. The British beefed up their Atlantic squadron and established a blockade of the American coast that was gradually extended to include all the ports and harbors south of New England. The blockade took a heavy toll on the American economy and cut into government revenue. In addition, the British won the principal naval duel when the British frigate *Shannon* subdued the American frigate

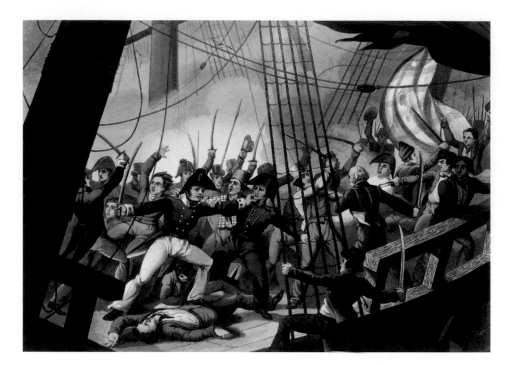

Fig. 2.3. *Boarding and Taking the American Ship Chesapeake, by the Officers & Crew of H.M. Ship Shannon, Commanded by Capt. Broke, June 1813* by Matthew Dubourg (active 1786–1838), after (Charles?) Heath, colored lithograph, c. 1813. Beverley R. Robinson Collection, U.S. Naval Academy Museum, Annapolis, Maryland

Chesapeake in fifteen minutes of well-directed fire (fig. 2.3). The American commander, Captain James Lawrence (cats. 47 and 48), was mortally wounded in the engagement. His words "Don't give up the ship" became the motto of the U.S. Navy, even though the *Chesapeake* had surrendered.[5]

Hoping to draw American troops away from the northern frontier, the British dispatched a squadron to the Chesapeake in the spring of 1813. Although the Americans beat back a British attack on Norfolk on June 22 in the Battle of Craney Island, elsewhere in the Chesapeake the British had their way, scattering militia, carrying off property, and, when they met with resistance, burning houses, barns, and warehouses. Although the British did not normally harm civilians, on June 25 at Hampton, Virginia, French units in British service committed atrocities. Many of the raids were carried out under the direction of Rear Admiral Sir George Cockburn (cat. 61), who earned the lasting enmity of the local population.

The balance of power in the war shifted toward the British in 1814 because Napoleon's defeat and abdication in spring brought peace to Europe, thus enabling the British to redeploy forces to America. The United States retained the initiative in the West, although an attempt to recapture Mackinac on August 4 failed. The new nation also took the offensive on the Niagara, capturing Fort Erie (cat. 33) on July 3, defeating the British at Chippawa on July 5, and then fighting to a draw in the bloody six-hour Battle of Lundy's Lane on July 25. After retiring to Fort Erie, the Americans beat back a British night attack on August 15 and then destroyed several British batteries in a sortie from Fort Erie on September 17. Although this campaign burnished the reputation of the U.S. Army and its two leaders

on this front, Major General Jacob Brown and Brigadier General Winfield Scott (cat. 29), in the end Fort Erie was abandoned, and little of strategic significance was achieved.

A large British force under Sir George Prevost launched a major invasion of upper New York in the late summer. Prevost's army was on the verge of overrunning the American lines at Plattsburgh on September 11 when Master Commandant Thomas Macdonough (cat. 53) defeated a British squadron on Lake Champlain. Macdonough prevailed by winding his flagship around in the midst of the battle to bring a fresh broadside to bear on the British ships. The British naval commander, Captain George Downie, was killed in the battle. American control of the lake threatened British supply lines, and Prevost ordered his army back to Canada, much to the disgust of his senior officers, many of whom were veterans of the Napoleonic Wars.

On the Atlantic coast, the British in 1814 extended their blockade to New England in the spring and then in the summer occupied a hundred miles of the coast of Maine, from Eastport to Castine. The British also stepped up their raids on the American coast, although the Chesapeake remained the principal target of their operations.

On August 24 the British in the Chesapeake defeated a mixed force that consisted mostly of militiamen in the Battle of Bladensburg (cat. 59) on the outskirts of Washington and then headed for the nation's capital. Dolley Madison (cat. 35) sacrificed personal property to save White House treasures (including a portrait of George Washington painted by Gilbert Stuart). The British high command enjoyed some food and wine in the White House and then burned that building as well as the Capitol and other government buildings in the city. The light from the fires in Washington during the night of August 24–25 could be seen for miles. U.S. officials returned to find the public buildings in ruins, and that fall Congress very nearly moved the capital to Philadelphia.

If the burning of Washington was the low point for the United States in the war, it was soon followed by a high point. A British force marched toward Baltimore but was slowed down on September 12 by the Battle of North Point. Major General Robert Ross (cat. 58), the British commander, was killed in the engagement. The British could not risk a frontal assault against the extensive fieldworks that protected Baltimore unless the Royal Navy could first soften the American lines. To get close enough to do the job, the British navy had to silence the guns of Fort McHenry, which protected the harbor. A squadron of ships bombarded the fort with explosive shells and Congreve rockets (cat. 74) for twenty-five hours straight on September 13–14, but the fort held out. As a result, the British army had to withdraw, and Baltimore was spared.

Young Francis Scott Key (cat. 75) watched the bombardment from a truce ship under the guns of the main British fleet, eight or nine miles away.

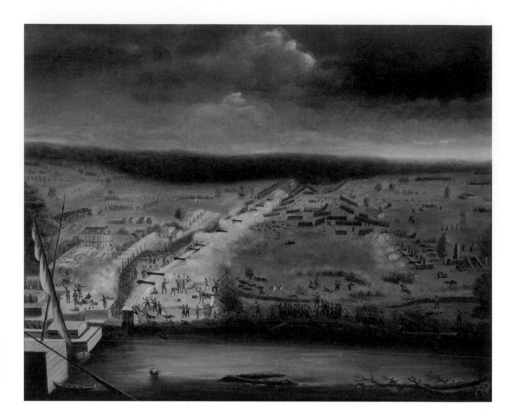

Fig. 2.4. *Battle of New Orleans* by Jean Hyacinthe Laclotte (1766–1829), oil on canvas, not dated. New Orleans Museum of Art, Louisiana; gift of Edgar William and Bernice Chrysler Garbisch

When he saw the British attack ships withdraw on the morning of September 14 and then saw the huge garrison flag (which was 30 × 42 feet) raised at about 9:00 AM (cat. 77), he knew that the fort had survived the attack. (That flag is now on display in the Smithsonian Institution's National Museum of American History.) Key was so moved that he wrote a song, initially entitled "Defence of Fort McHenry" but soon renamed "The Star-Spangled Banner." This patriotic air, describing the bombardment of Fort McHenry, became such a popular song that Congress made it the national anthem in 1931.

The final campaign of the war took place on the Gulf Coast. Major General Andrew Jackson, who had defeated Indians in the South in the Creek War (1813–14), was in charge of the defense of New Orleans. A larger British force under the command of Major General Edward Pakenham (cat. 79), the Duke of Wellington's brother-in-law, arrived in December. Jackson traded blows with the British in several preliminary engagements before Pakenham attacked Jackson's main line on January 8. The British sustained huge losses in the Battle of New Orleans, around 2,000 in all, whereas Jackson lost only seventy men (fig. 2.4). Among the British dead was Pakenham, whose remains were shipped home in a barrel of spirits for burial.

In the war at sea, there were several engagements. The U.S. frigate *Essex* surrendered to two British ships, and the heavy frigate *President* surrendered to a British squadron after being brilliantly outmaneuvered by the *Endymion*. Equally inspired seamanship on the American side enabled the *Constitution* to capture the *Cyane* and *Levant* in a single engagement, and the *Chasseur*

continued to show the pluck of American privateers by threatening the British coast and proclaiming a mock blockade of Britain and Ireland.

Although representatives of the two warring nations signed a peace treaty in Ghent (in modern-day Belgium) on December 24, 1814, the war did not end until the United States ratified the agreement on February 16, 1815. The war had lasted thirty-four months and had ended in a draw. Although only 2,260 Americans were killed in battle, other war-related deaths, mostly militiamen who perished from disease, drove up the total to around 20,000. British losses were about 10,000, and Indian losses perhaps 7,500.

The war left a considerable legacy, fostering a national identity and consciousness. It also had a significant impact on the American military establishment and national military policy. The Federalist policy of military preparedness, which the Democratic-Republicans had jettisoned in 1801 in the interest of economy and ideology, emerged triumphant after the war. The unexpected success of the U.S. Navy against the Mistress of the Seas led to a new appreciation of sea power and a long-term commitment to naval expansion. The U.S. Army, which had entered the war in such a sorry state, emerged with a new set of officers, headed by Andrew Jackson, Jacob Brown, and Winfield Scott, and a commitment to professionalism that gave promise of greater success in future wars. Both services came of age during the war, and both won public esteem that continues to this day.

Notes

1. Madison to Congress, November 5, 1811, *Annals of Congress*, 12th Cong., 1st sess., 13.

2. Speech of John Randolph, December 10, 1811, *Annals of Congress*, 12th Cong., 1st sess., 447.

3. Charles J. Ingersoll, *Historical Sketch of the Second War between the United States of America, and Great Britain . . .* (Philadelphia: Lea and Blanchard, 1845–49), 1:102.

4. Perry to Harrison, September 10, 1813, in Benson J. Lossing, *The Pictorial Field-Book of the War of 1812* (New York: Harper & Bros., 1868), 530. The original report, written on the back of an old letter, has been lost. Lossing has a facsimile based on the original.

5. Lawrence made his plea with several different expressions. This version was immortalized by Perry, who named his flagship after Lawrence and flew a banner with these words on it during the Battle of Lake Erie. That banner is now at the U.S. Naval Academy in Annapolis, Maryland.

Art and War: Truth and Myth

Sidney Hart

Although textbooks of American art do not contain chapters on the War of 1812, a large number of American portraits and paintings are indeed specific to the war. Many of the best American artists—Charles Willson Peale, his son Rembrandt Peale, John Wesley Jarvis, Thomas Birch, and the most popular cartoonist of the era, William Charles—responded to the American public's demand to see their heroes and, in Charles's case, castigate their enemies. If public opinion polls had existed, they would have indicated that a majority of Americans *believed* that their nation had won the war. They were especially proud of America's one-on-one naval victories and, except for New Englanders, overlooked the successful British blockade of American ports. This contemporary American view of the War of 1812 created a narrative—a myth—that generated and was reflected in the art stemming from the war.

All great nations have great myths. Myths play a pivotal role in defining us as a people and are essential parts of the "mystic chords of memory" that bind us to the past. In the Americans' mythical view of the War of 1812, the United States courageously declared war because the mighty British Empire was interfering with U.S. trade, and its navy was kidnapping American sailors. Against formidable odds, Americans beat Great Britain and, while doing so, invented Uncle Sam, composed the poetry of the "Star-Spangled Banner," and created America's greatest antebellum hero: Andrew Jackson. The myth was immortalized in artworks—portraits of the heroes, cartoons satirizing the British, and paintings of the victorious battle scenes, many of which are included in this book. Despite being the vehicle of mythology, this art is quite real and quite good, and its depictions of the war were quite true.

Myth is not synonymous with falsehood, and in the War of 1812, the staying power of the war art is the truth behind the myth: Great Britain impressed American sailors and interfered with U.S. trade, Uncle Sam was created to counter John Bull, the words to the "Star-Spangled Banner" were written by Francis Scott Key during Baltimore's heroic defense against a massive British bombardment, and Andrew Jackson's victory in New Orleans

was heroic. Even the mythical part of the narrative reflects the truth about the outcome of this war (see cat. 102). Although far from an American triumph, the war should have by all odds been lost, and although the United States did not win, it most certainly did not lose. There is victory in survival, especially in a war in which the British clearly had military superiority in ships and soldiers. More important, the myth that the United States won had a tremendous salutary effect on the nation. The national government became more viable, the sense of national unity increased, and the United States had greater autonomy from Europe and Great Britain. The war helped stimulate the creation of a distinctly American culture (see cat. 99) and accelerated development of U.S. transportation systems as well as commerce and industry, as seen in the last section of the catalogue. For contemporary Americans, it did indeed seem that they had won the war.

The symbiosis between American artists and the War of 1812 is not always clear. Some artists were reluctant participants; others established their careers in the war. Rembrandt Peale, the son of the artist and museologist Charles Willson Peale, moved to Baltimore in 1814 to open a museum of art and science right at the moment that city expected a British attack. Rembrandt was a pacifist. His father, one of the few artists who fought in the American Revolution, had also become a pacifist. On September 6, a week before the British attack, Charles, reflecting on the American Revolution, wrote Rembrandt: "These are the times that try men's souls' as well now as when that able writer [Thomas Paine] wrote his [American] Crisis."[1] It will, he continued, "require the best exertions of our ablest men to steer us through the impending Storm." He did not, however, want his son to be one of those "ablest men" defending Baltimore: "You are not fitted for a state of war; your nerves are feeble, yet very sensitive to the least touch."[2] "War is horrible," he wrote another of his sons; "men killing each other is truly savage. Differences between Nation and Nation may be easily settled by arbitrations."[3] But whereas Charles, living outside of Philadelphia, could safely ruminate about nations settling their differences peacefully, Rembrandt's position in Baltimore was precarious. He had thought about enlisting in the city militia but wrote his younger brother Rubens that he "found it impossible to shoot a human being."[4] He had determined to be a conscientious objector and feared either being forced into the militia or arrested. Instead, Rembrandt turned to his art and his talents as a portraitist, and embraced the mythology of the War of 1812. By celebrating American war heroes, particularly naval heroes, he insulated himself and his museum. On August 17, 1814, two days after his museum's opening, he inserted an advertisement in the *Federal Gazette and Baltimore Daily Advertiser* describing the many attractions of the museum and bragging of new additions: "the portraits of *Bainbridge, Decatur, Jones, Perry, Harrison* [cat. 22] and others like distinguished."[5] The timing of his new exhibition

was critical: the British were approaching Washington, and a week later, on August 24–25, they burned its public buildings; three weeks after that, on September 13–14, they bombarded Fort McHenry. As one whose livelihood depended on knowing what his fellow citizens would pay to see, Rembrandt was well aware of the way that not just Baltimoreans but Americans viewed their new heroes, who were so critical to morale during that time. In the midst of those dark days, America needed and held on to its glorious naval victories, and the artist Rembrandt Peale was glad to oblige.

Charles Willson Peale was retired during the war and did not paint many portraits. In 1816, however, he did paint three war heroes for his Philadelphia museum collection: James Biddle, Edmund Pendleton Gaines, and Jacob Jennings Brown. Peale had pleaded with Brown to release his son Linnaeus from active duty during the war and painted Brown's portrait as a gift from a grateful father. In 1819 he painted the portrait of the war's greatest hero, Andrew Jackson (cat. 83).

John Wesley Jarvis was born in England of American parents, Loyalists who had fled to England during the American Revolution and later returned. Jarvis apprenticed with Edward Savage in Philadelphia and went with him to New York, where he then partnered with Joseph Wood to paint miniatures. Jarvis was in Baltimore from 1810 to 1813 and made a few notable portraits, particularly that of Supreme Court justice Samuel Chase. He returned to New York, where the city government had been offering a commission of six full-length portraits of heroes of the War of 1812 and had been turned down by Thomas Sully and Gilbert Stuart. Jarvis eagerly accepted, earning him a disdainful dismissal from Stuart as a government hireling. Jarvis had already painted a portrait of John Armstrong (cat. 69), a brigadier general in command of New York City at the start of the war; President Madison would make Armstrong his secretary of war in 1813. Jarvis began the city commission in 1815 and completed the portraits in 1817: Oliver Hazard Perry, William Bainbridge, Jacob Jennings Brown, Isaac Hull, Thomas Macdonough, and Joseph Gardner Swift. These grand works would establish Jarvis as one of the best portraitists in America. He would go on to paint between 750 and 1,000 portraits and to become one of the most popular artists of his time.

Thomas Birch, a landscape and marine painter, is the artist most associated with the War of 1812. The son of enamel painter William Russell Birch, he was born in England and immigrated with his family to America in 1793. Birch painted in Philadelphia and was initially known for his watercolor portraits. In 1807, after a trip to the Delaware capes, he began painting seascapes. During the War of 1812, responding to the public demand for images of American naval victories, Birch painted a series of battle scenes that were extremely popular and were the subjects of numerous prints. These paintings of American naval victories would comprise the high point of

Birch's career. Prints of Birch's paintings, such as the *Engagement Between the Constitution and the* Guerrière *1813* and *Capture of H.M.S.* Macdeonian, were in great demand. Birch's engraving of Oliver Hazard Perry's victory on Lake Erie (cat. 51) was viewed by Benjamin West, who purportedly remarked that it was "the best composition of a picture to have come from America."[6]

Caricature became an important part of American politics during the War of 1812, and the most prominent American cartoonist was William Charles. A Scottish-born engraver who immigrated to America in 1806, Charles did most of his work in New York and Philadelphia. Ironically, given the strong anti-British subjects of his wartime cartoons, much of Charles's fame rests on his role as an important transmitter of the methods and tone of English caricature—then at its height—to America. It was an era in which satire, earthly humor, and ridicule in political discourse were admired and in demand. Although not considered an expert draftsman or an original wit, Charles achieved prominence with his ability to render political opinions and military events in pictures. His seventeen political prints constituted a greater number—and were more widely circulated—than the cartoons of any of his contemporaries: Peter Pencil, Alexander Anderson, James Akin, and Amos Doolittle. Charles's political caricatures celebrated American military glory while ridiculing the British, such as in his *Queen Charlotte and Johnny Bull Got Their Dose of Perry*, celebrating Perry's great victory on Lake Erie, punning with the name of one of the defeated British ships, the *Queen Charlotte*. His cartoon *A Boxing Match* (cat. 52), showing James Madison giving a bloody nose to John Bull, refers to the 1813 battle of the *Boxer* and the *Enterprise*, in which the American ship defeated the British ship off the coast of Maine. Charles also ridiculed Americans whose behavior was less than heroic, as in his cartoon on the "surrender" of the citizens of Alexandria, Virginia, to the British (cat. 70). Charles's imitation of English caricature in the service of his new country not only made this genre accessible to an American popular audience but also helped perpetuate the myth of American victory in the War of 1812.

How, then, do we balance the myth and truth of the War of 1812? Using the art of another time, in one of the greatest Westerns, *The Man Who Shot Liberty Valance* (directed by the incomparable John Ford), a newspaper writer learns at the end of the movie that the story of the hero's courage is not true: he did not shoot the outlaw Liberty Valance; someone else deserved the credit. When the mythical "hero" then asks the newspaperman if he will print the real story, the reporter replies, "no sir." This is the West, and when "myth becomes fact, we print the myth." So, yes, America did win the War of 1812; its artists left memorable paintings of the war and its heroes. So it must be true.

Notes

1. Charles Willson Peale to Rembrandt Peale, September 6, 1814, in *The Selected Papers of Charles Willson Peale and His Family*, ed. Lillian B. Miller, Sidney Hart, and David C. Ward (New Haven, CT: Yale University Press, 1991), 3:262–65.

2. Ibid.

3. Charles Willson Peale to Benjamin Franklin Peale, September 14–15, 1814, in *Selected Papers,* 3:266.

4. Rembrandt Peale to Rubens Peale, August 22–23, 1814, in *Selected Papers*, 3:258.

5. *Selected Papers,* 3:268.

6. Tony Lewis, "Thomas Birch," *American National Biography Online,* http://www.anb.org (accessed November 2, 2011).

Early America, 1800–1811

If we were transported back to the United States of 1800, we would be immediately struck by how few people occupied such a vast space. Little more than five million people, a sixth of them slaves, occupied 888,000 square miles, soon to be doubled by the Louisiana Purchase. With the exception of a few cities located in a narrow strip along the eastern seaboard, the new country was composed of farms and endless forests. Indian nations, often aligned with the British or other European powers, were always a potent force on the frontiers. Only one in twenty-five Americans lived in a city. The largest and most cosmopolitan city was Philadelphia, with a population of 69,000. In June of 1800, the new nation's capital moved from that city to a virtual wilderness on the Potomac River between Maryland and Virginia. After the election of 1800, John Adams, the nation's second president, was leaving the President's House still unfinished, and Thomas Jefferson (cat. 4), the leader of a new political party, would be moving in, taking part in the first real transfer of power in the new republic. Although we would see the beginnings of industry and mills operated by water power, farming was the dominant way of life; land was plentiful, but free labor was scarce. Only a vestigial transportation network existed, roads were terrible, and there were few canals and fewer bridges. Settlers west of the Appalachians were isolated. Notwithstanding Washington's and Jefferson's warnings, America would be unable to avoid European conflicts, and pirates in the Mediterranean would stimulate the building of an American navy. The wars generated by the French Revolution would interfere with America's prosperous trade and growing merchant fleet, leading the country toward war.

SH

List of Authors
SH—Sidney Hart
RLP—Rachael L. Penman

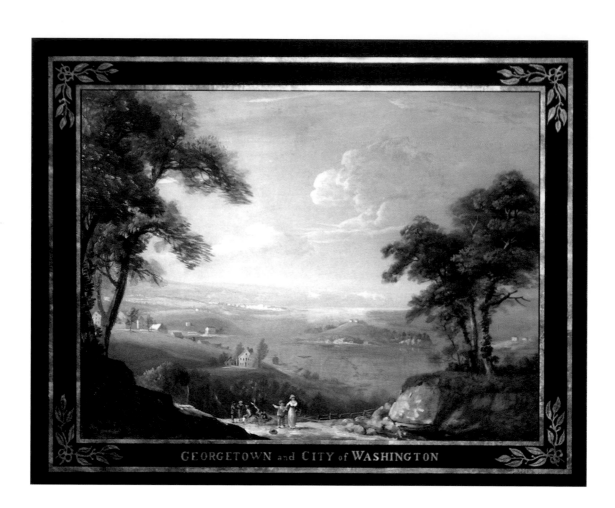

GEORGETOWN and CITY of WASHINGTON

I Georgetown and City of Washington

George Beck (1748–1812)
Gouache on paper, 38.1 × 50.8 cm (15 × 20 in.), c. 1795
Arader Galleries, Philadelphia, Pennsylvania

The Residence Act of 1790 required that the federal government relocate in 1800 to the new Federal City, a square, ten miles on each side, on the banks of the Potomac River. President George Washington appointed a three-man planning commission that met with Thomas Jefferson and James Madison in 1791. As everyone expected, the commission named the capital after the first president and authorized him to pick out the precise locations for the buildings that would house Congress, the Supreme Court, and the president. In 1800, about five years after George Beck's drawing was made, the city contained 400 scattered dwellings, most of them wooden shacks, and only 109 permanent structures of brick and stone. There were a few stores, hotels, and boarding houses but no churches or schools. To many in Congress, who had served in New York and then Philadelphia, the new capital appeared to be a "howling, malarious wilderness" and a swampy wasteland. Declaration of Independence signer and physician Benjamin Rush warned John Adams, who would be the first president to occupy the White House, that when the capital was moved to the "bank of the Potowmac," he would find himself with "Negro Slaves" as "servants by day, . . . mosquitoes your centinels by night, and billious fever your companions every summer and fall." Still, some congressmen who had experienced the terrible outbreaks of yellow fever in Philadelphia in the 1790s were hopeful about Washington, while one New York representative claimed, "we only need houses, cellars, kitchens, scholarly men, amiable women and other such trifles to possess a perfect city."

SH

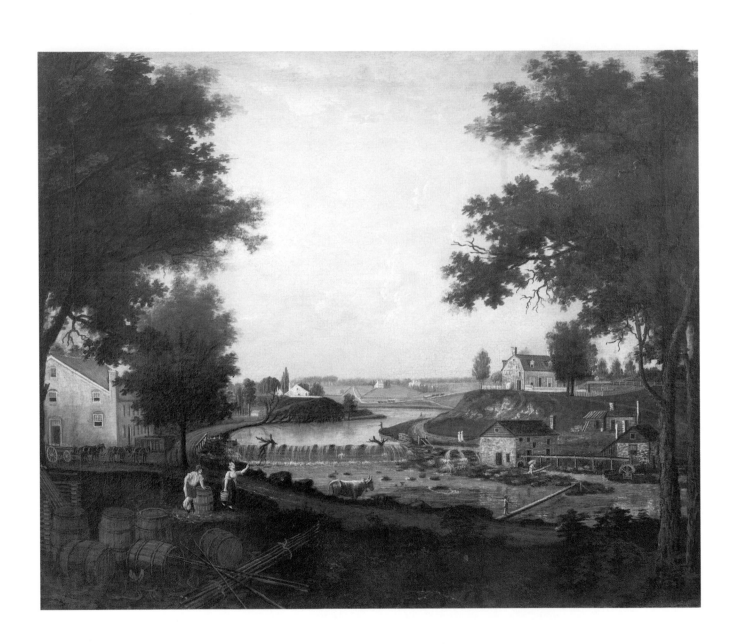

2

Pennington Mills, Looking Up Stream

Francis Guy (1760–1820)
Oil on canvas, 80 × 94 cm (31½ × 37 in.), c. 1804
Maryland State Archives, Annapolis

In 1804, about when Francis Guy painted Pennington Mills on the Jones Falls in Baltimore, American mills in the Delaware and Chesapeake regions ranked among the most successful and best designed in the world. Baltimore, in particular, had become one of the nation's fastest-growing ports, accounting for two-thirds of Maryland's exports. Demand from Europe and the West Indies for American flour had markedly increased, tripling from 1790 to 1810. Successful flour mills required access to wheat growers and ocean-going vessels, giving Baltimore a considerable advantage. By 1803 there were twelve mills situated on Jones Falls. Josias Pennington (fl. 1790–1805) was operating four mills as early as 1795 and had previously married the daughter of a man who owned several flour mills on the falls. That year Pennington joined with John Taggart in constructing a mill race in the area, increasing the water power for the mills on the falls. The success of mills like Pennington's inspired Philadelphia inventor Oliver Evans to create new machinery for them. Evans's linked machinery weighed, cleaned, and ground wheat and then packed the superfine flour into barrels; there was little hand labor involved. Pennington Mills exemplified both the development of manufacturing in America and the importance of the export trade since the American Revolution. The Embargo Act of 1807 and the War of 1812 greatly accelerated mill production in America and channeled exports into internal trade.

SH

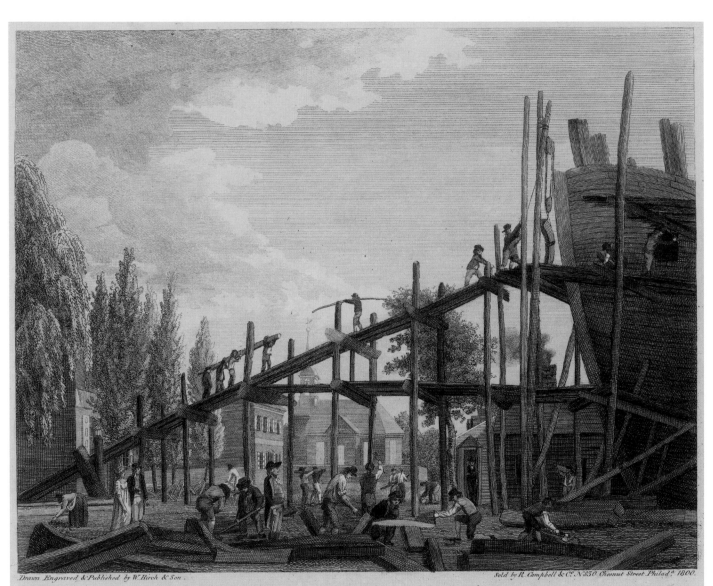

Drawn Engraved & Published by W. Birch & Son.

Sold by R. Campbell & Co. N°. 30 Chesnut Street Philad°. 1800.

Preparation for WAR to defend Commerce.

The Swedish Church Southwark with the building of the FRIGATE PHILADELPHIA.

3

Preparation for War to Defend Commerce: The Swedish Church Southwark with the Building of the Frigate Philadelphia

William Russell Birch & Son (1755–1834)
Hand-colored engraving, 33.9 × 40.9 cm (13⅜ × 16 ⅛ in.), 1800
The John Carter Brown Library, Brown University,
Providence, Rhode Island

Born in Haverford, Pennsylvania, Joshua Humphreys (1751–1838) established his own shipyard in Philadelphia and during the American Revolution fit out vessels for the Continental Navy. For this he was "disunited from religious fellowship" by his fellow Quakers. Humphreys hoped to design the new navy frigates approved by Congress and wrote government officials about his design, which would be stronger and faster than comparable European ships. On June 28, 1794, he was appointed naval constructor and submitted a design for a frigate with a keel twenty feet longer than that of the largest British frigates. Humphreys's frigates, capable of mounting forty-four or more guns, had innovative features, such as diagonal braces, which gave strength and stiffness to the whole vessel. Humphreys also insisted on using live oak (*Quercus virginiana*), found in abundance on the Georgia Sea Islands; live oak was 50 percent denser than white oak, making his frigates more resistant to enemy fire. Ships' carpenters, however, complained of working with a wood so hard it dulled their tools. In 1797, three frigates of Humphreys' design were launched: the *United States*, from his yard in Philadelphia; the *Constitution*, from Boston; and the *President*, from New York. Although Humphreys collected data from British handbooks and merchant captains, there were no physical laws in the eighteenth century establishing proportional measurements to insure how sailing ships would perform. So it was with great relief that he received a letter from the captain of the *United States*, indicating that "no ship ever went to sea steers and works better." The record of his frigates in the War of 1812 confirmed the captain's praise and Humphreys' genius. In this print of Humphreys' yard, which contains the only known image of him—the man in the hat and yellow vest—the smaller thirty-six-gun frigate *Philadelphia* is under construction.

SH

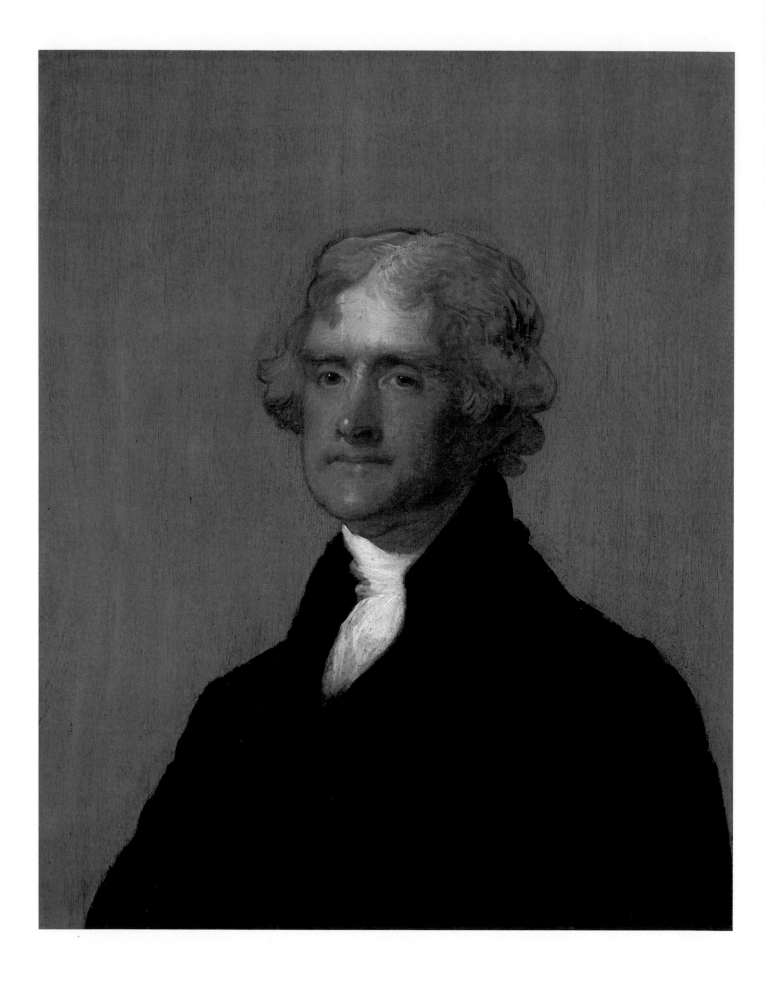

4
Thomas Jefferson, 1743–1826

Gilbert Stuart (1755–1828)
Oil on panel, 66.4 × 53.3 cm (26⅛ × 21 in.), 1805/1821
National Portrait Gallery, Smithsonian Institution,
Washington, D.C.; owned jointly with Monticello, Thomas
Jefferson Foundation, Inc., Charlottesville, Virginia; purchase
funds provided by the Regents of the Smithsonian Institution,
the Trustees of the Thomas Jefferson Foundation, Inc.,
and the Enid and Crosby Kemper Foundation

In his epitaph, Thomas Jefferson wanted to be remembered for three
achievements: author of the Declaration of Independence, author of the
Virginia Statute for Religious Freedom, and founder of the University of
Virginia. Glaring in its omission is that he was the third president of the
United States. Perhaps the omission stemmed from a difficult second term,
during which his policies failed to end British and French encroachments on
American rights during the Napoleonic Wars, which had resumed in 1803.
This was the most important test of the administration, and Jefferson's failed
policies would be left for his successor, James Madison (cats. 9 and 19).
Both Great Britain and France sought to prevent American merchants from
supplying the other power. Great Britain, however, with its overwhelming
naval superiority, was the most serious violator of America's neutral trading
rights, forbidding American ships from supplying Napoleon's armies with
staples from the United States or French and Spanish colonies in North
and South America. Great Britain blockaded European ports and impressed
American sailors into its navy. After failing to change British policy with
the Non-Importation Act (1806) and negotiation, Jefferson recommended,
and Congress passed, the Embargo Act (1807), prohibiting American ships
and goods from leaving port. American merchants, with British cooperation,
evaded the law. Mercantile New Englanders opposed the legislation and even
talked about nullifying it. In the final month of his presidency, Jefferson
agreed to the repeal of the embargo, signing the Non-Intercourse Act, which
reopened trade with all nations except Great Britain and France and their
colonies and authorized the president to resume trade with whichever of
those nations stopped violating American neutral trading rights.

SH

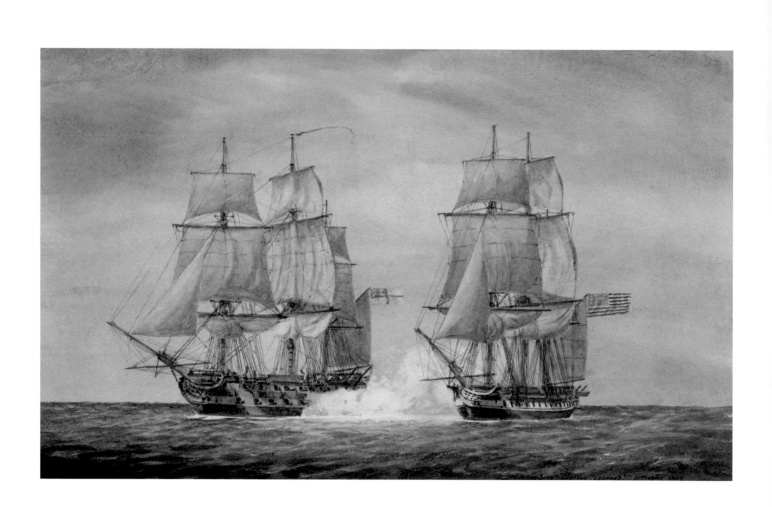

5 Chesapeake *vs.* Leopard, *June 21* [*sic*], *1807*

Unidentified artist
Watercolor on paper,
26.6 × 43.2 cm (10½ × 17 in.), c. 1852
The Mariners' Museum, Newport News, Virginia

On the voyage from Washington to Norfolk, tensions had arisen between the officers of the American frigate *Chesapeake* and its new captain, James Barron (1768–1851), who had served honorably in the Mediterranean but had not seen battle. When the *Chesapeake* docked in Norfolk, British warships, including the fifty-five-gun *Leopard*, were anchored in American waters at the mouth of the Chesapeake Bay. During the *Chesapeake*'s stay in port, several sailors from the British ships, whom the British considered deserters, signed on with the *Chesapeake*. On June 21, the *Chesapeake* headed out to sea. The next morning, June 22, the *Leopard* closed on her, guns out and ready to fire. Barron did not clear his ship for action, standard practice when approached by another nation's warship. The *Leopard* ordered the *Chesapeake* to submit to a search for deserters—a direct infringement of American sovereignty, which could be considered an act of war. Barron refused but delayed calling the crew to battle stations, causing confusion. The *Leopard* began firing, causing considerable damage to the *Chesapeake*. A *Chesapeake* officer fired one shot before Barron shouted, "stop firing, stop firing! We have struck; we have struck." On the U.S. ship, three men were dead and sixteen wounded (one of whom later died). The British boarded and took four deserters, and the *Chesapeake* limped back to port. Americans were enraged. President Jefferson ordered all British warships out of American waters, and state governors were called to ready 100,000 militiamen for service. The British apologized for the American casualties, but their warships did not leave American waters and impressments of American sailors continued. Barron was court-martialed, found guilty of neglecting "to clear the ship for action," and sentenced to a five-year suspension from the navy.

SH

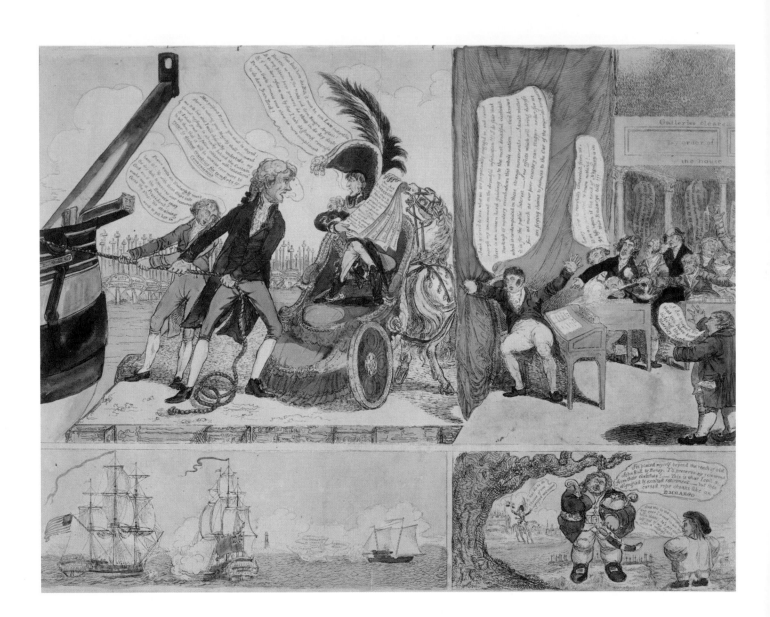

6

An Old Philosopher Teaching His Mad Son Economical Projects

James Akin (1773–1846)
Etching, 32.7 × 43.2 cm (12⅞ × 17 in.), 1809
Free Library of Philadelphia, Pennsylvania

James Akin's cartoon tells the story of the Embargo Act from the Federalist (anti-Jefferson) viewpoint. At the lower left the British naval ship *Leopard* attacks the American frigate *Chesapeake* (cat. 5). Another American ship retaliates, hurling angry proclamations by the Jefferson administration, which was incensed by the *Leopard*'s attack. *An Old Philosopher* probably appeared during the last months of Jefferson's presidency, as a reaction to the Enforcement Act of January 9, 1809, which gave government officials extensive powers to enforce the embargo. Strong opposition arose in New England and New York, areas in which the carrying trade—American ships moving agricultural and other goods to the West Indies and to European and British ports—was vital. Politically, Federalists made huge gains in New England and were joined in their opposition to the national government by Jeffersonian Republicans in New York and even in states like Virginia. Federalists viewed Jefferson's policy of commercial warfare as really directed against Britain, with the president and his secretary of state, James Madison, in collusion with Napoleon (cat. 14). In the cartoon, Jefferson and Madison are hauling a ship in drydock at the emperor's command. Madison says, "France wants an Embargo & must have it! Up with these Ships into the dry dock to preserve our resources. God send the Emperor may make me a President." On the right, behind the curtain, Congress debates the embargo policy, with one dissident bitterly complaining, "Everything is carefully concealed from us. . . . My life upon it the hand of Napoleon is in this Embargo bill." At the lower right a distraught American places a noose around his own neck: "I've placed myself beyond the reach of old John Bull & Boney [Bonaparte]."

SI I

The First Great Western Empire: or, THE UNITED STATES OF AMERICA.

WE hold these truths to be self-evident; that all Men are created equal; that they are endowed by their Creator with certain unalienable rights; that among these are life, liberty, and the pursuit of happiness.

Dec. Independence, 1776.

THE Unity of government which constitutes you one people, is also now dear to you. It is justly so; for it is a main pillar in the edifice of your real independence; the support of your tranquillity at home; your peace abroad; of your safety; of your prosperity; of that very liberty you so highly prize.

Washington's Farewel Address.

DISTRICT OF Columbia.

E PLURIBUS UNUM

Census—taken in 1810.		Census—taken in 1810.	
214,460	N. HAMPSHIRE	MARYLAND	380,546
700,745	MASSACHUSETTS	VIRGINIA	974,622
76,931	RHODE-ISLAND	N. CAROLINA	555,500
261,942	CONNECTICUT	S. CAROLINA	415,115
217,895	VERMONT	GEORGIA	252,433
959,049	NEW-YORK	KENTUCKY	406,511
245,562	NEW-JERSEY	TENNESSEE	261,727
810,091	PENNSYLVANIA	OHIO	230,760
72,674	DELAWARE	GRAND TOTAL	7,239,903

TERRITORIES.

* Including the population of territories, &c.

AGRICULTURE AND DOMESTIC MANUFACTURES.

The IMMOVEABLE PILLARS of the Independence of our country, are Agriculture and Domestic Manufactures.

We wish for the friendship of ALL—We will submit to the insults of NONE.

The ocean is the highway of nations—However alone, has a right to command it.

TEMPLE OF FREEDOM

COMMERCE.

Whenever we can receive the productions of other countries at a fair profit, then Commerce is not only advantageous, but it is a STRONG SUPPORT to our national edifice.

THE FEDERAL Constitution.

 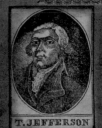

G. WASHINGTON JOHN ADAMS T. JEFFERSON JAS. MADISON

THESE are the Men who, with thousands of others, achieved the Independence of the United States. They laid the foundations of our freedom broad and deep; they constructed her TEMPLE of the choicest materials of past ages; and embellished it with the finest ornaments of modern times. Should this vast fabric be left to decay, or be rent asunder, then the fairest hopes of the friends of freedom, throughout the world, will be forever lost.

General Washington's Resignation.*

THE Representatives of the sovereignty of the Union remained seated and covered. The spectators were standing and uncovered. The General was introduced by the Secretary, and conducted to a chair. After a decent interval, silence was commanded, and a short pause ensued. The President then informed him, that "The United States in Congress assembled were prepared to receive his communications." With a native dignity, improved by the solemnity of the occasion, the General rose and delivered the following Address.

"MR. PRESIDENT,

"The great events on which my resignation depended, having at length taken place, I have now the honor of offering my sincere congratulations to Congress, and of presenting myself before them to surrender into their hands the trust committed to me, and to claim the indulgence of retiring from the service of my country.

"Happy in the confirmation of our independence and sovereignty, and pleased with the opportunity afforded the United States of becoming a respectable nation, I resign with satisfaction the appointment I accepted with diffidence; a diffidence in my abilities to accomplish so arduous a task, which however, was superseded by a confidence in the rectitude of our cause, the support of the Supreme Power of the Union, and the patronage of Heaven.

"The successful termination of the war has verified the most sanguine expectations; and my gratitude for the interposition of Providence, and the assistance I have received from my countrymen, increases with every review of the momentous contest.

"While I repeat my obligations to the army in general, I should do injustice to my own feelings not to acknowledge in this place, the peculiar services and distinguished merits of the gentlemen who have been attached to my person during the war. It was impossible the choice of confidential officers, to compose my family, should have been more fortunate. Permit me, Sir, to recommend in particular, those who have continued in the service to the present moment, as worthy of the favorable notice and patronage of Congress.

"I consider it as an indispensable duty to close this last act of my official life, by commending the interests of our dearest country to the protection of Almighty God, and those who have the superintendence of them, to his holy keeping.

"Having now finished the work assigned me, I retire from the great theatre of action, and bidding an affectionate farewel to this august body, under whose orders I have so long acted, I HERE OFFER MY COMMISSION, and take my leave of all the employments of public life."

THE General advanced to the chair, and delivered his Commission to the President, then returned to his place, and, after receiving an answer, retired from the hall of Congress.

* From the works of Judge Marshall, Chief Justice of the United States.

THE UNITED STATES OF AMERICA,

INCLUDING Louisiana, has the most extensive territory, the Russian Empire excepted, of any nation on the globe. Its length, breadth, and boundaries are not accurately known.—The face of the country, excepting the lofty range of mountains, denominated the Allegany, may be called level. These mountains with some interruptions, extend the whole length of the United States, in a North-East and South-West direction, dividing the country into two grand divisions, called Eastern and Western.—The lakes and rivers next come under our view. Our lakes are the largest in the known world; and many of them are navigable for heavy vessels; and are convenient for opening the most extensive inland navigation of any country on earth. They abound with a great variety of excellent fish, and the soil on their shores is generally fertile, producing all the necessaries of life with very little manual labor. The rivers, though of not such an enormous size as those of South-America, are most of them, especially those running immediately into the ocean, of depth sufficient to receive large vessels a considerable distance up their waters; and in some places, boats ascend to their very sources, pass over portages, and descend other rivers into the great northern lakes.—The climate of this vast country is various. In no part, however, is it excessively cold. The southern parts are warm, and not so healthy as the more northern districts. In the northern sections, the air is salubrious, and the inhabitants healthy.—The mineral, animal, and vegetable productions of the United States comprehend almost every kind found in the other parts of the world. The various mines, it is presumed, have not all been discovered, nor have all the vegetable productions been analysed. The deer, the bear, and multitudes of other quadrupeds, abound in the forests; and the pastures of those lands brought under cultivation, are filled with all sorts of domestic animals.—The forests are immense. The oak, the pine, the maple, and the hickory constitute the greatest proportion of the forest trees. Trees and shrubs, however, of almost every other description, are found in greater or less abundance, and taken together, form an incomparable resource for excellent timber, necessary for building houses, ships, and the ornamental departments of wood-work.—Nor is the maritime situation of the country less advantageous. A long range of sea coast, indented with innumerable bays and rivers, forms many excellent harbors for shipping in all seasons of the year. Our commerce, although the country is in its infancy, has become very extensive, and has already excited the envy and jealousy of the most powerful potentates of Europe. The sea on our coasts is stored with immense quantities of excellent fish, of nearly of every description.—The interior part of the United States, west of the Allegany mountains, has likewise every advantage which nature can bestow on an inland country. Innumerable salt springs, inexhaustible beds of pit coal, form the vast natural magazines, which will ever render this portion of our Union equally respectable with the Atlantic parts.—Added to all these, the soil of the United States is generally fertile; and in some parts, rich beyond calculation. Springs and streams of water are found every where. No, burning deserts, no mountains covered with eternal snows, here obstruct the exertions of industry; but in every part, the dwellings of civilized man may be erected, and the whole vast country exhibit one uninterrupted body of inhabitants.—Considering the extent of our territory, the population of the country is small; but when we reflect, that the first European settlement took place on our shores only about two hundred years ago, we may consider it unparalleled. The increase of inhabitants from among ourselves, has not only been great, but the emigrations from all parts of Europe has been equally numerous.—Our improvements in the arts of civilized life, are also respectable; notwithstanding it has been the uniform policy of some of the European governments to throw every obstacle in the way of our advancement.—In addition to all these advantages, the United States has one invaluable privilege above all other nations. She has a Republican form of Government; a form of government which secures to her citizens the right of choosing and dismissing their own rulers; a form of government, which should ever command our highest reverence, and strongest attachment; for on its existence depends every thing which can render life valuable to a virtuous and enlightened people.

Entered according to act of Congress,

On the Fifteenth Day of January, 1812,

By Jonathan Clark,

OF ALBANY, IN THE STATE OF NEW-YORK.

PRINTED BY AND FOR THE AUTHOR, AT THE PRESS OF E. PACKARD, No. 51, STATE-STREET, ALBANY.

Columbia.*

COLUMBIA! Columbia! to glory arise,
The queen of the world and the child of the skies;
Thy GENIUS commands thee; with rapture behold,
While ages on ages thy splendors unfold.
Thy reign is the last, and the noblest of time,
Most fruitful thy soil, most inviting thy clime;
Let the crimes of the East ne'er encrimson thy name,
Be freedom, and science, and virtue thy fame.

To conquest and slaughter let Europe aspire;
Whelm nations in blood, and wrap cities in fire;
Thy heroes the rights of mankind shall defend,
And triumph pursue them and glory attend.
A world is thy realm; for a world be thy laws,
Enlarg'd as thine empire, and just as thy cause;
On freedom's broad basis thy empire shall rise,
Extend with the main and dissolve with the skies.

Fair science her gates to thy sons shall unbar,
And the east see thy morn hide the beams of her star;
New bards and new sages unrivall'd shall soar
To fame unextinguish'd, when time is no more;
To thee, the last refuge of virtue design'd,
Shall fly from all nations the best of mankind;
Here, grateful to Heaven, with transport shall bring
Their incense more fragrant than odors of spring.

Nor less shall thy fair ones to glory ascend,
And genius and beauty in harmony blend;
The graces of form shall awake pure desire,
And the charms of the soul ever cherish the fire;
Their sweetness unmingled, their manners refin'd,
And virtue's bright image, instamp'd on the mind,
With peace and soft rapture, shall teach life to glow,
And light up a smile in the aspect of wo.

Thy fleets to all regions thy pow'r shall display,
The nations admire, and the ocean obey;
Each shore to thy glory its tribute unfold,
And the east and the south yield their spices and gold.
As the day-spring unbounded, thy splendor shall flow,
And earth's little kingdoms before thee shall bow,
While the ensign of Union, in triumph unfurl'd,
Hush the tumult of war and give peace to the world.

Thus, as down a lone valley, with cedars o'erspread,
From war's dread confusion I pensively stray'd;
The gloom from the face of fair heaven retir'd;
The winds ceas'd to murmur; the thunders expir'd;
Perfumes as of Eden, flow'd sweetly along,
And a voice, as of angels, enchantingly sung,
"Columbia! Columbia! to glory arise,
The queen of the world, and the child of the skies."

* Written by Dr. Dwight, President of Yale College.

7

The First Great Western Empire

Jonathan Clark (lifedates unknown)
Wood-engraving,
43 × 27.5 cm (16 $^{15/16}$ × 10 $^{13/16}$ in.), 1812
National Portrait Gallery, Smithsonian Institution,
Washington, D.C.; acquired through the generosity of
Sidney Hart and David C. Ward

Rising tensions before the U.S. declaration of war against Great Britain in June 1812 led many Americans to expect an outbreak of hostilities. In July 1811, James Madison had notified Congress that he was calling it into special session in November to consider "great and weighty matters." This broadside, published on January 15, 1812, is a propaganda piece supporting a forceful defense of American rights. It warns other nations not to interfere in American commerce and affirms the power of "the First Great Western Empire: or, the United States of America." The broadside, published in Albany, New York, lists a Jonathan Clark as the author and includes patriotic symbols and writings. The upper left contains the preamble of the Declaration of Independence; an excerpt of George Washington's Farewell Address extolling "the Unity of government" and "one people" is on the upper right. Timothy Dwight's popular poem "Columbia," celebrating the "glories of America," is on the bottom left. To emphasize the growth of the United States, figures from the 1810 census embellish the upper center, with a "Grand Total" of 7,239,903. Two circles in the upper part of the broadside, flanking the "Temple of Freedom," warn other nations about interfering in American commerce. The left circle reads, "We wish for the friendship of all—We will submit to the insults of NONE"; the right circle notes, "The ocean is the highway of nations—Heaven alone has a right to command it." The broadside also contains portraits of Washington, Adams, Jefferson, and Madison, who are described as "the Men who, with thousands of others, achieved the Independence of the United States . . . Should this vast fabric be left to decay, or be rent asunder, then the fairest hopes of the friends of freedom, throughout the world, will be forever lost."

SH

8 *View of Montpelier*

Anna Maria Thornton (1775–1865)
Watercolor, c. 1802
James Madison's Montpelier, Orange, Virginia;
purchase made possible through the generosity of several
Montpelier patrons, 2011

In 1797, James Madison (cats. 9 and 19) retired from public life, returning to Montpelier with his recent bride, Dolley (cat. 35). Madison built an addition to his father's house, a side hall townhouse, disguised with a large portico to meld it with the original 1765 house where his parents still lived. Retirement lasted only three years. In 1801 his father died, and Madison was called to the new capital to serve as secretary of state for his friend Thomas Jefferson. In 1802 Dr. William Thornton (cat. 68), architect of the U.S. Capitol and superintendent of the Patent Office, and his wife, Anna (cat. 36), visited their close friends at Montpelier. William Thornton had shared lodgings with Madison in Philadelphia during the summer of 1787, when Madison was attending the Constitutional Convention. During the Thorntons' visit to Montpelier, Anna produced this extraordinary watercolor, the only surviving documentation of the 1797–1809 house, describing, as Anna commented in her diary entry of September, 5, 1802, its "plain but grand appearance, rendered more pleasing by Displaying a taste for the arts." Interestingly, Anna also depicted sweeping landscape changes that were then only in the conceptual stage. When he was elected president in 1809, Madison, anticipating that Montpelier would be receiving crowds of visitors and dignitaries, began substantial renovations. Assisted by builders James Dinsmore and John Neilson and with advice from both Jefferson and Dolley, Madison transformed his home. He also began transforming the landscape that year, removing older dependencies and adjacent blacksmithing operations and constructing a classical temple to hide a new icehouse.

Lynne Dakin Hastings, Montpelier

CAUSES OF WAR

Historians have given many reasons for America's declaration of war against Great Britain: the desire to force Britain to stop interfering with their trade and impressing their seamen; the desire to expand American settlement into areas controlled by Indian nations and their British and Spanish allies; a desire to conquer Canada and end British influence on the North American continent; and the need to uphold the nation's sovereignty and vindicate its honor. Since nations go to war infrequently, even if they have compelling reasons, why did the United States in 1812 choose to act on those reasons and declare war on Britain? While some new, young members of Congress, the War Hawks, were in favor of fighting Britain, the nation's two presidents during this era, Thomas Jefferson (cat. 4) and James Madison (cats. 9 and 19), certainly were not. Both presidents viewed war and its necessary measures—a large standing army, an increase in government size and powers, and debt—as antithetical to republican government. Both were convinced that Britain and France were dependent on American food and raw materials. They believed that self-imposed restrictions on American trade—embargoes and nonintercourse—would force them to respect American neutrality. Many Americans also did not want war. The New England states in particular feared even greater losses to their trade, and their representatives in Congress voted against war; the conflict was agreed to by the smallest margin in American history. The nation, with its tiny military and inadequate administrative structures, was totally unprepared for war against one of the strongest powers in the world. Perhaps, however, War Hawk Henry Clay glimpsed why Americans would fight when he voiced concerns about British violations of American sovereignty. Another, John C. Calhoun, referred to the conflict as "a second struggle for our liberty." Many Americans went to war again to win their independence.

SH

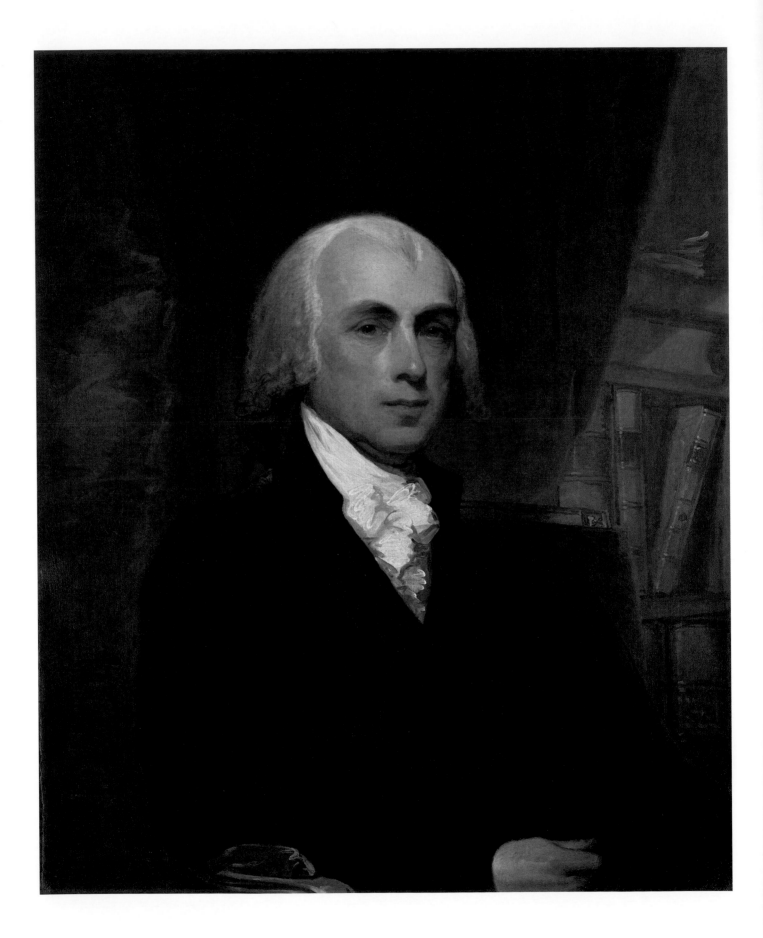

9

James Madison, 1751–1836

Gilbert Stuart (1755–1828)
Oil on canvas,
74.9 × 62.4 cm (29½ × 24⁹⁄₁₆ in.), 1804
The Colonial Williamsburg Foundation, Virginia

James Madison, the principal architect of the American Constitution, was one of the most profound political thinkers in American history. During the American Revolution he served in the Continental Congress. In 1787, at the Constitutional Convention in Philadelphia, he submitted the Virginia Plan, which became the basis of the Constitution. He also joined with Alexander Hamilton to write *The Federalist,* a series of newspaper articles defending the Constitution, which became one of the most significant documents in American history. In the First Federal Congress (1789–91), Madison drafted the first ten constitutional amendments, known as the Bill of Rights. In the 1790s, he opposed the Washington administration, which he believed favored too powerful a central government, and with Thomas Jefferson (cat. 4) he launched the Democratic-Republican Party.

When Jefferson became president in 1801, Madison, his friend and advisor, served as the secretary of state. With the resumption of the Napoleonic Wars in 1803, Jefferson and Madison resorted to economic warfare to counter British and French interference with U.S. commerce. The United States exported raw materials and food and in return received— according to Madison and Jefferson—"luxuries" that Americans could do without and manufactured goods that could be made in this country. By avoiding war and using embargoes, nonintercourse, and nonimportation as levers against British and French interference with American trade they believed that the United States could protect its rights while still maintaining a pure republican government, with low taxes, a small navy, citizen militias, and little or no debt. Problems arose quickly: widespread smuggling, a depression, fierce opposition by New Englanders, and a revived Federalist Party. More important, the economic warfare failed to alter the policies of Great Britain and France. By the time Madison followed Jefferson to become the nation's fourth president, the nation was already inching toward war.

SH

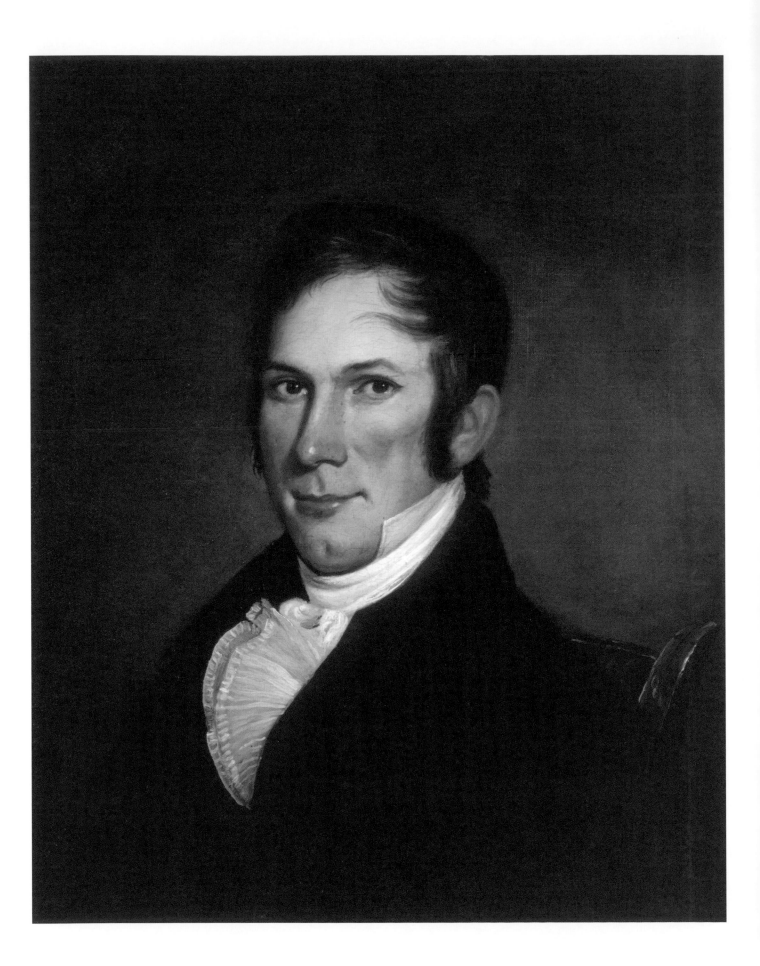

IO *Henry Clay, 1777–1852*

Charles Willson Peale (1741–1827)
Oil on canvas, 58.7 × 48.5 cm (23⅛ × 19⅛ in.) sight, 1818
Philadelphia History Museum at the Atwater Kent,
The Historical Society of Pennsylvania Collection

Charismatic, eloquent, and ambitious—and a charmer with unparalleled
powers of persuasion—Henry Clay was only thirty-four years old when he
entered the House of Representatives in late 1811. The wave of young War
Hawks entering Congress at the same time—John C. Calhoun (cat. 11),
Langdon Cheves, Felix Grundy, and others—quickly elected the "Western
Star" from Kentucky to be Speaker of the House of Representatives. As
a member of the first generation of leaders born after the Declaration of
Independence, Clay led his War Hawks on a campaign against Great Britain
for what they saw as encroachments on the sovereign rights of the United
States. "War," wrote Clay, "calamitous as it generally is, seems to me the
only alternative worthy of our Country. I should blush to call myself an
American were any other adopted." By significantly expanding the powers of
the Speaker (which until then had been a ceremonial position), Clay steadily
drove the nation toward war. Second in political power only to the president,
Clay sparred with John Randolph of Roanoke (cat. 12), a staunch opponent
of war and Clay's equal in debate. Even at the time, it was recognized that
it was Clay's "influence and power more than that of any other [that]
produced the war of 1812." Through the many defeats and dark days that
followed in the war he had instigated, Clay worked tirelessly to propel
America toward victory and, ironically, served as a peace commissioner at
the Treaty of Ghent (cat. 88). Although Clay went on to become a legend,
earning the title "the Great Compromiser" in the Senate, he never achieved
his ultimate goal of the presidency, despite numerous attempts.

RLP

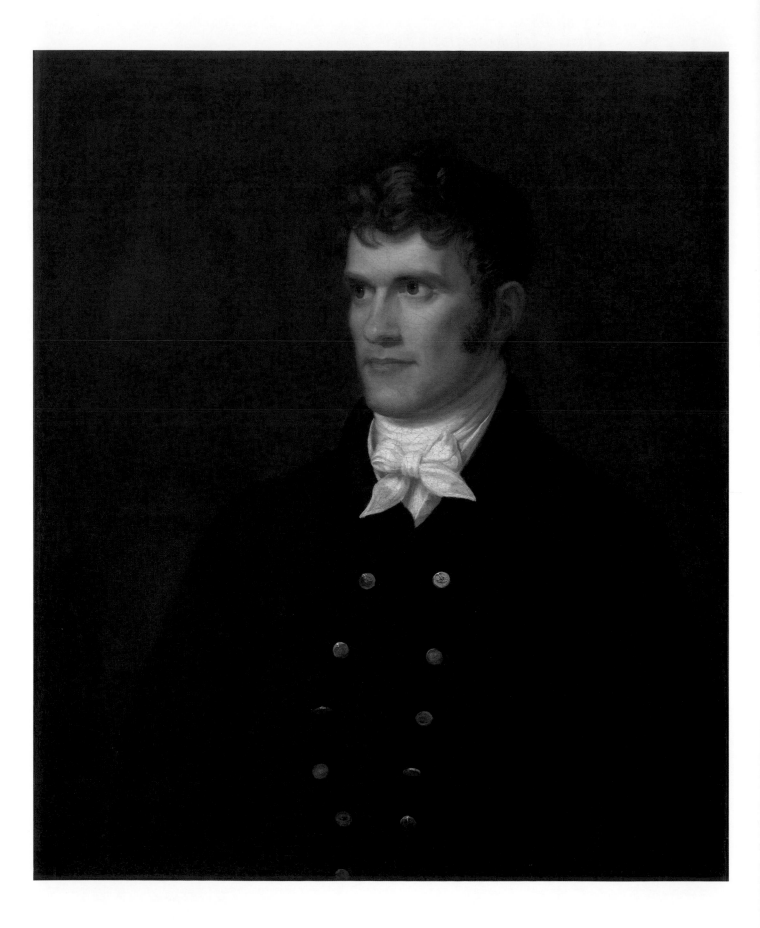

II *John C. Calhoun, 1782–1850*

Attributed to Charles Bird King (1785–1862)
Oil on canvas, 76.2 × 63.5 cm (30 × 25 in.), c. 1823
National Portrait Gallery, Smithsonian Institution,
Washington, D.C.; gift of the A. W. Mellon Educational and
Charitable Trust

Of all the War Hawks, John C. Calhoun of South Carolina most eloquently put forward the argument that a "second struggle for our liberty" was not only necessary but positive for the country. Known for his oratorical skills rather than for personal charisma, Calhoun was appointed by Henry Clay (cat. 10) as head of the foreign relations committee, where he assisted in pushing for war with Great Britain. "I assert it with confidence," he acknowledged in the days before war was declared, "a war just and necessary in its origin, wisely and vigorously carried on, and honorably terminated, would establish the integrity and prosperity of our country for centuries." Calhoun strongly believed that another war was needed to reinvigorate the country and create a new generation of patriots. He wrote to a friend, "The war will be a favorite one with the country. Much honor awaits those who may distinguish themselves."

Throughout the war, mismanagement by the War Department frustrated Calhoun, and he spent much of his time seeking legislation to raise troops and funds. When James Monroe (cat. 89) appointed him secretary of war in 1817, Calhoun overhauled the department, making vast improvements for the future of the military. Calhoun became the only vice president to serve under different presidents, John Quincy Adams (cat. 87), followed by Andrew Jackson (cats. 81 and 83). He resigned under Jackson to return to the Senate, where he became a champion of states' rights and nullification. Calhoun's last act was to oppose the Compromise of 1850, proposed by his former ally, Henry Clay.

RLP

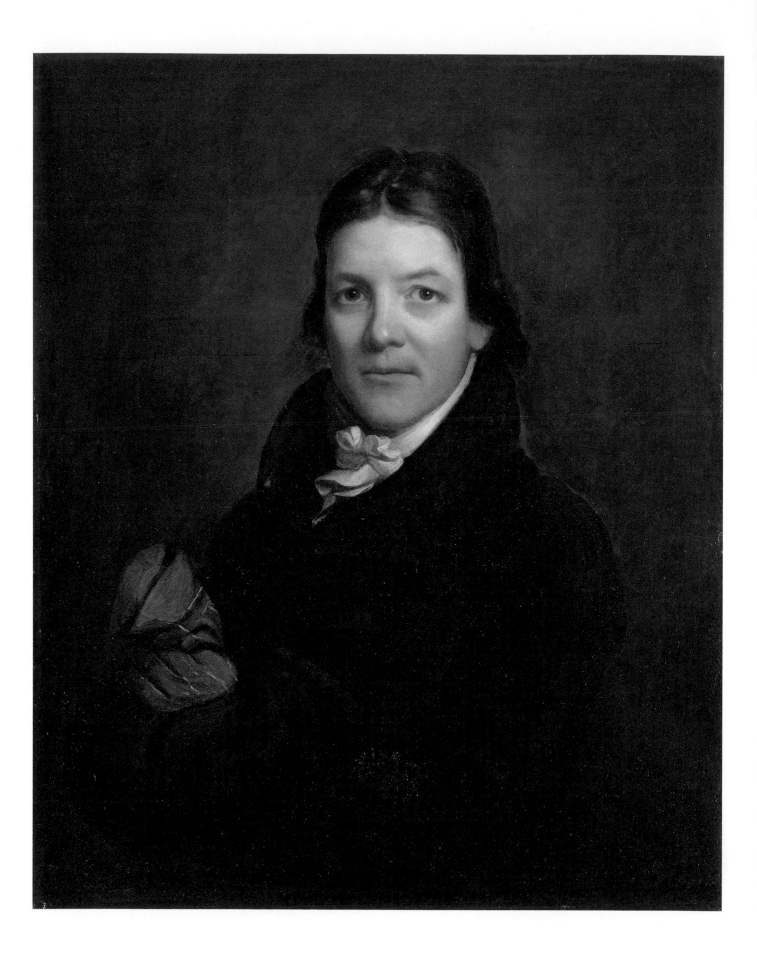

12 *John Randolph, 1773–1833*

John Wesley Jarvis (1781–1840)
Oil on wood, 68.6 × 55.6 cm (27 × 21⅞ in.), 1811
National Portrait Gallery, Smithsonian Institution,
Washington, D.C.; gift of Mrs. Gerard B. Lambert

Against the wave of War Hawks who swept into Congress in 1811, it seemed that only one man, John Randolph of Roanoke, stood against them. Randolph saw war with Great Britain as foolhardy and driven by hunger for land rather than a desire to end Britain's violations of American rights on the high seas. "We have heard but one word," Randolph accused his fellow congressmen, "like the whip-poor-will, but one eternal monotonous tone—Canada! Canada! Canada!" Conservative, aristocratic, and eccentric, Randolph's colleagues feared his sharp tongue, if not his physical presence. Because of a childhood illness, Randolph remained slight of stature and kept his boyish looks and high-pitched voice all his life. When Henry Clay (cat. 10) was made Speaker of the House, partly to stand up to Randolph, Clay quickly asserted his dominance by ordering the Virginian's hunting dogs, which had always accompanied Randolph to the House floor, out of the chamber. Yet Randolph's biting speeches could not be ignored. As one congressman put it, "I admire his ingenuity and address; but I dislike his politics." Although he briefly lost his seat because he opposed the war, Randolph proved in some ways prophetic: "Gentlemen, you have made war. You have finished the ruin of our country. And before you conquer Canada your idol [Napoleon] will cease to distract the world and the Capitol will be a ruin." Randolph and Clay did unite briefly in the founding of the American Colonization Society, which promoted "the colonizing of the free people of color in the U. States, with their own consent, in Africa." In his will, Randolph freed his slaves, more than three hundred, and provided land and money for their support in Ohio.

RLP

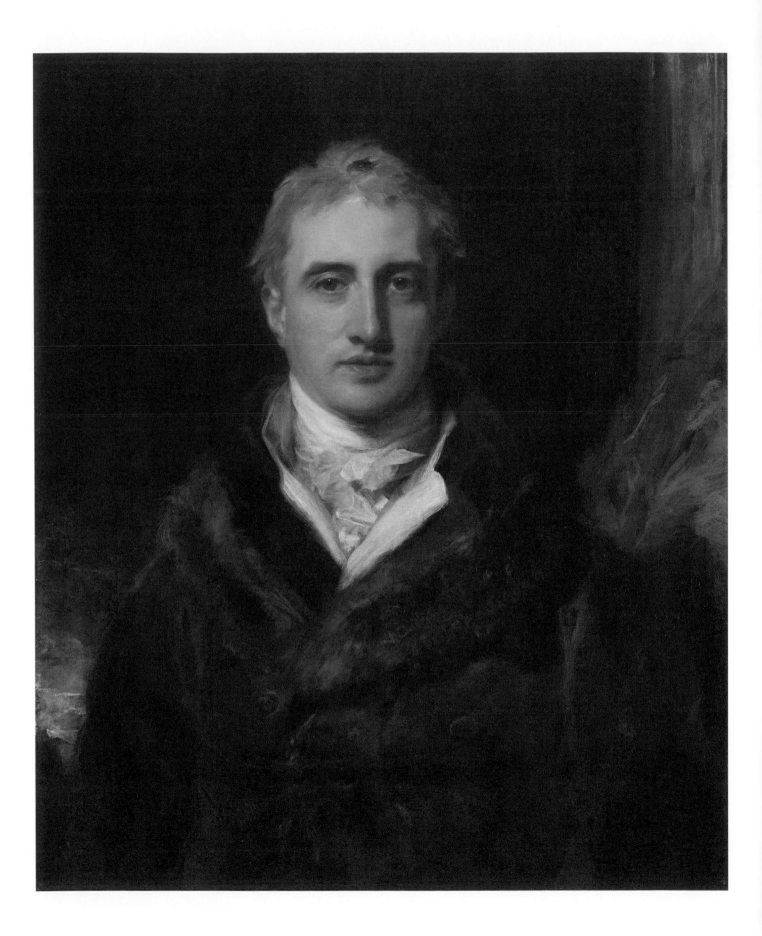

13

Lord Castlereagh (Robert Stewart, second Marquess of Londonderry), 1769–1822

Sir Thomas Lawrence (1769–1830)
Oil on canvas, 74.3 × 61.6 cm (29¼ × 24¼ in.), 1809–10
National Portrait Gallery, London; purchased, 1892

Amid the historic events that Lord Castlereagh faced during his time as foreign minister, the "millstone of an American war" was an annoyance more than a high priority. Only three months after his appointment in 1812, Britain experienced its only assassination of a prime minister, Spencer Perceval, and across the Channel, Napoleon loomed as a constant threat. With all British attention trained on the actions of the French, the war with the United States was simply seen as a side effect of British naval policies against Napoleon (cat. 14). The British Orders in Council challenged the rights of American neutrality in the Napoleonic Wars and blocked American ships from reaching the French-controlled Continent. In retaliation, the United States restricted trade with Great Britain. When these measures failed to win any concessions, the United States declared war on June 18, 1812. Slow communications resulted in an awkward situation when the Madison administration learned that the Orders in Council had been repealed five days after America declared war. This left impressments as the principal unresolved issue. Indignant that war was declared with what he considered so little cause, Castlereagh refused to stop impressments and soon issued new orders. During the negotiations for peace at Ghent in 1814, Castlereagh directed matters from afar, focusing his attention on the Congress of Vienna after Napoleon's defeat. However, it was Castlereagh who, on the advice of the Duke of Wellington, ordered his commissioners to drop their hard line with the Americans, thus paving the way for the successful conclusion of the negotiations. Although his successes made him a respected diplomat, Lord Castlereagh was never popular at home and fought personal demons. In 1822, after ten years as foreign minister, he committed suicide.

RLP

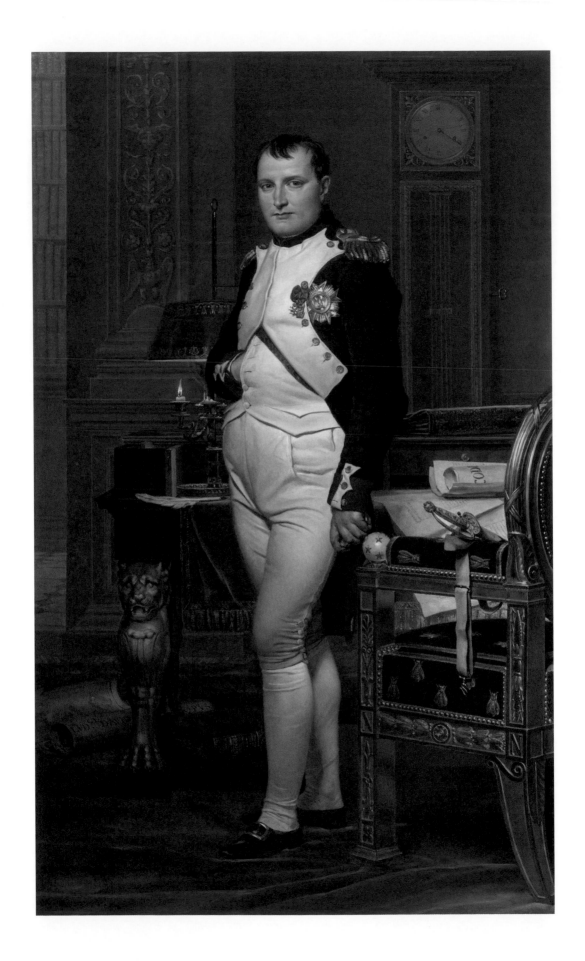

14

The Emperor Napoleon in His Study at the Tuileries

Jacques-Louis David (1748–1825)
Oil on canvas, 203.8 × 125.1 cm (80¼ × 49¼ in.), 1812
National Gallery of Art, Washington, D.C.;
Samuel H. Kress Collection (1961.9.15)
[Not in exhibition]

America's war against Great Britain in 1812 was for the British a peripheral event in a world war against Napoleon (1769–1821). The French Revolution of 1789, threatening all the European monarchies, led to a world war that intensified in 1799 with Napoleon's ascension. During President Jefferson's first term (1801–5), American commerce, according to Ambassador James Monroe in London, "never enjoyed in any war as much freedom . . . as it now does." But after Napoleon's victories in 1805–7, which placed Europe under his control, the emperor aimed at bringing the "nation of shopkeepers" to its knees by prohibiting British goods or ships trading with Britain from entering European ports. In retaliation, Britain declared that the war against *le petit corporal* would no longer allow it to respect American neutral trading rights.

In May 1810 President Madison signed Macon's Bill No. 2, which provided that if either Britain or France rescinded its trade restrictions, the president could impose nonimportation on the other power. A seemingly positive French response came in an August 5 letter from French Foreign Minister Jean Champagny, duc de Cadore, suggesting that French restrictions on American trade would be revoked. Madison welcomed this letter, as the country was reeling under the seizures of American ships. Under the law, Madison then ordered nonimportation against Britain, hoping it would modify its restrictions. Napoleon, however, did not rescind his restrictions, and Madison was attacked both by opponents at home and by the British, who accused him of being duped. In July 1811, he issued a proclamation calling Congress into an early session to prepare the United States for war. Napoleon's maneuverings were in part responsible for forcing Madison's hand.

SH

15 Pitcher: Sailor's Rights

Earthenware, 23.2 cm (9⅛ in.) height, c. 1804
The New-York Historical Society, New York City;
bequest of Mrs. J. Insley Blair (1952.143);

Thousands of American sailors were forcibly taken from American merchant ships and impressed into the British navy. Impressment was a longstanding custom of the Royal Navy. Moreover, the practice increased suddenly in 1803, after Great Britain resumed its war with France; its navy expanded from 16,000 sailors in 1792 to 145,000 by 1812. American merchant ships, with so many experienced British sailors aboard, were good targets. However, almost as quickly as the British were impressing men, their own sailors were deserting because of the harsh conditions and relatively low pay.

British officers boarding American ships claimed that the sailors it impressed were British subjects. Many were immigrants whom the British government did not recognize as American citizens. Under British law, anyone residing in America before 1783 or born there since was an American citizen. But under U.S. law, after 1802, residency in America for five years entitled immigrants for citizenship, although few seamen bothered. American officials provided its sailors with certificates of citizenship, but British naval officers claimed—with some justification—that the documents were available to almost anyone by theft, purchase, or fraud. The United States maintained that between 1803 and 1810, 6,257 American sailors were forced into the British navy, a number so precise that the British dismissed it as "almost ridiculous." However, by 1812, the British government had ordered approximately 2,000 Americans released from service on British warships and at the start of the war discharged another 2,000 and held them as prisoners of war. American historians put the true figure of impressments at around 6,000 men between 1803 and 1812—a considerable number for a nation with a population of about 7.7 million.

SH

16

King George IV, 1762–1830

Richard James Lane (1800–1872), after Sir Thomas Lawrence
Lithograph, 47.9 × 38.4 cm (18⅞ × 15⅛ in.), 1814
National Portrait Gallery, London; purchased, 1890

During a war that was rooted in the search for a national identity, Americans were also fighting against a national symbol like no other—one that many still remembered had once been their own. As the symbol of nation and state, George III had ruled Great Britain for fifty years, but in 1811 his son George was made prince regent in his stead after it was determined that George III had lapsed into permanent insanity. A playboy of his time, the prince regent managed to be a "national scandal, a national disaster, a national achievement, and a national entertainment." The Duke of Wellington (cat. 78) called him "the worst man he ever fell in with . . . entirely without one redeeming quality." Yet as the country's undisputed leader, the prince regent loomed large in the public consciousness. Every campaign was commanded and all victories were toasted in his name. After major victories, officers were sent to London to personally report to him (and this usually meant a promotion). Reflecting most British opinion, the prince regent found the war unnecessary. After reporting to the prince on the ultimate triumph—the burning of the enemy's capital—a British officer reported, "In his heart I fancied I saw he thought it a barbarian act." The prince finally became King George IV in his own right, after nine years of regency.

RLP

17 *James Wilkinson, 1757–1825*

Unidentified artist
Oil on canvas, 74.9 × 62.2 cm (29½ × 24½ in.), c. 1820
National Portrait Gallery, Smithsonian Institution,
Washington, D.C.

Although now forgotten to history, Major General James Wilkinson committed more acts of treason against the United States than his former mentor, Benedict Arnold, ever did, and yet he was put in command of the entire army before the War of 1812. Although he was almost universally hated by his contemporaries, called an "unprincipled imbecile" by Winfield Scott (cat. 29) and the "only man I ever saw who is from the bark to the very core a villain" by John Randolph (cat. 12), Wilkinson shrewdly endeared himself to those in power. Every president from Washington to Madison trusted Wilkinson and put him in positions of authority. As governor of the Louisiana Territory under Jefferson, Wilkinson is believed to have conspired with former vice president Aaron Burr in a plot to create a kingdom by separating the western territories from the rest of the United States. When Burr was arrested, Wilkinson turned on his coconspirator to save himself. Burr was tried for treason and Wilkinson was court-martialed, but both were acquitted. At the same time, Wilkinson became a highly valued spy for the Spanish government, known as Agent 13 and paid in silver. Wilkinson tipped off the Spanish to Meriwether Lewis and William Clark's secret expedition west, although the Spanish were unsuccessful in finding the explorers. In the end, charm could not save Wilkinson from two failed invasions of Canada, and his military career ended in disgrace. Only after his death was Wilkinson proven to be a spy for Spain.

RLP

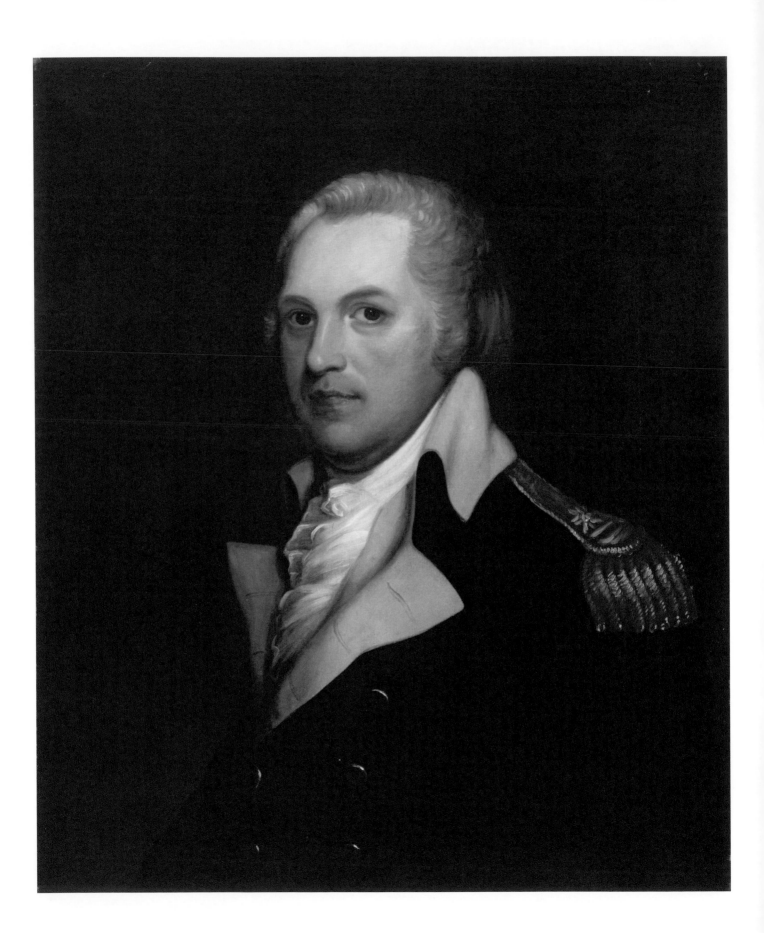

18 Henry Lee, 1756–1818

James Herring (1794–1867), after Gilbert Stuart
Oil on canvas, 76.2 × 63.5 cm (30 × 25 in.), c. 1834
National Portrait Gallery, Smithsonian Institution,
Washington, D.C.

A foreshadowing of civil war yet to come, the first casualties of the War of 1812 resulted from Americans fighting Americans. On the night of July 27, 1812, the city of Baltimore erupted into violent riots against those who opposed the weeks-old war, including Revolutionary War hero Major General "Light-Horse Harry" Lee. A cavalry officer, former Virginia governor, congressman, and friend of George Washington, Lee found himself barricaded in a house with other supporters of the Federalist newspaper editor Alexander Contee Hanson, who had spoken out against a war "without funds, without an army, navy or adequate fortifications." When the outraged mob attacked his office, the besieged men defended themselves, causing the death of a ringleader and further inciting the prowar mob. Near morning, city leaders and militia finally intervened, escorting Lee, Hanson, and the other Federalists to jail for their own protection. That night, angry citizens broke into the jail and brutally beat, tarred, and maimed their victims, killing sixty-year-old Revolutionary War veteran Brigadier General James McCubbin Lingan. Left for dead, Lee was smuggled out of the city, and described as beaten "black as a negro, his head cut to pieces without a hat or any shirt . . . one eye apparently out, his clothes torn and covered with blood from tip to toe, and when he attempts to stir he tottered like an infant." The man who had eulogized Washington as "first in war, first in peace, first in the hearts of his countrymen" never recovered from his wounds and died five years later, when his son Robert E. Lee was only eleven.

RLP

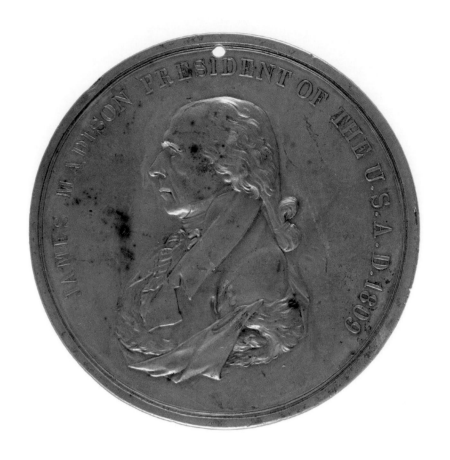

19

James Madison Peace Medal

John Reich (1768–1833)
Silver medal, 7.6 cm (3 in.) diameter, 1814–15
National Portrait Gallery, Smithsonian Institution,
Washington, D.C.; gift of Betty A. and Lloyd G. Schermer

Presenting presidential peace medals to Indian tribes began with George Washington, but earlier it had been, in Thomas Jefferson's phrase, the "ancient custom" of the Spanish, French, and British in their dealings with Native Americans. The medals were given to chiefs and warriors on such important occasions as the signing of a treaty or a visit to the capital. By Madison's presidency the Indians considered the medals an essential part of their peace negotiations. The striking of Madison medals was delayed, perhaps because Jefferson medals were still available. In May 1812, John Mason, the head of the Office of Indian Trade, ordered medals with Madison's image after learning that chiefs from the Missouri and the upper Mississippi rivers would be visiting Washington. He did not want to give them the hollow Jefferson medals but instead heavy, solid ones similar to those that the British were giving out and were preferred by the Indians. Because no local craftsmen or presses could produce a solid medal, Mason used the U.S. Mint in Philadelphia. He was fortunate in getting John Vaughan, a member of the American Philosophical Society, to supervise the project. Vaughan engaged John Reich, the assistant to the chief coiner and engraver at the Mint, to cut the dies and make arrangements to strike the medals. In Washington, Mason determined that existing images of Madison were not suitable and hired an unnamed "Italian artist" to construct a bust of the president, which was completed in mid-December 1812. Perhaps because of the exigencies of war, the bust did not reach Philadelphia until February 1814. Finally, on December 17, 1814, twelve silver medals of three different sizes arrived in Washington. The largest, pictured here, were given to the most important Indian chiefs.

SH

BY THE PRESIDENT,

OF THE

United States of America,

A PROCLAMATION:

WHEREAS the Congress of the United States, by virtue of the Constituted Authority vested in them, have declared by their act, bearing date the eighteenth day of the present month, that WAR exists between the United Kingdom of Great Britain and Ireland, and the dependencies thereof, and the United States of America and their territories; Now, therefore, I, JAMES MADISON, President of the United States of America, do hereby proclaim the same to all whom it may concern: and I do specially enjoin on all persons holding offices, civil or military, under the authority of the United States, that they be vigilant and zealous, in discharging the duties respectively incident thereto: And I do moreover exhort all the good people of the United States, as they love their country; as they value the precious heritage derived from the virtue and valor of their fathers; as they feel the wrongs which have forced on them the last resort of injured nations; and as they consult the best means, under the blessing of Divine Providence, of abridging its calamities; that they exert themselves in preserving order, in promoting concord, in maintaining the authority and the efficacy of the laws, and in supporting and invigorating all the measures which may be adopted by the Constituted Authorities, for obtaining a speedy, a just, and an honorable peace.

IN TESTIMONY WHEREOF I have hereunto set my hand, and caused the seal of the United States to be affixed to these presents.

(SEAL.)

DONE at the City of Washington, the nineteenth day of June, one thousand eight hundred and twelve, and of the Independence of the United States the thirty-sixth.

(Signed) JAMES MADISON.

By the President,
(Signed) JAMES MONROE, Secretary of State.

20

By the President of the United States of America, a Proclamation

Prints and Photographs Division, Library of Congress, Washington, D.C.

As Thomas Jefferson's secretary of state and his successor to the presidency, James Madison (cats. 9 and 19) inherited the policies of commercial warfare that he had helped formulate and had expected would force Britain and France to respect American neutral rights. In 1810, Madison ended America's nonintercourse with Britain and France and signed a law that would reimpose nonimportation on one nation if the other respected American rights. Napoleon (cat. 14) appeared to give in, so Madison reimposed the policy on Great Britain. When it turned out that Napoleon had not altered his policies, the president's maneuvering room was severely narrowed. In the winter of 1811–12 the economy slumped, support for the Federalist Party increased, and British-Indian alliances in the Northwest Territory increased alarmingly. Madison, although fearing that the Union might not be sufficiently united to withstand a war, realized that he must either capitulate or declare war on Great Britain, which he perceived as attempting to place America in a state of semidependency. On June 23, the British government would revoke its restrictions on American trade, but Madison, unaware that such concessions were forthcoming, sent a strident message to Congress on June 1. In tones reminiscent of the Declaration of Independence, he indicted Great Britain for a series of violations: impressing sailors, violating American territorial waters, forming illegal blockades, and inciting the Indians. Madison did not recommend war but declared that "a state of war [exists] against the United States." The House Republicans passed a declaration of war in two days; the Senate, where opposition was strong, took two weeks. The final tallies, 79–49 in the House and 19–13 in the Senate, were the closest votes for a declaration of war in American history. Madison signed the bill on June 18, beginning the War of 1812.

SH

NORTHERN BATTLES AND INDIAN WARS

The land battles of the War of 1812, although small in comparison to the Napoleonic and later wars, ranged over a vast continent, from New Orleans in Louisiana and Horseshoe Bend in what is today Alabama, to Tippecanoe in the Indiana Territory, to Detroit in the Michigan Territory, to the Niagara frontier and to Lower Canada, at the Battle of Châteauguay. Generalizations are difficult, but one may be offered: the American conquest of Canada would not, as Thomas Jefferson had claimed, be "a mere matter of marching." Under the capable leadership of officers like Major General Isaac Brock (cat. 25), the British offered stout resistance. They were aided by Canadians such as Charles de Salaberry (cat. 34), who fought bravely in defense of their homeland. In addition, the Indian nations, fighting mainly on the British side under such gifted leaders as Tecumseh (cat. 27) and John Norton (cat. 31), were essential to British victories and had a major impact on the course of the war. Under the leadership of new officers such as Brigadier General Winfield Scott (cat. 29) and Major General Jacob Brown, American regular forces made rapid improvements, both in the quality of their officers and the discipline and courage of their soldiers. The abject surrender of the elderly Brigadier General William Hull (cat. 24) at Detroit in August 1812 would be more than compensated for by the bravery of a new generation of officers at Chippawa and Lundy's Lane in July 1814.

SH

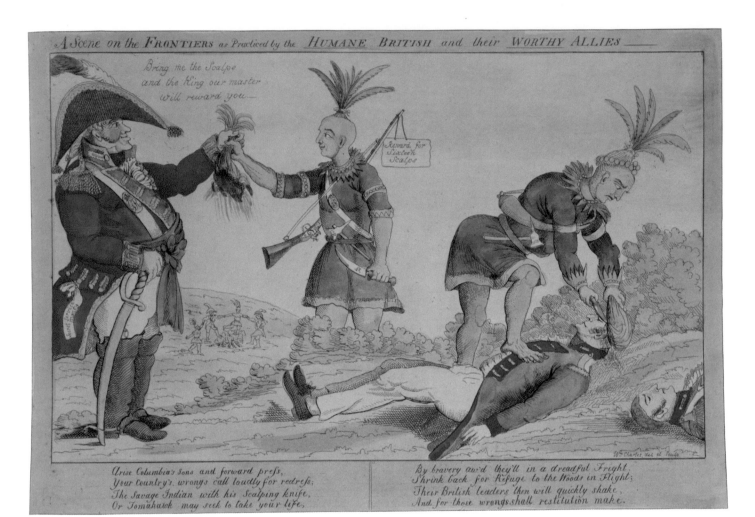

A Scene on the FRONTIERS as Practiced by the HUMANE BRITISH and their WORTHY ALLIES

Arise Columbia's Sons and forward press,
Your Country's wrongs call loudly for redress;
The Savage Indian with his Scalping knife,
Or Tomahawk may seek to take your life.

By bravery aw'd they'll in a dreadful Fright,
Shrink back for Refuge to the Woods in Flight;
Their British leaders then will quickly shake,
And for those wrongs shall restitution make.

21

A Scene on the Frontiers as Practiced by the Humane British and Their Worthy Allies!

William Charles (1776–1820)
Etching with watercolor on wove paper,
24.8 × 34.9 cm (9¾ × 13¾ in.), 1812
Prints and Photographs Division, Library of Congress,
Washington, D.C.

William Charles's *A Scene on the Frontiers* probably refers to the massacre of the Fort Dearborn (present-day Chicago) garrison on August 15, 1812. The soldiers and families at the fort had been ordered to evacuate and were escorted by trader William Wells and a group of Miami warriors. Wells, married to the sister of the Miami tribes' chief, Little Turtle, had been raised by Indians but had returned to white society and was now an Indian agent. Five hundred warriors, mostly Potawatomi, attacked the Americans one mile from the fort. Twenty-six soldiers, twelve militiamen, two women, and twelve children were killed. Americans had long blamed the British for arming and inciting the Indians. In truth, the British sought to restrain the Indians but needed them as allies. Their allegiance would be critical in securing the bloodless surrender (August 16, 1812) of William Hull (cat. 24) and the entire American Northwest army at Detroit. Although British officers usually tried to save prisoners captured by their Indian allies, Americans mistakenly believed that they had offered bounties for American scalps.

In the cartoon an Indian warrior is paid for American scalps. The sign on his flintlock reads "Reward for sixteen scalps." The British officer says, "Bring me the scalps and the King our master will reward you." The tag hanging on the officer's coat reads, "Secret Service money." A poem on the bottom calls for "Columbia's Sons" to "arise" and "redress" the "Savage Indian with his Scalping knife."

SH

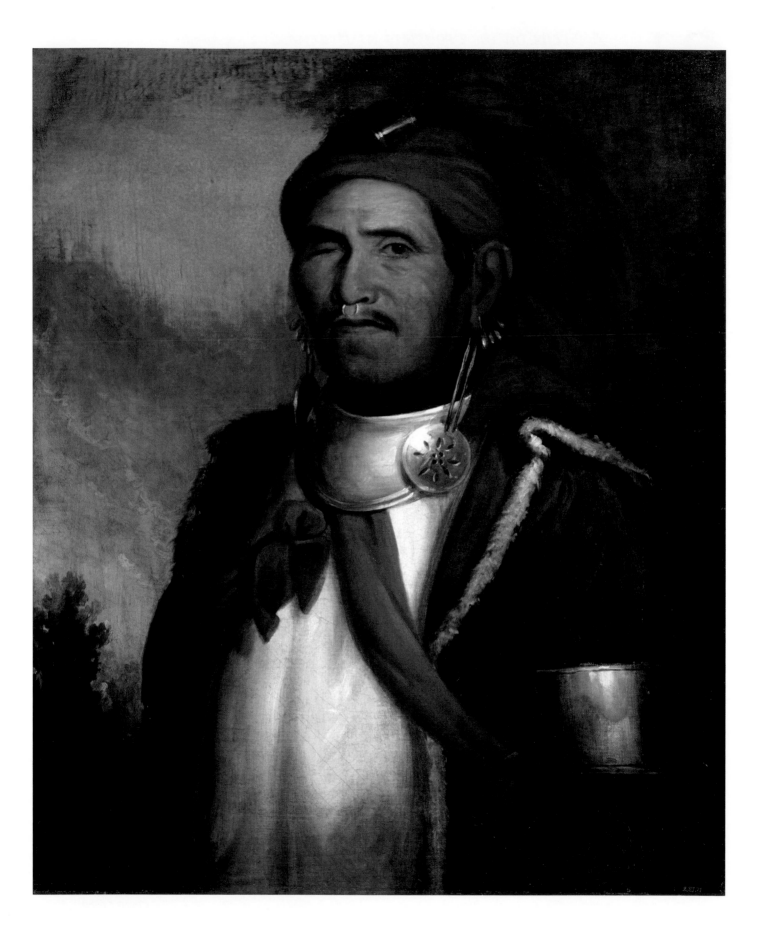

22 *Tenskwatawa (the Prophet), 1768–1837*

Henry Inman (1801–46), after Charles Bird King
Oil on canvas, 77.2 × 62.9 cm (30⅜ × 24¾ in.), c. 1830–33
National Portrait Gallery, Smithsonian Institution,
Washington, D.C.

The most important Native religious leader of the early 1800s, Tenskwatawa emphasized renouncing the white man's customs and returning to the old ways. An alcoholic as a young man, Tenskwatawa sank into a coma in 1805 and almost died. He awoke claiming to have had visions of heaven, populated with Indians living in the old ways, and hell, populated with "civilized" Indians consuming large quantities of alcohol. He gave up alcohol and assumed the status of a Shawnee prophet and holy man. Tenskwatawa was endowed with great oratorical skills, and his religious movement quickly spread. In 1808 he established Prophet's Town in the Indiana Territory. Relations between Tenskwatawa and the governor of the territory, William Henry Harrison (cat. 23), were initially peaceful. The turning point was Harrison's Treaty of Fort Wayne (1809), a dubious agreement in which a number of Indian chiefs ceded three million acres to the United States. Tenskwatawa opposed the treaty because the Indian signers did not have a legitimate claim to the land. He threatened the chiefs who signed the agreement and warned Harrison not to allow white settlement on the lands. As tension mounted, Tenskwatawa's warrior brother, Tecumseh (cat. 27), assumed leadership of the Shawnee. When Tecumseh left Prophet's Town to recruit more tribes in the south, Harrison led his troops to break up the settlement, demanding the Indians disperse and hand over those guilty of frontier raids. Tenskwatawa attacked on November 7, 1811, promising that his special powers would protect his warriors. Each side suffered heavy casualties in what became known as the Battle of Tippecanoe. The Indians left the field, and Harrison burned out Prophet's Town, claiming victory. Tenskwatawa was discredited and no longer led Indians into battle. After the war he fled to Canada, where he was supported by a British pension.

SH

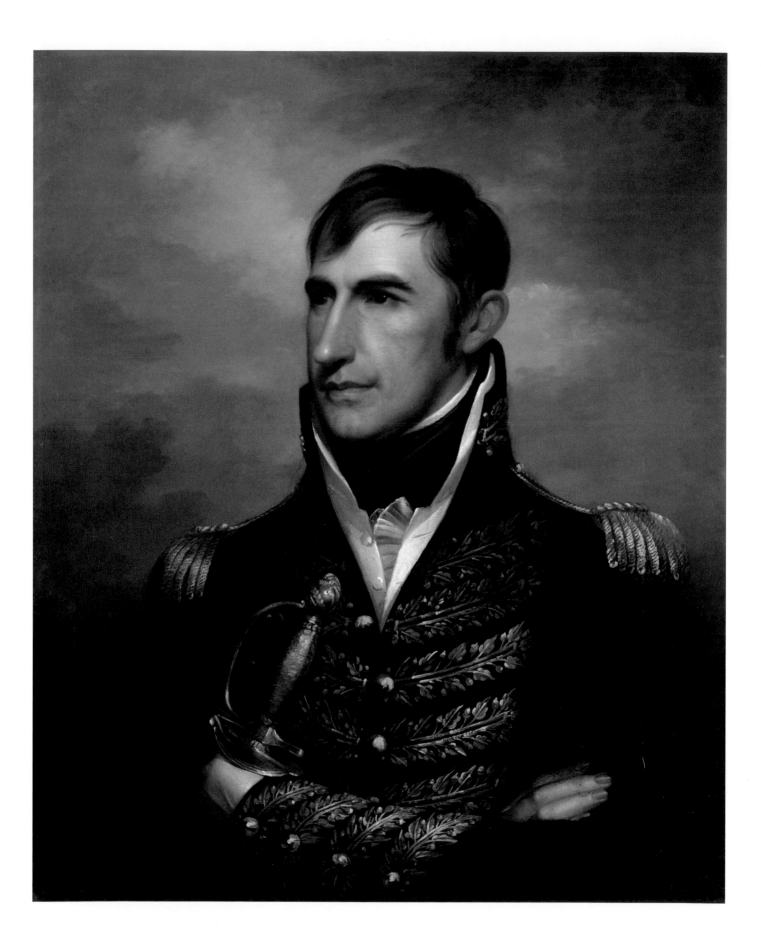

23

William Henry Harrison, 1773–1841

Rembrandt Peale (1778–1860)
Oil on canvas, 72.4 × 60.3 cm (28½ × 23¾ in.), c. 1813
National Portrait Gallery, Smithsonian Institution,
Washington, D.C.; gift of Mrs. Herbert Lee Pratt Jr.

Among the heroes who came out of the war, William Henry Harrison took a longer path to the presidency than Andrew Jackson (cats. 81 and 82) did, but his path was no less influenced by his wartime victories. As governor of the Indiana Territory, Harrison faced increased resistance from Indian tribes forced from their homes by new settlers. In 1810, Harrison met with Shawnee leader Tecumseh (cat. 27) to discuss settlements on Indian land at a tense council that almost erupted into violence. Violence did erupt in November of 1811, when warriors commanded by Tecumseh's brother Tenskwatawa (the Prophet) attacked Harrison's force at Tippecanoe. The surprise strike resulted in a close American victory, despite heavy casualties that exceeded those of the Indians. In retaliation, Harrison then destroyed Tecumseh's stronghold, Prophet's Town. The Battle of Tippecanoe pushed many Indian nations into alliances with the British during the War of 1812. Although involved in other battles, such as his victory at the Battle of the Thames (1813), where Tecumseh was killed, Harrison could not overcome his differences with Secretary of War John Armstrong (cat. 69) and resigned his commission in 1814. Thirty years after the battle, the slogan "Tippecanoe and Tyler too!" propelled Harrison to the presidency in a landslide. Harrison died only a month after taking office at the age of sixty-eight.

RLP

24 *William Hull, 1753–1825*

Gilbert Stuart (1755–1828)
Oil on wood, 66 × 54.6 cm (26 × 21½ in.) sight, c. 1823
National Portrait Gallery, Smithsonian Institution,
Washington, D.C.

Within two months of James Madison's declaration of war, Americans experienced a severe and humiliating reality check on their prospects for an easy conquest of Canada when American forces at Fort Detroit surrendered in August 1812. The fort's commander, Brigadier General William Hull, was nearly sixty years old; with experienced commanders in short supply, this veteran of the American Revolution had been drafted back into service. Although well supplied, with reinforcements only miles away, Hull fell victim to the manipulations of British Major General Isaac Brock (cat. 25), who, allied with Tecumseh (cat. 27), raised the specter of a massacre by the Indians if the fort did not surrender. Witnesses reported that Hull cowered in fear and was drunk, drooling, and mumbling incoherently, with a complete loss of his capacities in the face of what he saw as certain slaughter. Without consulting any of his officers, Hull surrendered, sending out his son with the white flag after another officer refused such a humiliation. As Brock entered Fort Detroit, many of the American officers wept with shame. Hull was taken to Quebec as a prisoner but was so "loud in his complaints against the government" that he was quickly released as a form of antiwar propaganda against Madison's policies. Called a coward, traitor, and a "gasconading booby" by his peers, Hull was court-martialed, convicted, and sentenced to be shot. Because of Hull's age, President Madison commuted the sentence. Hull never recovered his reputation, yet he always stood by his belief that surrender had been his only option. Ironically, his nephew, Isaac Hull (cat. 43), as captain of the *Constitution,* gave the nation its first victory three days after the surrender of Detroit.

RLP

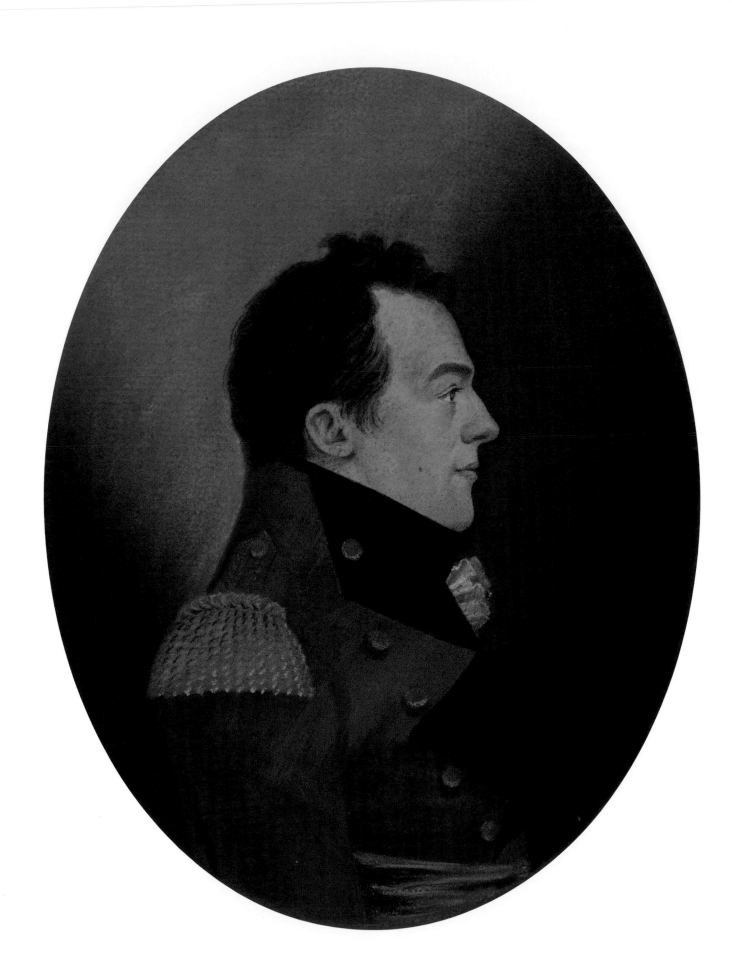

25 *Isaac Brock, 1769–1812*

Attributed to Gerrit Schipper (1775–c. 1830)
Pastel, 21.7 × 19 cm (8½ × 7½ in.), c. 1811
Guernsey Museums and Galleries, Channel Islands
© 2011 The States of Guernsey

Many, including Thomas Jefferson, assumed that the annexation of Canada would be a "mere matter of marching"; however, Major General Isaac Brock almost singlehandedly demoralized the United States within two months of declaring war. Six feet, three inches tall, refined, educated, and the epitome of a British officer, Brock grew up on the small island of Guernsey in the English Channel and had been assigned to Canada since 1802. As commander of Upper Canada, Brock inspired ambivalent Canadians to defend their territory in the early days of the war and delivered to the Americans the ultimate humiliation. Brock hatched a daring plan to attack Fort Detroit, commanded by William Hull (cat. 24), despite the Americans' strong entrenchments and his inferior numbers. Unlike other leaders, Brock earned the respect of Native tribes, and Tecumseh (cat. 27) collaborated with him in the attack. Capitalizing on Hull's fears, Brock, in his terms of surrender, insinuated to Hull that the Indians would be "beyond my control the moment the contest commences." Although Brock's first terms were initially rejected, Hull was paralyzed by fear, and the next day he surrendered the fort.

Brock had famously claimed he would not send his men where he himself would not lead them, and weeks later, on October 13, 1812, he led a charge at the Battle of Queenston Heights, where he was shot in the chest. The British, however, were ultimately victorious, after renewing the attack with the battle cry "Revenge the General!" Captured during the battle, Lieutenant Colonel Winfield Scott (cat. 29) sent an order back across the river to Fort Niagara that a salute be fired in Brock's honor, and "there was a long-continued roar of American and British cannon in honor of a fallen hero."

RLP

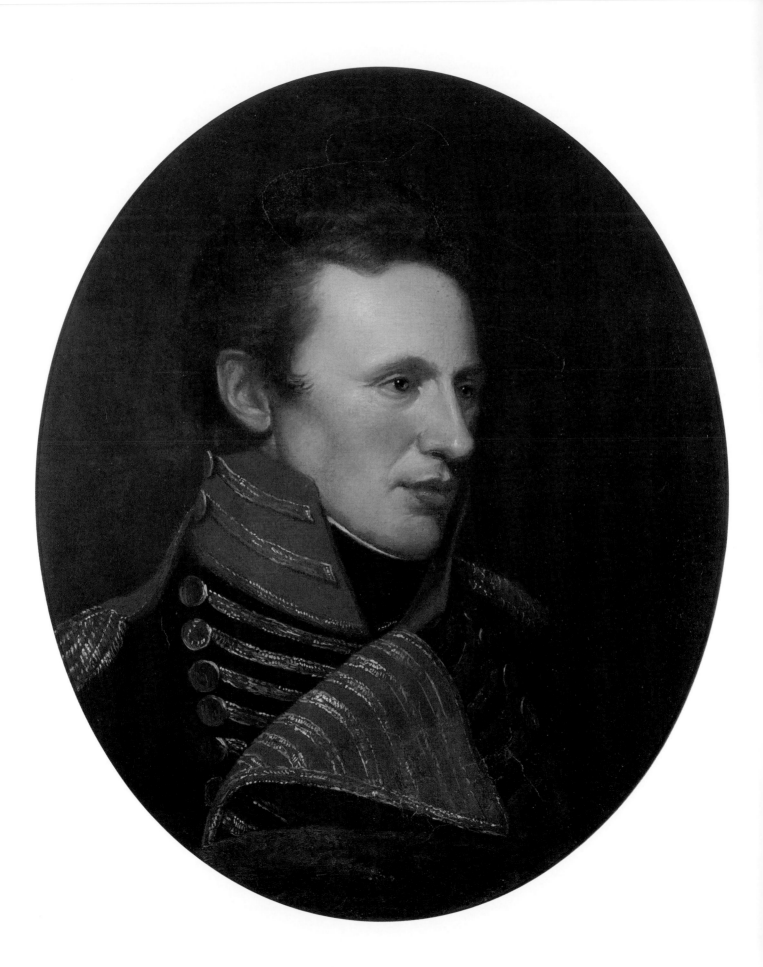

26 *Zebulon Pike, 1779–1813*

Charles Willson Peale (1741–1827)
Oil on canvas, 66 × 55.9 cm (26 × 22 in.), framed, 1808
Independence National Historical Park,
Philadelphia, Pennsylvania

Once considered one of the most promising young officers in the army, Zebulon Pike has the unusual distinction of having his name live on while his accomplishments have been all but forgotten. A protégé of the powerful Brigadier General James Wilkinson (cat. 17), Pike led two expeditions for Wilkinson to find the source of the Arkansas River and explore the Southwest. It was during the second of these expeditions (1806) that Pike attempted to climb the peak in modern-day Colorado that now bears his name, but he was unable to reach the summit. Writing in his diary, Pike declared, "I believe no human being could have ascended to its pinical." During the return journey, Pike and his men were captured by the Spanish and taken to Mexico as spies. It is unclear if the traitorous Wilkinson tipped off the Spanish about Pike's whereabouts or if Pike's capture was part of an elaborate scheme to spy on the Spanish. Released from Mexico in 1807, he was implicated in Wilkinson's and Aaron Burr's conspiracy to detach the West from the United States. Pike was saved only after a public letter from Secretary of War Henry Dearborn cleared his name. Assigned to Upper Canada during the War of 1812, Pike led the attack on York (now Toronto), the capital of Upper Canada. Known for his bravery, Pike was leading his men into the city when an ammunitions store exploded; a large stone crushed Pike, killing him instantly. He was only thirty-four. Pike had ordered that there be no looting of the city on pain of death; however, without his restraining influence, the American victors pillaged York and burned the parliament buildings.

RLP

27 Dying Tecumseh, 1768?–1813

Ferdinand Pettrich (1798–1872)
Marble with painted copper alloy tomahawk,
197.2 cm (77⅝ in.) length, 1856
Smithsonian American Art Museum, Washington, D.C.

Tecumseh's courage in such battles as the victory over Arthur St. Clair, governor of the Northwest Territory, in 1791 stirred fear and admiration in the hearts of Americans. A U.S. officer remembered the Shawnee chief and warrior as "perhaps one of the finest-looking men I ever saw." In the fall of 1810, Tecumseh, which means Shooting Star, paddled down the Wabash River, accompanied by four hundred warriors, to meet William Henry Harrison (cat. 23), governor of the Indiana Territory. Representing the Indian movement led by his brother, Tenskwatawa (cat. 22), Tecumseh demanded the return of three million acres of land ceded in the Treaty of Fort Wayne. Harrison, fearing war, saw in Tecumseh "one of those uncommon geniuses which spring up occasionally to produce revolution." When Tecumseh went to enlist additional tribes, Harrison's troops marched to the center of the Indian movement, Prophet's Town, and burned it following Tenskwatawa's ill-advised attack near Tippecanoe. After returning, Tecumseh joined forces with British Major General Isaac Brock (cat. 25) and was instrumental in forcing William Hull's (cat. 24) humiliating surrender at Detroit. Brock considered Tecumseh most "sagacious" and "gallant"—the "Wellington of the Indians." Although Tecumseh is credited with a major role in the British victories of 1812, his actions weakened the alliance in 1813. Following Oliver Hazard Perry's victory on Lake Erie (cat. 51), Tecumseh opposed the British retreat eastward, leading to discord and confusion as the Americans pursued. On October 5, 1813, he was killed at the Battle of the Thames, when he and his warriors stood their ground while the British broke ranks. The image we have of him as a young, courageous warrior was evident only seven years after his death, when an Indiana newspaper proclaimed, "Every school boy . . . knows that Tecumseh was a great man."

SH

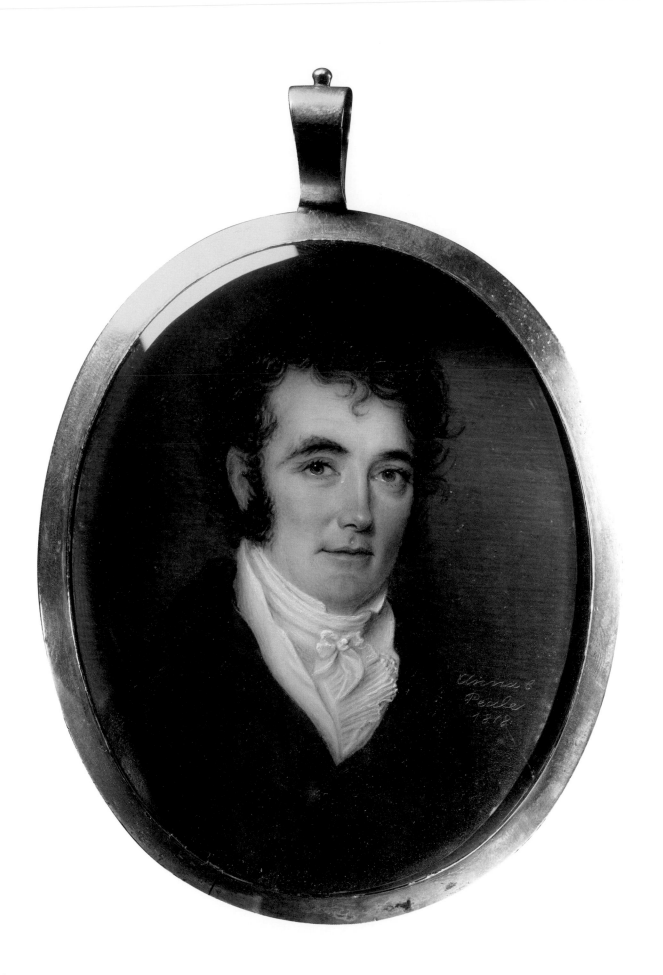

28 *Richard Mentor Johnson,*
1780–1850

Anna Claypoole Peale (1791–1878)
Watercolor on ivory, 6.98 × 5.46 cm (2¾ × 2⅛ in.), 1818
Museum of Fine Arts, Boston;
Emma F. Munroe Fund (68.619)
Photograph © 2012 Museum of Fine Arts, Boston
[Not in exhibition]

In 1813, during the Battle of the Thames, after the British forces retreated, warriors led by Tecumseh (cat. 27) continued to fight furiously as Colonel Richard Mentor Johnson led a charge back into the fray. As a congressman from Kentucky and ally of Henry Clay (cat. 10), Johnson had enlisted, not wanting "to be idle during the recess of Congress." At some point during the charge, Johnson was wounded by an unknown chief, and Tecumseh was killed. Although it could never be verified, credit was immediately given to Johnson for the great chief's death, making him an instant sensation, featured in plays, poems, and songs retelling the battle. This reputation as "the man who killed Tecumseh" propelled Johnson's political career and made him Martin Van Buren's vice president, although his enemies declared they did not believe "a lucky random shot, even if it did hit Tecumseh, qualifies a man for the Vice Presidency." There was a time when Johnson was fully expected to be nominated for president in his own right; however, any aspirations were hindered by his open relationship with a slave named Julia, whom he considered his wife. On his death, their surviving daughter, who had married a white man, was denied any inheritance because according to law Johnson had no widow or children.

RLP

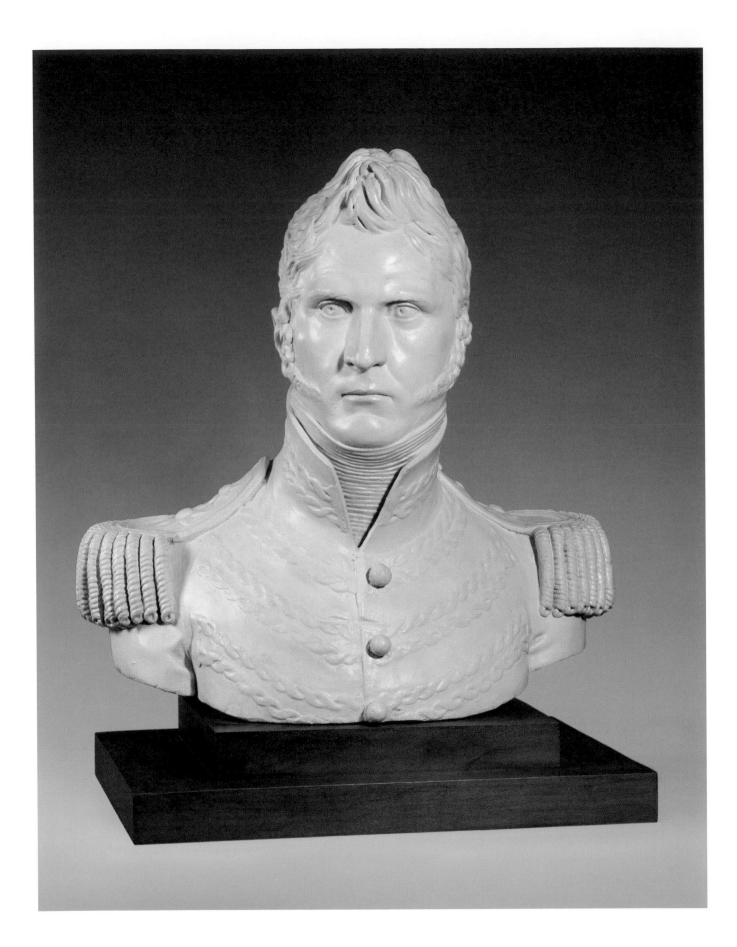

29 Winfield Scott, 1786–1866

William Rush (1756–1833)
Plaster, 61 cm (24 in.) height, c. 1814
National Portrait Gallery, Smithsonian Institution,
Washington, D.C.

Winfield Scott was compared in image to a "God of War," and at six feet, five inches, he was an imposing figure by any standard. Amid the lackluster performances of aging Revolutionary War veterans such as Henry Dearborn, William Hull (cat. 24), and James Wilkinson (cat. 17), the young, arrogant Scott emerged at a time when new military leadership was desperately needed. After being court-martialed for accusing Wilkinson of treason, Scott saw the War of 1812 as his chance for redemption. "Shall war come at last," he wrote, "my enthusiasm will be rekindled; and then who knows but that I may yet write my history with my sword." Taken prisoner at the Battle of Queenston Heights in October 1812, Scott was almost killed by Indians while in captivity. After his release, Scott's assault on Fort George quickly propelled the young officer to hero status. Scott's strict discipline with his soldiers created high standards, but his own willingness to throw himself into battle also gained their respect. At the Battle of Chippawa on July 5, 1814, Brigadier General Scott's formal training of his regulars paid off with a strategic American victory in Upper Canada. Although his service in the War of 1812 ended only weeks later when he was severely wounded at the Battle of Lundy's Lane, he continued his army career and built the military force that fought the Mexican-American War. Rising to the rank of lieutenant general, the first to do so since George Washington, Scott ran unsuccessfully for president in 1852. The Grand Old Man of the Army retired under political pressure just after the start of the Civil War in 1861, but he lived to see his Anaconda Plan—a blockade of southern ports and a strategy to cut the South in two—bring Union victory.

RLP

30 New York State Militia Artillery Service Dress Coatee, c. 1815

Canadian War Museum, Ottawa, Ontario

At the onset of the War of 1812, the U.S. regular army consisted of only 12,000 officers and men and had to rely on state militias. Notwithstanding the provisions of the Militia Act of 1792, America did not have a well-coordinated and efficient military when war was declared against Great Britain in 1812. In a population of 7.7 million, 703,000 were enlisted militiamen from seventeen states, with 20,000 more in the five territories; 458,000 of those were called into service.

America's reliance on citizen-soldiers stemmed from the republican principle that standing armies could be used against free citizens by the national government. This principle also directed Presidents Jefferson and Madison to keep expenses low and to use revenues to pay debts and reduce deficits. Even after relations with Britain and France worsened, congressional Democratic-Republicans opposed increases in military budgets, and states opposed legislation to coordinate militias. The inability of Madison's War Department to place state militias under federal authority in emergencies severely hampered the nation's war effort. The governors of Massachusetts, Rhode Island, and Connecticut, who commanded the best militias, at times did not allow their militias to serve under federal officers or cross into Canada.

Militia participation in the War of 1812 was mixed. There were bad officers and bad militia performances at Queenston, Frenchtown, and in the defense of Washington. There were also excellent officers and successes: Andrew Jackson (cats. 81 and 82) in the Creek War and New Orleans and Samuel Smith (cat. 71) in the defense of Baltimore. The young, intelligent officer corps created in the war formed the armies that fought in the Mexican-American War and on both sides of the Civil War. Although the citizen-soldier remained a part of the nation's defense, the United States would henceforth have a professional standing army.

SH

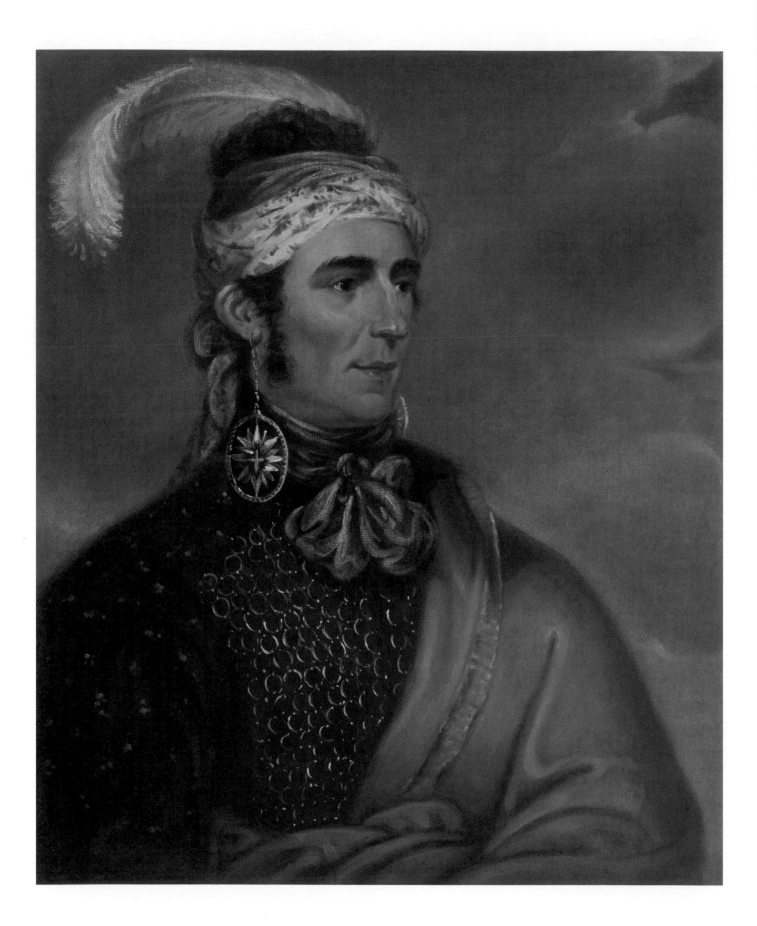

31 John Norton (*Teyoninhokarawen*), 1770–1831?

Mather Brown (1761–1831)
Oil on canvas, 76.2 × 63.5 cm (30 × 25 in.), c. 1805
Yale Center for British Art, New Haven, Connecticut;
Paul Mellon Fund (B2010.5)

Of all the Indians to fight during the war, Mohawk chief Teyoninhokarawen is arguably the most underrated. Throughout his lifetime, British officials in Canada worked to undermine his influence, despite the fact that the man more commonly known as John Norton was a lifelong supporter of Great Britain. Born in Scotland to a Scottish mother and Cherokee father, Norton was well educated before he joined the British army around 1784. While posted in Canada, he deserted, beginning a return to his Native ancestry, during which he became "as perfect an Indian as ran in the woods, having his ears cut & his nose bored." Norton became the protégé of the great leader Joseph Brant, which led Norton to be adopted into the Mohawk tribe and made a chief. Norton sat for this portrait during an 1804 trip to England to plead for the land rights of the Grand River Iroquois community before the Privy Council. Although he was not successful, the trip had considerable influence on Norton's life; it was there that he was befriended by the Duke of Northumberland (half-brother of James Smithson, founder of the Smithsonian Institution) and other elites. During this time Norton, a devout Anglican, translated the gospel of St. John into Mohawk for the first time.

When the War of 1812 began, Norton's staunch commitment to Britain influenced some warriors to fight for the British, although others, such as Sagoyewatha (cat. 32), fought for the Americans. Norton fought in almost every battle on the Niagara frontier but was most critical in the Battle of Queenston Heights. Although considered "a great intriguer" by some British commanders and a man of "coolest and most undaunted courage" by others, Norton played a vital role in the defense of Upper Canada. He was last heard from in Mexico in 1825.

RLP

32 Sagoyewatha (Red Jacket), c. 1750–1830

Thomas Hicks (1823–1890), after Robert Walter Weir
Oil on canvas, 81.3 × 55.9 cm (32 × 22 in.), 1868
National Portrait Gallery, Smithsonian Institution,
Washington, D.C.

Seneca leader Sagoyewatha was born in New York. He fought for the British
in the American Revolution and was given the name Red Jacket because he
was often seen in the red coat the soldiers gave him. Sagoyewatha left the
scene of several battles during the Revolutionary War and was later accused
by Indian war leaders, such as Joseph Brant, of cowardice. In his dealings
with the new American republic, he excelled as an orator and negotiator for
his tribe. In 1792, he led a fifty-man delegation to Philadelphia to present
the claims and grievances of the Seneca to the president. George Washington
presented him with one of the large peace medals reserved for the most
important Indian leaders, which can be seen in many of his portraits. At
the onset of the War of 1812, Sagoyewatha, unlike most influential Indian
leaders, convinced the Seneca Indians in New York to fight on the American
side. Although he was in his sixties, he fought bravely at the battles of Fort
George (August 27, 1813) and Chippawa (July 5, 1814), clearing his
reputation of earlier charges of cowardice. The heavy Indian casualties on
both sides at the Battle of Chippawa led Sagoyewatha to reconsider Indian
participation in the war, and he became an important participant in the talks
between the Seneca and the other Iroquois tribes of Upper Canada, which led
both tribes to withdraw from the conflict.

SH

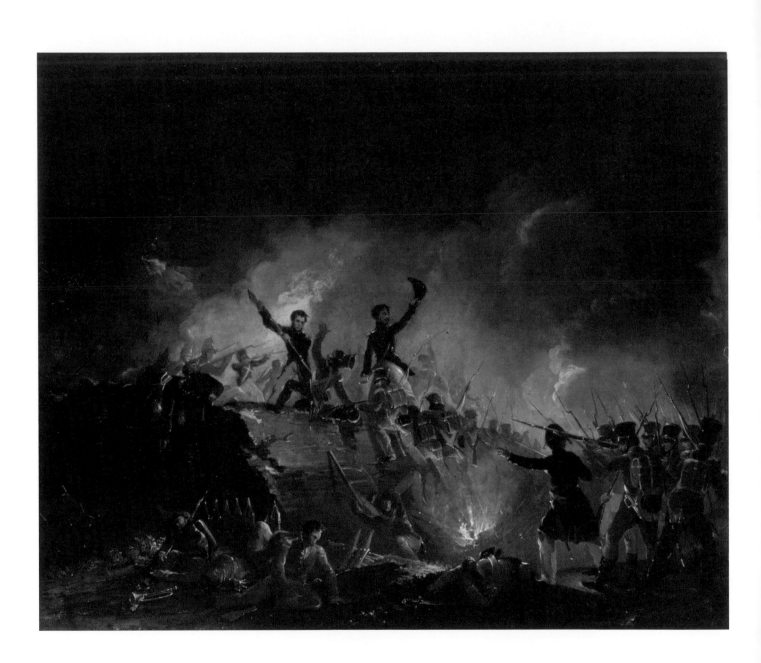

33 Repulsion of the British at Fort Erie, 15th August 1814

E. C. Watmough (active 1841–48)
Oil on canvas, 63.5 × 76.2 cm (25 × 30 in.), c. 1840
Chicago History Museum, Illinois

In the summer of 1814 the United States invaded Upper Canada. On July 3, 1814, Major General Jacob Brown, commander of the Army of the North, led 3,500 men across the Niagara River, capturing a small British force at Fort Erie. Brown then sent Brigadier General Winfield Scott's highly disciplined force of 1,500 regulars north to the Chippawa River, resulting in a significant American victory. Another major battle followed on July 25 at Lundy's Lane, not far from Niagara Falls. In this bloody battle, both sides sustained heavy casualties. The conflict ended in a draw but clearly demonstrated that the American army was finally able to stand up against British regulars. When the Americans withdrew to Fort Erie, the British began pounding the fort with artillery. Then, at 2:00 AM on August 15, in a heavy rain, the British launched an assault on the fort. Breaching a part of the fort and engaging the Americans in an hour of furious hand-to-hand fighting, the British officers yelled to their troops to "give the Damned Yankee rascals no quarter." A huge powder magazine blew up, inflicting grievous casualties on the British, whose two commanding officers had already been killed. Failing to take the fort in the assault, the British again began pounding it with their heavy batteries. Brown, who was in the fort recovering from injuries he received at Lundy's Lane, ordered the British batteries stormed and their cannons disabled. American forces evacuated and blew up Fort Erie on November 5. Brown's offensive into Canada had been halted.

SH

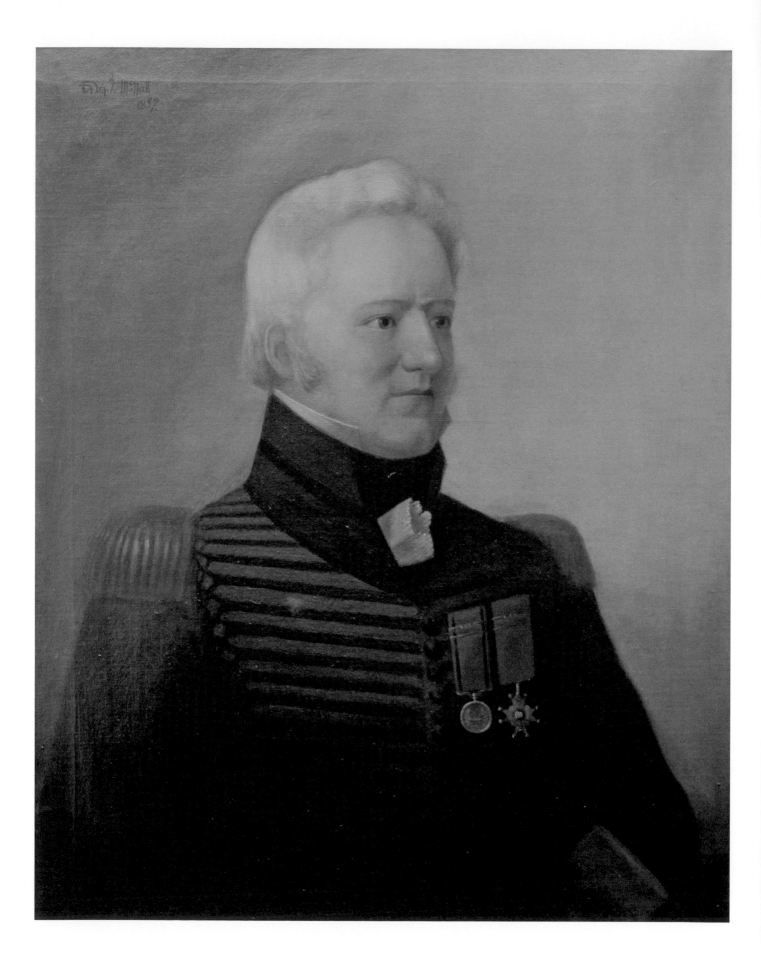

34

Charles-Michel d'Irumberry de Salaberry, 1778–1829

Donald G. McNabb (died 1923)
Oil on canvas, 76.1 × 61 cm (29^{15}⁄$_{16}$ × 24 in.), 1897
Château Ramezay—Historic Site and Museum of
Montréal, Canada

Although the War of 1812 in Canada had a distinctly British identity, the French-Canadian community also played a role in the country's defense. The Voltigeurs Canadiens were a French-speaking militia corps formed under the leadership of Lieutenant Colonel Charles de Salaberry. Unlike the many English or Irish officers sent to Canada, Salaberry was a native-born Canadian from a prominent Quebec family and had served in the British regular army in Europe and the West Indies. Strong-willed and demanding of his men as well as himself, Salaberry spent much of his career preoccupied with gaining promotion. Much of his advancement was due to the patronage of the Duke of Kent, the future father of Queen Victoria, who served for a time as commander-in-chief of the army in North America. In October of 1813, during the Battle of Châteauguay, Salaberry found himself with 1,700 soldiers and Mohawk warriors up against 3,000 Americans under Major General Wade Hampton, who was spearheading the assault on Montreal. By felling trees to create obstacles and using deception to make his force appear larger than it was, Salaberry easily defeated the superior force in what has become perhaps the most legendary battle in Canadian history. Although Salaberry's commanding officer, Governor General George Prevost, wrote the battle report and shared the limelight, over time it was Salaberry who received recognition as the Canadian who led his countrymen to victory.

RLP

THE REPUBLICAN COURT

During James Madison's two administrations, his wife Dolley (cat. 35) reigned supreme over a glittering age in Washington. Dolley's Wednesday-night drawing rooms were the anchor of the social week and brought together every important person of the day, from political and literary figures to generals and socialites. It was here in the midst of Dolley's pastries, ice cream, and punch that normally combative politicians often softened and deals were made. Among the women who made up Washington's social sphere were Dolley's sister Anna Cutts (cat. 38), married to a congressman; Anna Maria Thornton (cat. 36), a Federalist; and the ever-present Margaret Bayard Smith (cat. 37), a detailed chronicler of Washington social life and close friend of Dolley's. Much of what we know about the personal lives of Washingtonians is from the letters and diaries of these women. Young belles, such as the lovely Maria DeHart Mayo (cat. 40), came to Washington to see and be seen. They thrived under Dolley's watchful eye. Maria Mayo and other debutantes were captivated by the dashing new heroes the War of 1812 created, as Ann McCurdy Hart (cat. 41) of Saybrook, Connecticut, gushed, "What a delightful thing it must be to be the wife of a hero!" Before the war was out, Mayo and Hart became, respectively, Mrs. Winfield Scott and Mrs. Isaac Hull.

RLP

Lafourche Parish Public Library
Thibodaux, LA

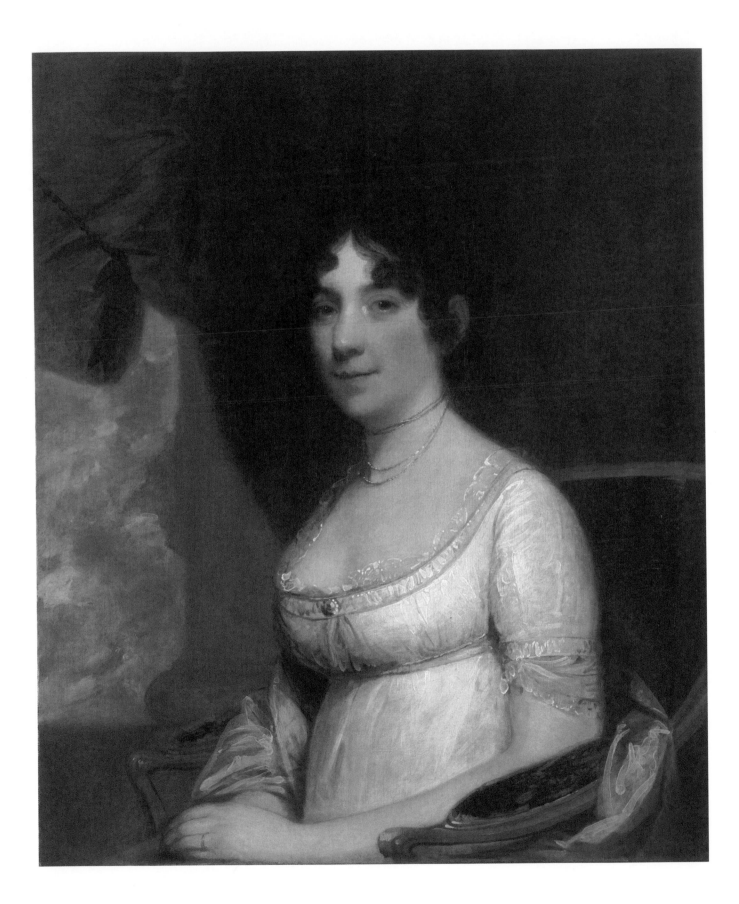

35

Dolley Dandridge Payne Todd Madison, 1768–1849

Gilbert Stuart (1755–1828)
Oil on canvas,
74.1 × 61.3 cm (29³⁄₁₆ × 24⅛ in.) sight, 1804
White House Historical Association (White House Collection), Washington, D.C.

In an age of republican simplicity, she was called "Queen Dolley" and "Her Majesty" and held the admiration of the entire nation. Dolley Payne Todd, a Quaker widow from Philadelphia, was introduced to the "great little Madison" by Aaron Burr, and through her 1794 marriage to James Madison (cats. 9 and 19) she became an acclaimed hostess and one of the most powerful first ladies Washington has ever known. Her Wednesday-night drawing rooms, known as "squeezes" because of the crowds, were designed to be politically neutral. All were welcome, including President Madison's political enemies, which allowed for private conversations outside of any official capacity. Dolley was beautiful, charming, and fashionable, and the fact that she indulged in the unladylike practice of taking snuff only added to her charm, as "in her hands the snuff-box seems only a gracious implement with which to charm." Dolley's ebullience was the perfect counterpoint to her husband's subdued personality, and she is often credited with helping him win the presidency; contemporaries called her Presidentress. One observer commented, "She looks like an Amazon: he like one of the puny knights of Lilliputia." After her husband's death in 1836 at their Virginia home, Montpelier, Dolley returned to Washington and once again ruled over society as a respected symbol of another age, a living connection to the Founding Fathers. When she died, the government closed down for a state funeral, the largest Washington had ever seen. Henry Clay once declared, "Everybody loves Mrs. Madison," to which Dolley replied, "that's because Mrs. Madison loves everybody."

RLP

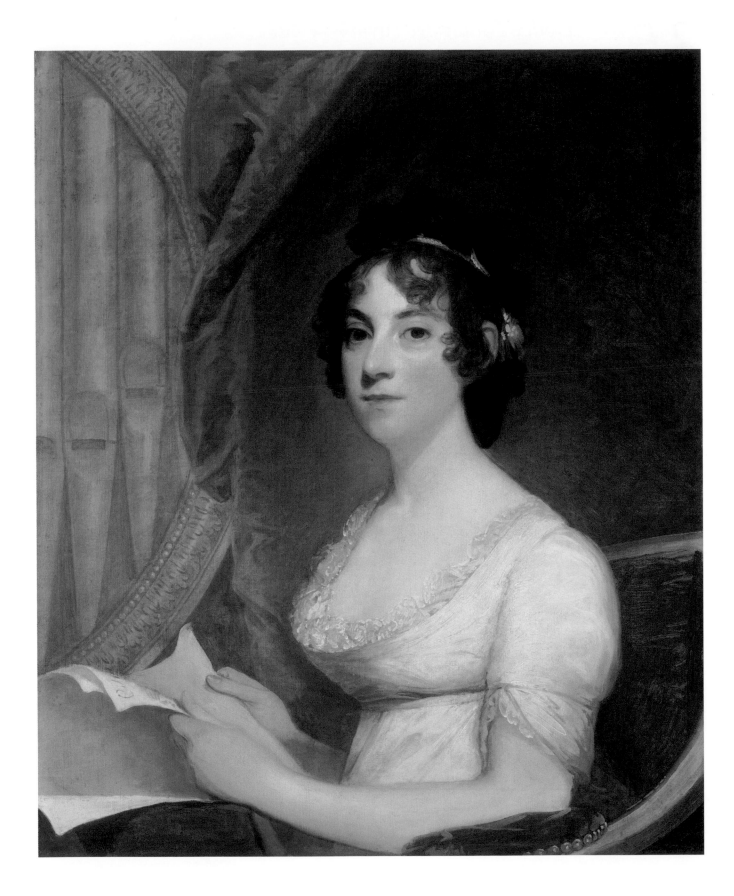

36

Anna Maria Brodeau Thornton, 1775?–1865

Gilbert Stuart (1755–1828)
Oil on canvas, 73.2 × 61.3 cm (28¹³⁄₁₆ × 24⅛ in.), 1804
National Gallery of Art, Washington, D.C.;
Andrew W. Mellon Collection (1942.8.26)

Anna Maria Brodeau was only fifteen years old when she married the sophisticated William Thornton (cat. 68), a doctor, architect, and inventor twice her age. Thornton had only come to the United States four years before after living the life of a Renaissance man in London and Paris. He was clearly looking for a wife in America and vented his frustration in a letter that "it is more difficult to find a lady here with good teeth, than in England with bad." Little is known about the Thorntons' relationship, although it seems to have been happy, and Anna proved adept at managing the family accounts, including a farm near modern-day Chevy Chase, Maryland. As the wife of a prominent man, Anna served as one of the top hostesses in Washington, and despite being Federalists, the couple were close to the Madisons. Anna stayed in Washington after her husband's death in 1828 and later reentered the headlines in 1835 after a family slave, Arthur Bowen, threatened her with an axe while he was intoxicated, plunging the city into its first race riot. Anna pleaded with President Andrew Jackson for Bowen's life against what she considered the malicious prosecution of the city's district attorney, Francis Scott Key (cat. 75). Because of her intervention Bowen was pardoned, although Anna then sold him south. A witness to the burning of Washington, Anna Thornton lived to see the end of the Civil War. Her personal papers at the Library of Congress are one of the best sources on the everyday lives of early Washingtonians.

RLP

37

Margaret Bayard Smith, 1778–1844

Charles Bird King (1785–1862)
Oil on canvas, 76.2 × 63.5 cm (30 × 25 in.), 1829?
Redwood Library and Athenaeum, Newport,
Rhode Island; gift of the artist

With her book *The First Forty Years of Washington Society* (first published in 1906), Margaret Bayard Smith gave the world insight into the personalities of the most famous figures of her day and an almost exclusive look into the social scene of Washington's elite. She was the wife of the newspaperman Samuel Harrison Smith, who founded the semiofficial Democratic-Republican newspaper *The National Intelligencer*; the Smiths moved to Washington in 1800 upon Thomas Jefferson's election. Margaret soon became Jefferson's confidant, admirer, and defender. In an age before it was socially acceptable, she managed to be known and respected as a writer, serving as a journalist as well as a biographer and novelist. Smith was also a great friend of Dolley Madison (cat. 35), admiring her "good humour and sprightliness, united to the most affable and agreeable manners." A particular friend of Federalist Anna Maria Thornton (cat. 36) as well, Margaret believed in the social world Dolley had created without regard to political biases, "accustoming us to see those who differ from us." Smith was a constant participant in society rather than an unbiased observer, and her personal opinions often colored her observations on her contemporaries, making them all the more fascinating. As she confessed about her biography of Dolley Madison, "all I say is true—but I have not of course told the whole truth."

RLP

38 Anna Payne Cutts, 1779–1832

Charles Bird King (1785–1862), after Gilbert Stuart
Oil on canvas,
76 × 63.5 cm (29¹⁵⁄₁₆ × 25 in.), c. 1812–45
Virginia Historical Society, Richmond

On attending one of Dolley Madison's drawing room squeezes, author Washington Irving left a vivid image of Mrs. Madison as "a fine, portly, buxom dame, who has a smile and a pleasant word for everybody" and her sisters, Mrs. Cutts and Mrs. Washington, as "like the two merry wives of Windsor." Anna Payne Cutts was referred to by Dolley (cat. 35) as her "sister-child" because Anna was eleven years younger and was largely raised by Dolley, living with the Madisons in both Philadelphia and Washington. In 1804 she married Congressman Richard Cutts of Maine (which was then part of Massachusetts) and stayed in Washington throughout the Madison presidency. Second only to Dolley in social status, Anna Cutts and Lucy Washington (whose marriage in 1792 to George Washington's nephew originally brought the family to prominence) were mainstays of Washington society. After her husband's death, Lucy Washington married Supreme Court Justice Thomas Todd in the first White House wedding. After the Madisons retired to Montpelier, Dolley wrote to Anna, "let me hear from you directly— that you'l [sic] come or you shall see me bounce in upon you some night from the boat, to force you all on board next day for Montpelier." Cutts died at age fifty-three of a heart condition. After James Madison's death in 1836, Dolley moved back to Washington, into the Cutts house, which still stands on the corner of Lafayette Square.

RLP

39 *Madison Dinner Plate*

Nast Manufactory
Porcelain, 23.2 cm (9⅛ in.) diameter, c. 1806
White House Historical Association (White House Collection),
Washington, D.C.

Dolley Madison (cat. 35) began her reign as the head of Washington society during her husband's time as secretary of state (1801–9), hosting receptions at their home and dinners for the widowed Thomas Jefferson (cat. 4). James Madison (cats. 9 and 19) specially ordered this yellow and black china service from France in 1806; it was made by Thomas Nast of Paris. Despite Dolley's fine French porcelain, a diplomat referred to her dinners as "more like a harvest-home supper, than the entertainments of a Secretary of State." However, Dolley was unabashed in her simple dining style, offering a traditional combination of French and American dishes that featured such selections as pies, gravies, cabbage, and ham. Dessert was the centerpiece, with "ice creams, macaroons, preserves and various cakes . . . almonds, raisins, pecan-nuts, apples, pears, etc." Although Dolley is best known for serving ice cream at her squeezes and at James Madison's second inaugural, Jefferson was actually the first to serve it in the President's House. Dolley's favorite flavor was oyster, made from a cream-based frozen oyster stew, although the most popular flavor was strawberry. As the Madisons' personal china, this service returned to Montpelier (cat. 8) after James became president and was therefore not in Washington when the British burned the White House. The china was then brought back to the temporary presidential quarters at the Octagon House on Eighteenth Street, NW, and was used for the remainder of Madison's presidential term.

RLP

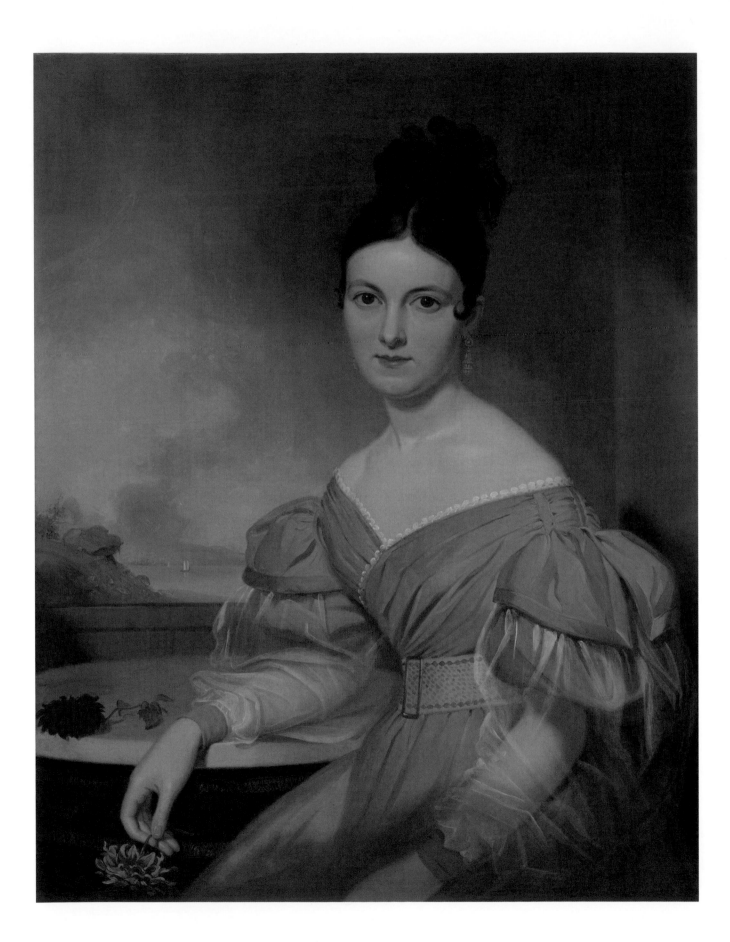

40

Maria DeHart Mayo Scott, 1789–1862

Asher B. Durand (1796–1886)
Oil on canvas, 96.4 × 68.6 cm (34 × 27 in.), 1831
The Metropolitan Museum of Art, New York City; gift of
Mrs. John C. Newington, 1965 (65.69)

In the glittering social world created by Dolley Madison (cat. 35), no
debutant shown brighter in the parlors of Washington than Maria DeHart
Mayo. The daughter of an aristocratic Richmond family tracing its roots
back to 1723, Mayo, who was praised and admired her entire life, was once
described as "not only beautiful both in face and figure but intelligent,
witty, cultivated, charming—and modest withal." It is unclear where this
epitome of a southern belle first met the dashing war hero Winfield Scott
(cat. 29). After his exploits in the Niagara campaign, Scott was one of the
most eligible bachelors in the country and very much her equal in attention.
Despite the fact her father considered the ambitious young brigadier general
an upstart and was unimpressed by his sudden fame, the couple married
in 1816, followed by a honeymoon in which Scott took her to Niagara
Falls and retraced his military adventures. Although the wife of the man
who created the U.S. Army, Maria stayed outside of that sphere, raising
their seven children and spending long periods of time in Europe, both for
her health and for its the social scene, which she preferred to America's.
General Erasmus D. Keyes, who served as Scott's personal aide and knew
the general's wife later in life, wrote of her, "Although it has chanced me to
enjoy the acquaintance of many of the greatest and most gifted dames of all
the Christian nations of the world, I remember none who, in breeding and
accomplishments, were the superior of Mrs. Scott."

RLP

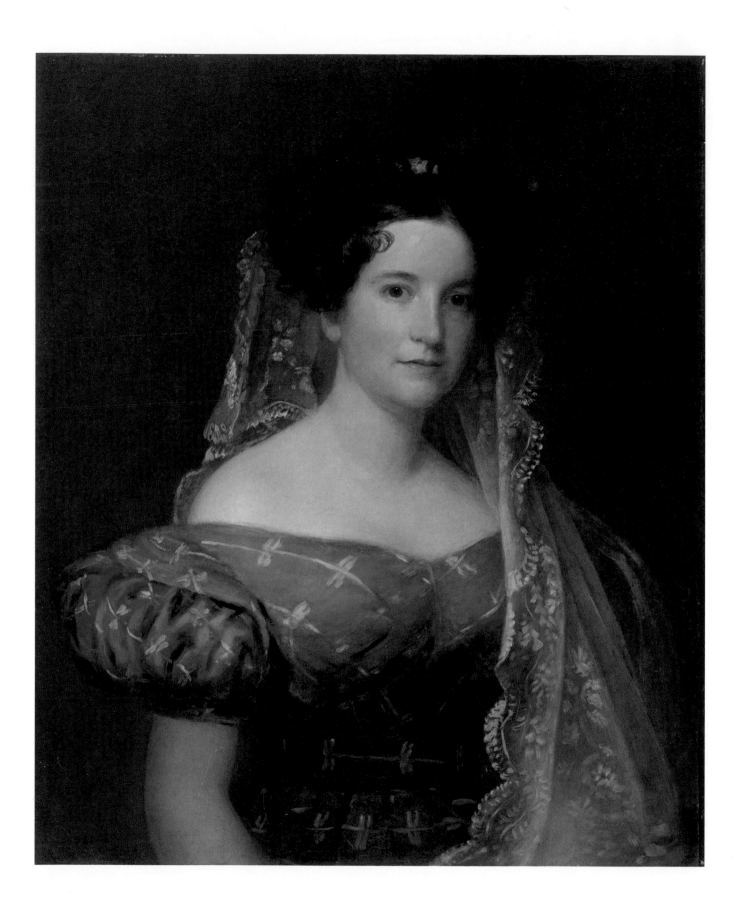

41

Ann McCurdy Hart Hull, 1790–1874

Unidentified artist
Oil on canvas,
62.2 × 76.2 cm (24½ × 30 in.), c. 1830–35
Wadsworth Atheneum Museum of Art, Hartford,
Connecticut; bequest of Miss Ellen A. Jarvis (1957.176)

The victory of the *Constitution*—Old Ironsides—in the first months of the war elevated not only the ship but its captain, Isaac Hull (cat. 43), to legendary status throughout America. So great was the force of the war's celebrity that a man described as "a sturdy, fat-looking fellow" won the hand of a renowned Connecticut beauty of whom it was said, "it would be difficult to meet with a lovelier face or figure." Ann McCurdy Hart was one of the seven daughters of Captain Elisha Hart of Saybrook, all celebrated for their beauty and refinement. Seventeen years his junior, Ann married Captain Hull in early 1813, barely four months after the *Constitution*'s victory, to widespread surprise. After the war, the Hulls lived in Washington for six years while Hull served as commandant of the Navy Yard. During their marriage, Ann also traveled with her husband on various cruises, and the couple were known for their shipboard entertainments when in port. Such was the influence of the beguiling Mrs. Hull that it was once commented that she was in "command of the ship." The Hulls had no children of their own but were often accompanied by family members on these voyages. Family legend maintains that during a cruise to South America, the Hulls were accompanied by Ann's sister Augusta, who captured the heart of Simón Bolívar, who reportedly proposed but was rejected by the family as unsuitable.

RLP

NAVAL BATTLES

During the War of 1812, Americans were justifiably proud of their frigates' victories over British warships on the high seas. In these one-on-one contests, the newly designed American ships proved faster, more maneuverable, and more resistant to enemy fire than the British frigates. American officers showed excellent seamanship, and their crews were well trained, usually exceeding their British counterparts in the accuracy of their gunnery. All of the celebrations of those flamboyant victories, however, distract us from perhaps what were the more basic and critical realities of the naval War of 1812. First, the British possessed a vastly larger navy. In 1812 the Royal Navy had more than 500 ships in service, including 115 ships of the line and 126 frigates. The entire American navy consisted of 17 vessels. With such numbers, the British were able to maintain a largely successful blockade of American ports throughout the war. Second, perhaps the greatest American naval victories of the war were not the dramatic contests of the frigates on the high seas but the clashes of naval squadrons on the inland waters of Lake Erie and Lake Champlain (cats. 51 and 54). The victory of Oliver Hazard Perry (cat. 50) secured the Northwest, and that of Thomas Macdonough (cat. 53) prevented a British occupation of upper New York. These victories shaped the course of peace negotiations and convinced the Duke of Wellington (cat. 78)—whom many in the British government wanted to send to America after Napoleon was defeated—that the war in America could not easily be won.

SH

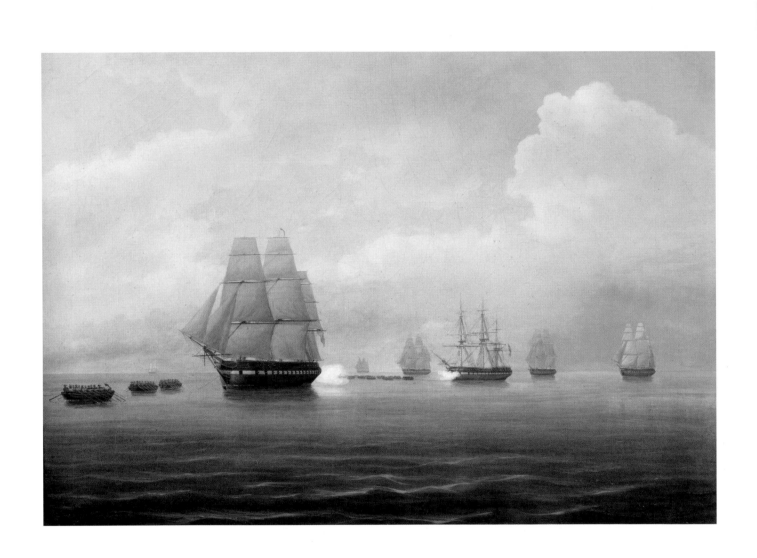

42 *Escape of the U.S. Frigate* Constitution

Thomas Birch (1779–1851)
Oil on canvas,
62.9 × 90.2 cm (24¾ × 35½ in.) sight, 1838
The New-York Historical Society, New York City; bequest of
Matilda Wolfe Bruce (1908.5)

On the day war was declared against Great Britain (June 18, 1812) Isaac Hull (cat. 43), captain of the *Constitution,* was ordered to sail from Washington to join the naval squadron in New York. During the afternoon of July 16, off present-day Atlantic City, lookouts on the *Constitution* spotted four ships but could not tell whether they belonged to the United States or the enemy. At dawn the next day, the situation became clear: six to ten miles behind and coming up fast were a British ship of the line, three frigates, a brig, and a schooner. The wind died, and Hull ordered boats lowered to tow his helpless vessel. The nearest British vessel, the *Shannon,* which was being towed by all the squadron's boats, was gaining on the *Constitution.* Hull was ready to turn broadside to take on the British squadron when Lieutenant Charles Morris suggested they try kedging— rowing out the ship's anchor, dropping it, and hauling the ship forward by brute manpower. Hull was dubious because kedging was not used at their 144-foot depth but gave the go-ahead, and their distance from the British gradually increased until the British matched Hull's maneuver. The slow-motion chase continued through the night. Dawn brought a light breeze, and the British frigate *Belvidera* tacked eastward to intercept the *Constitution.* Hull tacked eastward also, putting him on a course that would risk fire from the *Aeolus,* the smallest British frigate. The *Aeolus* raced to cut off the *Constitution*'s escape. The *Constitution* slipped by just within *Aeolus*'s firing range, but the British frigate did not fire, fearing, Hull believed, she would lose her breeze. It became a race in which *Constitution*'s speed and agility became telling. By 6:00 PM she was eight miles ahead; at dawn, twelve miles. At 8:15 AM the British gave up the chase, and Hull headed north.

SH

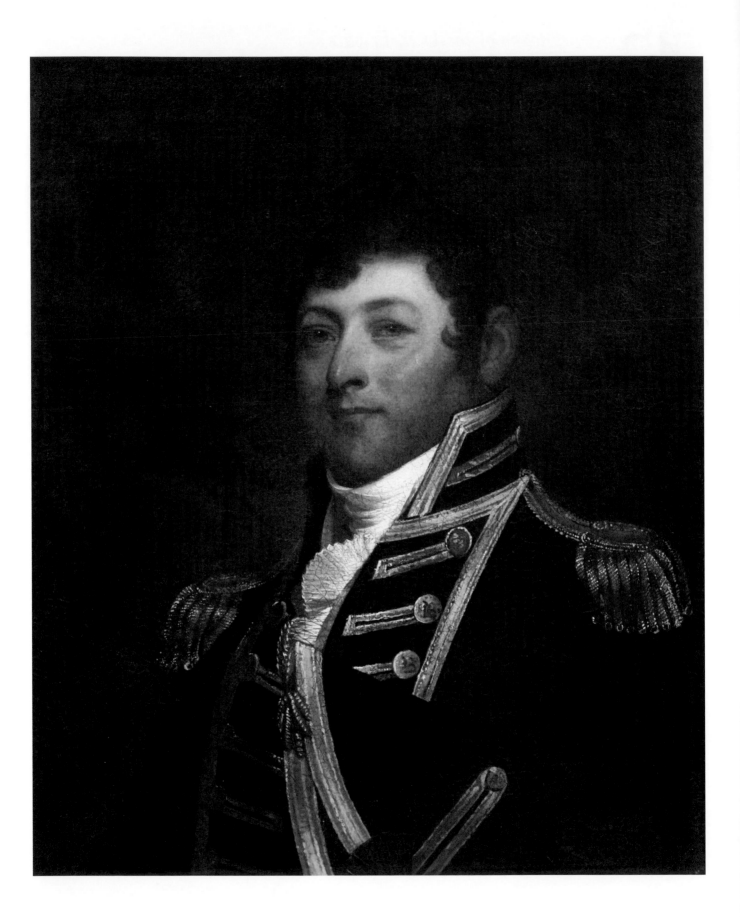

43 *Isaac Hull, 1773–1843*

Samuel Lovett Waldo (1783–1861), after Gilbert Stuart
Oil on canvas, 73 × 59.9 cm (28¾ × 23⁹⁄₁₆ in.), 1834
U.S. Naval Academy Museum, Annapolis, Maryland

The son of a Connecticut mariner, Isaac Hull was, through the influence of his uncle, Brigadier General William Hull (cat. 24), appointed a lieutenant in the U.S. Navy in 1798. He served during the Quasi-War with France (1798–1800) and saw no action, but he was credited with saving his ship from foundering on rocks. Hearing cries and racing to the deck, he saw his captain frozen. Hull grabbed the speaking trumpet, issued orders, and turned to his astonished captain, saying, "Keep yourself cool, Sir, and the ship will be got off." "Keep yourself cool, Sir" became the watchword among the amused sailors. At the onset of the War of 1812, Hull commanded the *Constitution*. After a masterly escape from a British squadron (cat. 42), Hull spotted the British frigate *Guerrière* on August 19 in the North Atlantic. As the ships closed, the *Guerrière* fired. When a cannonball bounced off the *Constitution*, a crew member shouted that its sides were "made of iron," and the moniker Old Ironsides was born. Hull maneuvered his ship alongside the *Guerrière* and ordered every starboard gun fired. After a thunderous crash on the *Guerrière*, the short, stocky Hull leapt on an arms chest, shouting "By God that vessel is ours." It was the first American victory over a British frigate, and the first good news of the war. Three days earlier, William Hull had surrendered at Detroit. Upon the *Constitution*'s return to Boston, Hull and the crew were greeted with celebrations, and numerous cities held dinners for the gallant Captain Hull. Hull's victory led to a congressional appropriation of $2.5 million for warships and contributed to President Madison's reelection. Hull held several more commands but would always be remembered for his heroic captaincy of the *Constitution*.

SH

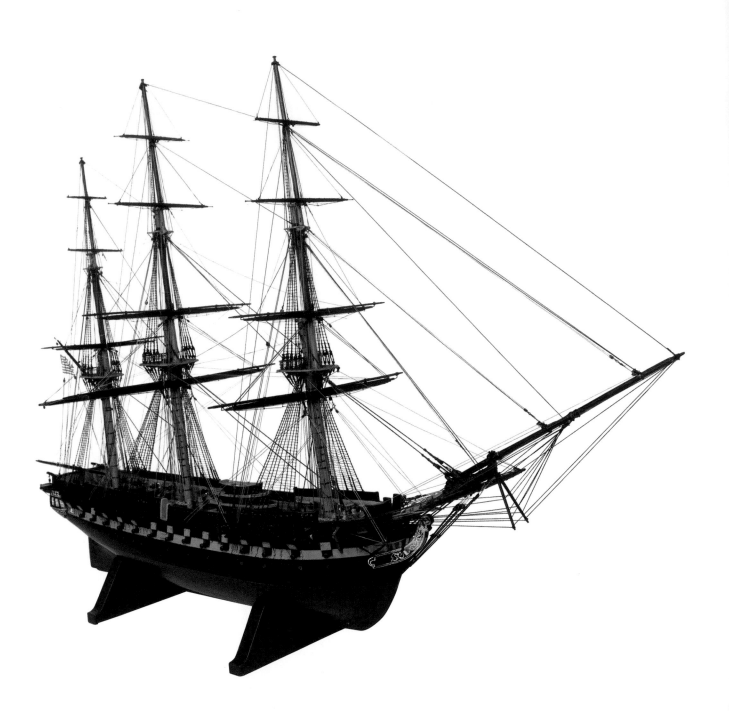

44 *Model of the* Constitution

Wood, 98.4 × 35.6 × 70.5 cm
(38¾ × 14 × 27¾ in.), 1920–21
U.S. Naval Sea Systems Command, Washington, D.C.

Constructed in Boston, the *Constitution* was launched on October 21, 1797. She made several captures in the Quasi-War against France (1798–1800) and saw action in the war against Tripoli (1801–5). In 1810 Isaac Hull (cat. 43) was appointed captain, and the *Constitution* became the flagship of the North Atlantic Squadron. In the first months of the War of 1812, the *Constitution* was celebrated for her escape from a British squadron and the defeat of the *Guerrière*. She also captured or burned nine merchantmen and five warships. After the war, the *Constitution* served as flagship in the Mediterranean. She was judged unseaworthy in 1830, and a rumor circulated that she was about to be scrapped when Oliver Wendell Holmes's poem "Old Ironsides" appeared in the *Boston Advertiser*:

> Ay, tear her tattered ensign down!
> Long has it waved on high . . .
> Beneath it rung the battle shout,
> And burst the cannon's roar.

A public outcry forced the navy to appropriate money for reconstruction, and she served on a variety of missions before returning to Boston in 1897 for decommissioning. In 1905 she underwent renovation, was recommissioned, and in 1931 sailed triumphantly to ninety U.S. ports. She returned to Boston in 1934 to become a permanent museum but still remains in commission, the oldest ship on the Navy List.

This is one of eighteen models that Franklin Roosevelt selected as assistant secretary of the navy to be constructed by the H. E. Manufacturing Company in the early 1920s. It was later "uniquely embellished" at the U.S. Naval Academy. It has been dubbed the "Assassination model" because it was in the Oval Office when President John F. Kennedy was assassinated and was later in James Brady's office when he was wounded during the attempt on President Ronald Reagan's life.

SH

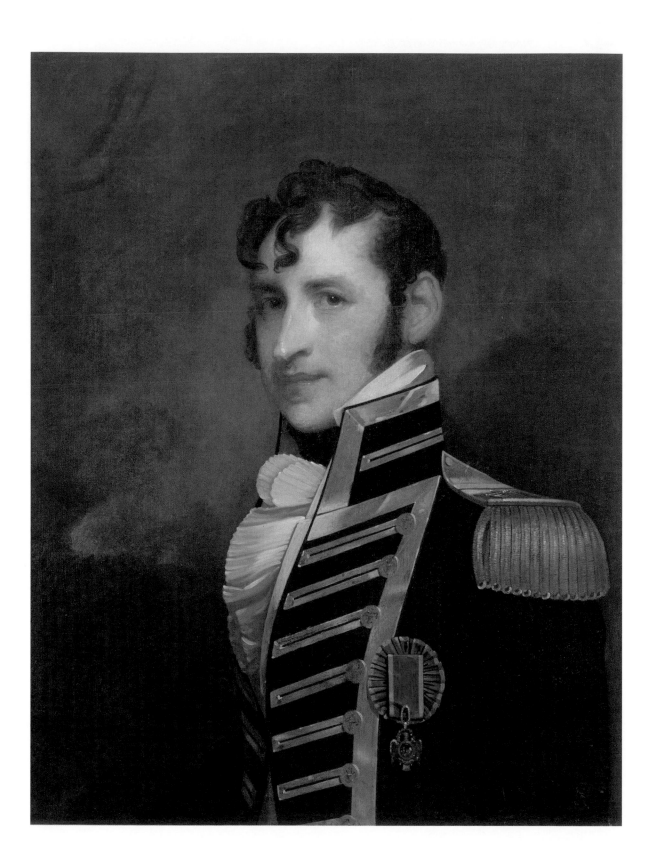

45

Stephen Decatur, 1779–1820

Gilbert Stuart (1755–1828)
Oil on canvas,
71.5 × 56.5 cm (28⅛ × 22¼ in.) framed, 1806
Independence National Historical Park,
Philadelphia, Pennsylvania

A celebrated hero even before the War of 1812 began, the "uncommonly handsome" Stephen Decatur was America's darling. Decatur survived Jefferson's reduction of the navy and distinguished himself during the Tripolitan War. In 1804 he led a daring mission to destroy the captured American frigate *Philadelphia* in the port of Tripoli, leading his sailors in hand-to-hand combat in what Admiral Lord Nelson called "the most bold and daring act of the age." Made a captain at the age of twenty-five, Decatur is the youngest ever to hold that rank. After war was declared on Great Britain, Decatur defeated the *Macedonian* (cat. 46) in a dramatic fashion and, in a bit of one-upmanship over Isaac Hull's recent victory against the *Guerrière* (cat. 43), repaired the captured ship in order to bring it into the American fleet. For the rest of the war, Decatur found himself boxed in by the British blockade of American ports and spent a brief time as a prisoner after a failed attempt to run the blockade aboard the *President*. Since the *Chesapeake-Leopard* affair (cat. 5) in 1807, Decatur had been in an ongoing quarrel with Commodore James Barron over what Decatur saw as Barron's dishonorable conduct as captain of the *Chesapeake*. In 1820, the pair met at the Bladensburg dueling grounds, where both were wounded, although Decatur mortally. He died later the same day in his house on Lafayette Square, which still stands today. Shortly before his death, Decatur said of the country he had served his entire life, "Our country! In her intercourse with foreign nations, may she always be in the right; but our country, right or wrong."

RLP

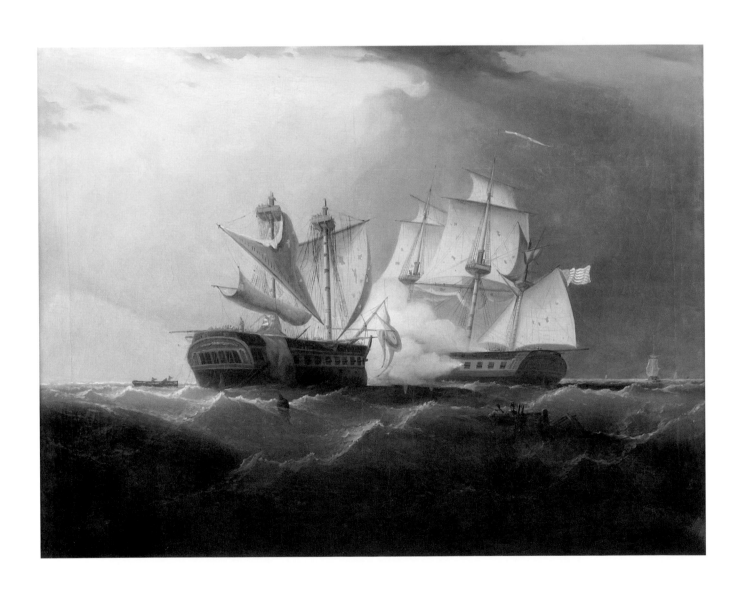

46 Capture of H.M.S. Macedonian by the U.S. Frigate United States

Thomas Birch (1779–1851)
Oil on canvas,
90.2 × 114.3 cm (35½ × 45 in.) sight, c. 1813
New-York Historical Society, New York City; gift of the
Naval History Society Collection (1925.112)

The *United States*, one of the six frigates authorized by Congress in 1794, was designed by naval architect Joshua Humphreys (see cat. 3). She was built in Philadelphia, launched in May 1797, and ordered to sea in the spring of 1798. The *United States* was decommissioned in June 1801 but was returned to active service in 1810. Captain Stephen Decatur (cat. 45), a naval officer who had seen action in the Quasi-War with France and was celebrated in the war against the Barbary pirates, was her new commander. A story circulated that during her refitting in Norfolk, Virginia, Decatur met Captain John S. Carden of the new British frigate *Macedonian*. Carden, believing that war was imminent between the two nations, bet Decatur a beaver hat that if there were hostilities, the *Macedonian* could take the *United States*. Two years later, on October 25, 1812 (war having begun the previous June), lookouts on the *United States*, which was about 500 miles south of the Azores, reported seeing a sail twelve miles away. Decatur made her familiar form to be the *Macedonian*. At 9:20 AM, Decatur, using his larger guns to advantage, engaged the British ship from long range. As the ships closed, the more accurate firing from the *United States* did major damage, taking out the *Macedonian*'s top mizzenmast, rendering her helpless, and forcing her to surrender at noon. In the lopsided battle, the *Macedonian* suffered 104 casualties to only twelve for the *United States*, which was relatively undamaged. After getting the *Macedonian* seaworthy, Decatur sailed her into Newport on December 4. He and his crew received a hero's welcome. Much later, on August 17, 1843, the *United States*, while docked in Honolulu, was boarded by ordinary seaman Herman Melville.

SH

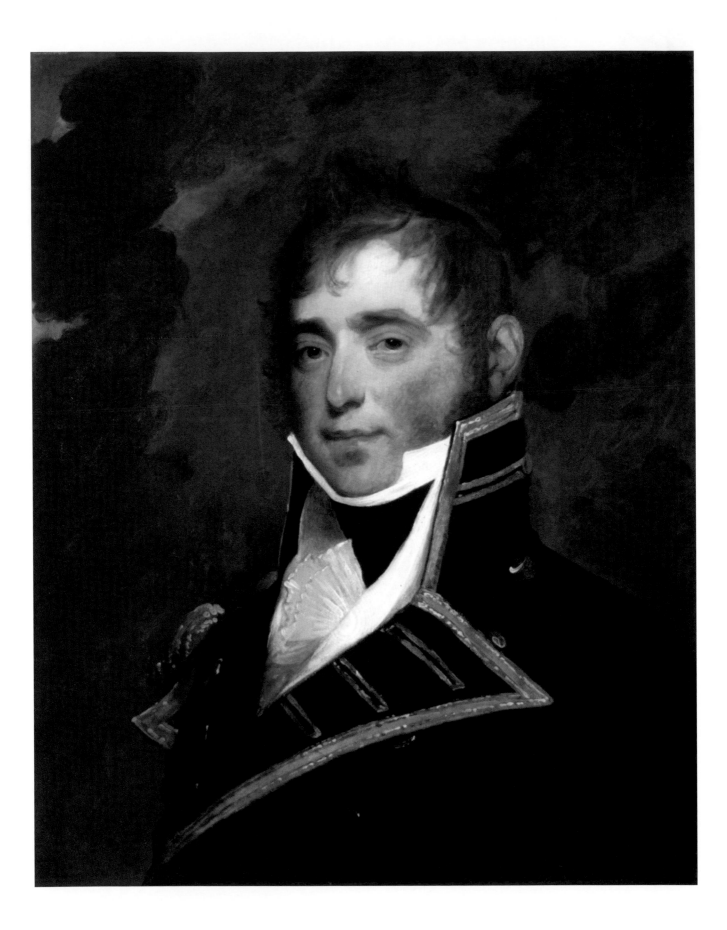

47 *James Lawrence, 1781–1813*

Gilbert Stuart (1755–1828)
Oil on wood,
70.5 × 56.8 cm (27¾ × 22⅜ in.) sight, c. 1812
U.S. Naval Academy Museum, Annapolis, Maryland

James Lawrence was born in Burlington, New Jersey. His mother died when he was young, and his father, a lawyer and a Loyalist, emigrated to Canada, leaving him in the care of his half-sister. Lawrence, following his father's wishes, was preparing for the law when his father died in 1796, leaving him free to choose a naval career. He received his midshipman's warrant in 1798 and saw action in the Tripolitan War (1801–5) as Stephen Decatur's (cat. 45) first lieutenant. He had a succession of commands in 1809, and in November 1810 he was promoted to master commandant. At the outbreak of the War of 1812, Lawrence was in New York, in command of the *Hornet*. He initially sailed with Commodore John Rodgers's squadron in an unproductive two-month cruise but later captured a ten-gun merchant brig and sank the Royal Navy brig-sloop *Peacock* on February 24, 1813. Lawrence took command of the frigate *Chesapeake* in Boston on May 20 and died from wounds in the *Shannon*'s victory over the frigate in June (cat. 48).

SH

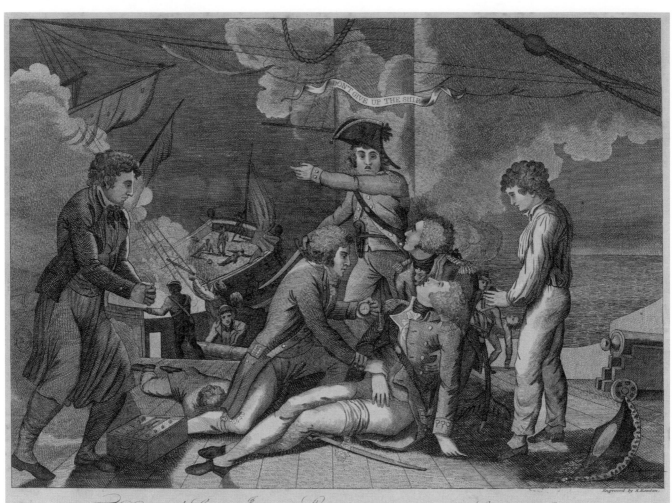

DON'T GIVE UP THE SHIP

The Death of Capt. James Lawrence on board the Chesapeake June 1st 1813

Engraved by R.Rawdon.

Published & Sold by Shelton & Kensett, Cheshire, Connecticut June 1st 1814.

48

The Death of Capt. James Lawrence on Board the Chesapeake June 1st 1813

Ralph Rawdon (1790–1860)
Engraving, 29.4 × 40.3 cm (11 9/16 × 15 7/8 in.), 1814
National Portrait Gallery, Smithsonian Institution,
Washington, D.C.

On May 20, 1813, James Lawrence (cat. 47) took command of the frigate *Chesapeake* in Boston. Two weeks later, he was challenged to battle by Captain Philip Bowes Vere Broke, commander of the frigate *Shannon*, which had been blockading Boston harbor. Broke, who had commanded the *Shannon* for seven years, believed in rigorous training for his crew, even supplying extra gunpowder at his own expense for gunnery exercises. When Broke was informed that Lawrence had left port ahead of his challenge, he sailed a course that allowed him to meet the oncoming *Chesapeake*. Lawrence, on overtaking the *Shannon*, in an ill-advised nod to chivalry, passed up the opportunity of raking its deck and maneuvered alongside the British frigate. Broke's intensive gunnery practice then made the difference. Although the *Chesapeake*'s crew members were well trained, they were unfamiliar with their new captain, and the ship's officers were inexperienced. The sailors of the *Chesapeake* inflicted great damage on the *Shannon*, but they were plagued with bad powder. The concentrated gunfire from the *Shannon* quickly disabled the *Chesapeake* and killed or incapacitated many of the senior officers. Lawrence was hit twice, and as he was carried below with fatal injuries, he issued his famous order, "Don't give up the ship." However, his helpless frigate was quickly boarded and captured. The casualties for both ships—228 men killed or wounded—made it the bloodiest frigate action of the war. It was Britain's first major naval victory in the war. Broke was also seriously wounded in the battle and became a national hero in Britain. The *Chesapeake* was taken into Halifax, Nova Scotia, as a prize of war, and Lawrence's last order became the slogan of the American navy: Oliver Hazard Perry dramatically unfurled its words on a pennant to signal the beginning of the Battle of Lake Erie (cat. 51).

SH

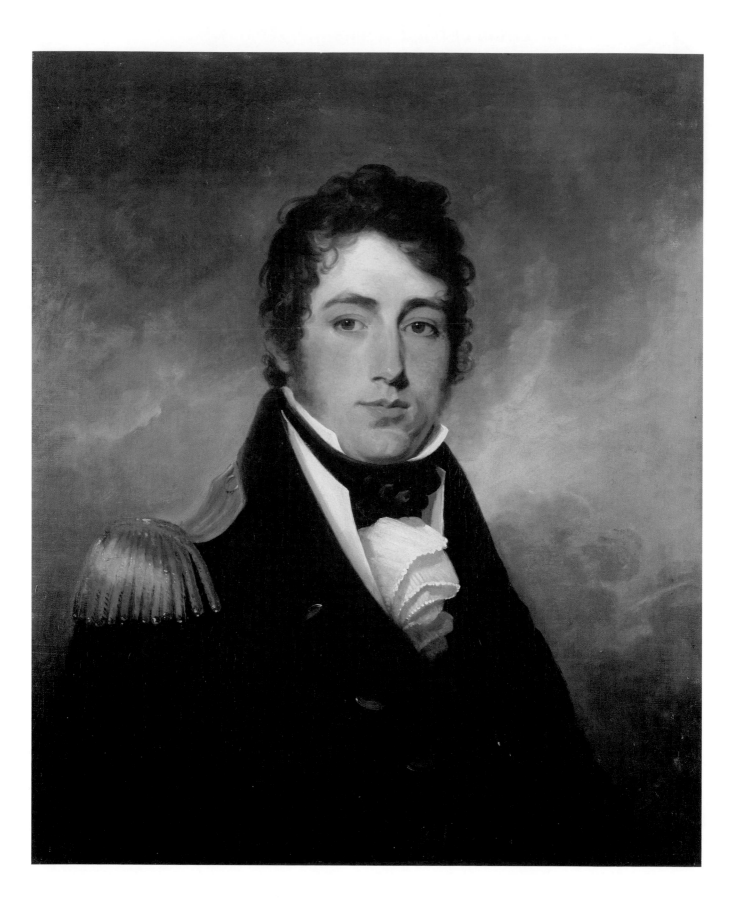

49

Provo William Parry Wallis, 1791–1892

Robert Field (1769?–1819)
Oil on canvas, 76.2 × 63.5 cm (30 × 25 in.), 1813
National Gallery of Canada, Ottawa, Ontario

Born in Halifax, Nova Scotia, Provo Wallis first appeared on the rolls of the Royal Navy at the age of four and ended his career at 101 as Admiral of the Fleet. Yet despite a long career, Wallis's moment of distinction came early in 1813, as a young second lieutenant on the *Shannon* during its victory over the *Chesapeake*. Although the battle was a British victory, the *Shannon*'s captain, Philip Bowes Vere Broke, was severely injured in hand-to-hand combat while boarding the *Chesapeake*, and the first lieutenant was killed. This left the command of the *Shannon* and the captured *Chesapeake* and its crew all in the hands of the twenty-two-year-old Wallis. Over the next six days he barely slept, anxious to get both his ship and its prize back to the safety of Halifax. Captain James Lawrence of the *Chesapeake* had been mortally wounded and was cared for by the British surgeon until he died on the fourth day.

All of Halifax turned out to see their native son return in command of a captured American ship after the British were recently humbled by the *Constitution*'s defeat of the *Guerrière* (cat. 43). As later remembered by one resident, "Every housetop and every wharf was crowded with groups of excited people, and, as the ships successively passed they were greeted with vociferous cheers. Halifax was never in such a state of excitement before or since."

RLP

50

Oliver Hazard Perry, 1785–1819

John Wesley Jarvis (1781–1840)
Oil on canvas, 81.9 × 66 cm (32¼ × 26 in.), c. 1814
Detroit Institute of Arts, Michigan; gift of Dexter M. Ferry Jr./
Courtesy The Bridgeman Art Library

Born in Rhode Island, the son of a naval officer, Oliver Hazard Perry was appointed a midshipman at age thirteen and assigned to his father's frigate. He saw action in the Quasi-War against France and in the Barbary Wars. In 1805 he commanded the schooner *Nautilus* and from 1807–9 was assigned gunboat duty to enforce the Embargo Act. At the onset of the War of 1812, Perry commanded gunboats in Newport harbor but sought sea duty. In February 1813 he was given command of the naval force on Lake Erie. After a heroic victory (cat. 51), Perry was rewarded with command of the frigate *Java*. During the *Java*'s "most boisterous" initial voyage, he quarreled with several marines and struck a marine captain, John Heath. In the resulting court-martial, both men were found guilty and reprimanded. Heath then challenged Perry to a duel, during which Perry refused to fire. Heath missed, and honor appeared satisfied. Jessie D. Elliott, who had commanded the brig *Niagara* in the Battle of Lake Erie, challenged Perry to another duel. The feud originated when Perry moved his flag to the *Niagara* after his own ship was disabled. For the first two hours of the battle, the *Niagara* had inexplicably avoided close combat with the enemy. Perry dispatched Elliott to a schooner and maneuvered the *Niagara* into battle. Perry's battle report glossed over what Theodore Roosevelt, in his *Naval War of 1812*, called Elliott's "misconduct," instead praising his "characteristic bravery and judgment." Elliott, rather than being grateful, was jealous of Perry's fame. Perry refused his challenge and filed charges against him for failure to do his duty. President James Monroe let the matter rest and in May 1819 assigned Perry to a diplomatic mission in South America. Perry had successfully completed the negotiations when he contracted yellow fever and died.

SH

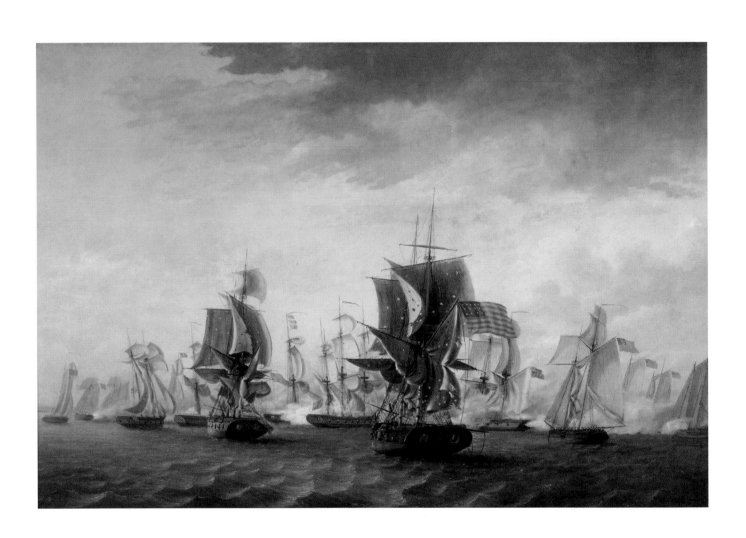

51

Perry's Victory on Lake Erie

Thomas Birch (1779–1851)
Oil on canvas, 167.6 × 245.1 cm (66 × 96½ in.), c. 1814
Pennsylvania Academy of the Fine Arts, Philadelphia;
gift of Mrs. Charles H. A. Esling

In February 1813, Commodore Oliver Hazard Perry (cat. 50) was given command of the naval force on Lake Erie. American failures in the land campaigns on the Canadian border made winning control of the Great Lakes and Lake Champlain crucial for securing the Northwest Territory and the Northeast. In the fall of 1812, crash shipbuilding programs were begun by both sides on Lake Erie, with the U.S. squadron constructed mainly at Presque Isle (now Erie), Pennsylvania. Perry arrived on March 27, 1813, and oversaw the construction. On August 2, he managed a difficult and dangerous maneuver, moving his brigs across the sandbar at Presque Isle into deep water, with the British fleet in sight but unaware of Perry's vulnerability. On September 10, Perry unfurled his "Don't give up the ship" pendant on his flagship, the *Lawrence*, named for the American captain who had uttered those words before dying from battle wounds earlier in the year. For two hours, the *Lawrence* took most of the British fire; when it became disabled, Perry transferred his flag to the *Niagara*. At 3:00 PM, more than three hours after the battle began, the British surrendered. Perry sent Major General William Henry Harrison (cat. 23) the most famous after-action report in American history: "We have met the enemy and they are ours." Perry's victory, giving the United States control of Lake Erie, had immediate implications: Harrison's army, 3,000 strong, assembled at the west end of the lake and retook Detroit (September 29) and then pursued the British army to the Thames River, where the Americans defeated the British (October 5) and killed the Indian chief Tecumseh (cat. 27). With this victory, the United States regained control over the Northwest Territory and shattered Tecumseh's Indian confederacy.

SH

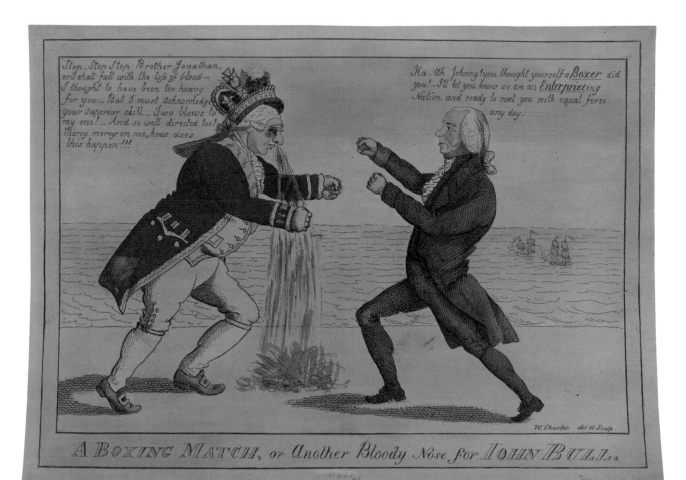

A BOXING MATCH, or Another Bloody Nose for JOHN BULL.

52

A Boxing Match, or Another Bloody Nose for John Bull

William Charles (1776–1820)
Etching with watercolor,
25 × 34.8 cm (9¹³⁄₁₆ × 13¹¹⁄₁₆ in.), 1813
Prints and Photographs Division, Library of Congress,
Washington, D.C.

In this cartoon, William Charles mockingly depicts the defeat of the British brig the *Boxer* by the American frigate *Enterprise*. On September 5, 1813, off the coast of Portland, Maine, the two ships opened fire at a distance of only ten yards. The British ship surrendered thirty minutes later. Later, a British inquiry acknowledged that the *Enterprise* exercised a "greater degree of skill in the direction of her fire." Both ranking officers, British Commander Samuel Blyth and his American counterpart, Lieutenant William Borrows, were mortally wounded in the brief engagement. In Charles's gloating account, King George III/John Bull says, "Stop, Stop, Stop Brother Jonathan [James Madison], or I shall fall with the loss of blood—I thought to have been too heavy for you—But I must acknowledge your superior skill—Two blows to my one! And so well-directed too!" Madison responds, "Ha-Ah Johnny! You thought yourself a Boxer did you! I'll let you know we are an Enterprizeing Nation, and ready to meet you with equal force any day."

SH

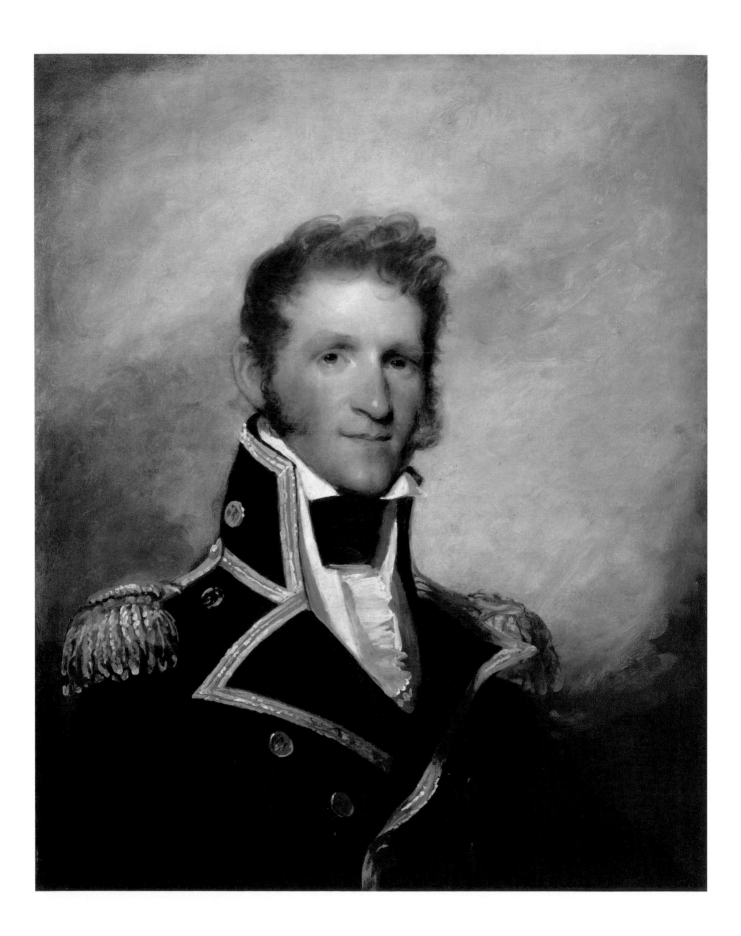

53

Thomas Macdonough, 1783–1825

Gilbert Stuart (1755–1828)
Oil on wood,
72.4 × 57.2 cm (28½ × 22½ in.), c. 1815/1818
National Gallery of Art, Washington, D.C.;
Andrew W. Mellon Collection (1942.8.17)

Thomas Macdonough was born in New Castle, Delaware, the son of a physician who was a major in the Delaware militia during the Revolution. Family influence helped him obtain a post as a midshipman in early 1800, and he saw action first in the Quasi-War against France and then against the Barbary pirates in the Mediterranean. In the latter action he served under squadron commander Commodore Edward Preble, as did many of the junior officers who achieved fame in the War of 1812. In the years between the peace in Tripoli (1805) and the outbreak of the War of 1812, Macdonough served in a variety of shore posts, and to get back to sea, he took a furlough to command a merchant ship on an East Indies voyage. He returned to duty at the outbreak of the war. In September 1812 Macdonough, now a master commandant, was given command of the small naval force on Lake Champlain, with orders to construct more vessels and establish control of the lake. As a result of his great victory on the lake in 1813 (cat. 54), he was promoted to captain. After the war, he was placed in charge of the navy yard at Portsmouth, New Hampshire. In 1818 Macdonough was given command of the frigate *Guerrière*, which he sailed to the Baltic and Mediterranean, returning in 1820. In 1824, he was assigned to the *Constitution* and put in command of the Mediterranean squadron. While en route to his home in Middletown, Connecticut, the following year, Macdonough died, 600 miles at sea. He was given a military funeral with honors in New York City and buried at Middletown.

SH

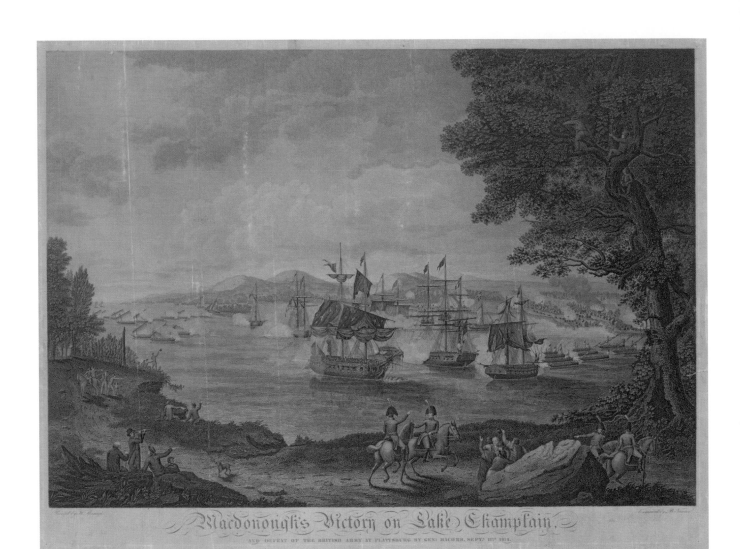

Macdonough's Victory on Lake Champlain.

AND DEFEAT OF THE BRITISH ARMY AT PLATTSBURG BY GENL. MACOMB, SEPT. 11th 1814.

54

Macdonough's Victory on Lake Champlain and Defeat of the British Army at Plattsburg by Genl. Macomb, September 17th 1814

Benjamin Tanner (1775–1848), after Hugh Reinagle
Engraving, 49.6 × 65.5 cm (19½ × 25¹³⁄₁₆ in.), 1816
Prints and Photographs Division, Library of Congress,
Washington, D.C.

In September 1812 Master Commandant Thomas Macdonough (cat. 53) had command of the small naval force on Lake Champlain, with orders to add to his fleet and establish control of the lake. A year later, Macdonough's command assumed much greater importance when Oliver Hazard Perry's victory on Lake Erie (cat. 51) forced the British to shift their focus to Lower Canada and use Montreal as a jumping-off point for invading New York. In August 1814, Governor Sir George Prevost's army of 10,000 British troops marched southward, while Captain George Downie's naval squadron sailed south on Lake Champlain. Macdonough, aware of the British movement, planned the location of the battle—at Plattsburgh—to his advantage. He is credited with a ship-handling masterstroke—using his kedge anchors to "wind" his ship, the *Saratoga,* around so that he could bring fresh batteries to bear against the British *Confiance*. This allowed him to batter the British ship, forcing it and the rest of the British squadron to surrender. With control of the lake lost, Prevost ordered his army back to Canada. Macdonough's victory, although not as dramatic as Perry's, was more significant in determining the outcome of the war and the peace: A successful British invasion of New York might have encouraged the British to fight on or demand better peace terms.

While Macdonough was fighting on Lake Champlain, Brigadier General Alexander Macomb (1782–1841) defended the Plattsburgh fortifications with a force of 3,400 regular militia against Prevost's 8,000 troops. Although Macomb claimed—and some accounts agree—that his troops repeatedly repulsed the much-larger British army, no major land battle actually occurred before Prevost ordered a withdrawal. Even had the British overrun Macomb, their situation in Plattsburgh was untenable with American control of Lake Champlain.

SH

55

12 at Midnight; the Hibernia Attempting to Run the Comet Down

Thomas Whitcombe (c. 1760–c. 1824)
Oil on canvas, 80 × 54.6 cm (31½ × 21½ in.) sight, 1814
Mr. and Mrs. Drew Peslar

Privateers like the *Comet* were privately armed vessels acting under legal authority to seize enemy vessels as prizes of war. Ship owners swore they were American citizens, put up a $5,000 bond, and pledged to obey the rules of war. Privateers were usually sleek and fast, sacrificing space and strength for speed and cramming in crews of 100 to 150 seamen. During the War of 1812, President Madison, as authorized by Congress, issued five hundred letters of marque. Only about 200 took prizes. Many ships were captured, sunk, or unable to run British blockades. It cost an owner $40,000 to buy and fit out a large privateer, but a rich prize could net him $100,000 or more. Half the spoils went to the owner; the other half was divided among the officers and crew in proportion to rank. Thomas Boyle (1776?–1825), one of the most successful privateer commanders of the war, captained the *Comet* from 1812 to 1814. He took twenty-seven prizes with the 350-ton schooner, which had sixteen guns and a crew of 130. On January 11, 1814, Boyle engaged the twenty-two-gun, 800-ton *Hibernia* in the West Indies. The battle began at 7:30 PM, with the *Comet* making several unsuccessful attempts to board. At half past midnight, with continuous firing by both sides, the *Hibernia*, as depicted here, attempted to ram the *Comet*. According to Boyle's journal, it "so far succeeded as to run his jib-boom into our mainsail . . . and come with his bows against our stern, without doing any damage to our hull." At 3:00 AM, the *Hibernia*'s fire "considerably slackened," and the *Comet* was "rendered almost unmanageable." At daylight, the *Hibernia* was two miles distant, heading for St. Thomas, with eight men dead and thirteen wounded to three dead and sixteen wounded on the *Comet*.

SH

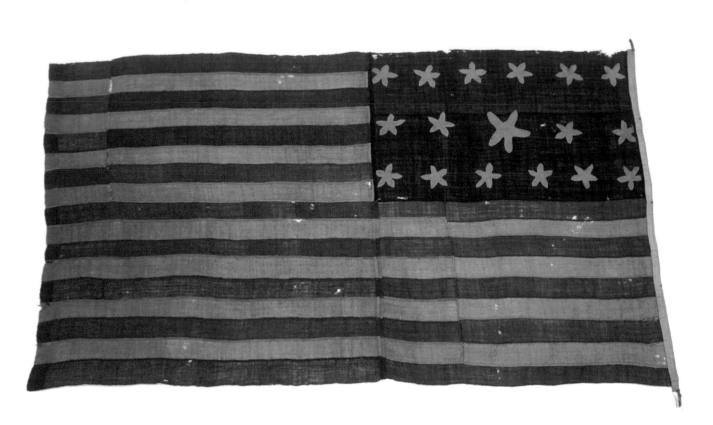

56

1812 Seventeen-Star, Seventeen-Stripe Flag

Hand-sewn wool bunting with cotton stars,
175.3 × 292.1 cm (69 × 115 in.), 1812
Veninga-Zaricor Family/www.Zaricorflagcollection.com

This handmade seventeen-star, seventeen-stripe U.S. flag flew on the American schooner *Blockade* after President James Madison issued a letter of marque on September 15, 1812, making it a privateer legally permitted to take prizes during the War of 1812. The 128-ton schooner, commanded by Captain Elisha Mix, carried about ten guns and a crew of about seventy and sailed out of Connecticut. She was captured off the island of Saba in the Caribbean on October 31, 1812, by the *Charybdis*, a 385-ton, eighteen-gun British navy brig with a crew of 121 commanded by Captain James Clephan (1768–1851). In the one-hour and twenty-minute battle, twenty-eight officers and men of the *Charybdis* were killed or wounded to eight on the *Blockade*. The *Blockade* was eventually sold as a prize of war, and Clephan retained the flag as a trophy.

No other seventeen-star, seventeen-stripe flag exists in the United States. The rounded, rather than the traditional sharp-pointed, stars are the flag's most striking feature. The pattern of three rows of irregular stars can be traced back to the American Revolution. The stripes and canton of the flag are made of handwoven single-ply worsted wool. The stars are made of cotton and contain the numerous irregularities of handspun fabric. The reinforcing stitching on the hoist is tarred, and the entire flag bears the hallmarks of being made by either a ship's chandler or sailmaker.

The flag remains in remarkable condition because of the care it received from the Clephan family, where it remained for almost two hundred years before coming to the current owner in 2007.

SH

THE BURNING OF WASHINGTON AND
THE DEFENSE OF BALTIMORE

On August 24, 1814, the citizens of Washington fled before an invading British army. After an easy victory against unprepared militia at Bladensburg, the British advanced into the city. Starting at the Capitol, the invaders, led by Major General Robert Ross (cat. 58), quickly set about burning the city's public buildings. At the abandoned White House, the British found an elaborate dinner, left in haste as Dolley Madison had fled the house only hours before, after securing the legendary Gilbert Stuart portrait of George Washington. In addition to the Capitol, the President's House, Treasury and War Departments, and Navy Yard joined the flames. Forty miles north, in Baltimore, residents could see the glow of the burning city and wondered if they would be next. Three weeks later, as the British advanced on Baltimore, Ross was killed at North Point, leaving the army without a strong commander. The next day, September 13, the British fleet began a twenty-four-hour bombardment of Fort McHenry (cat. 73) in an effort to break Baltimore's defenses by sea. From a truce ship in the harbor, eight miles away, Washington lawyer Francis Scott Key (cat. 75) watched the assault on the fort throughout the night, and as morning dawned, he penned the lines that became the American national anthem: "O say does that star-spangled banner yet wave, / O'er the land of the free and the home of the brave?"

RLP

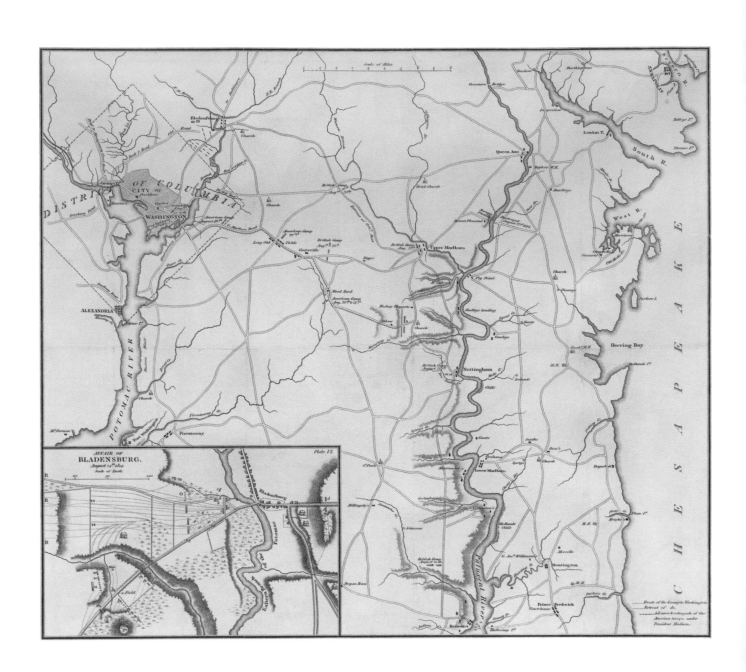

DISTRICT OF COLUMBIA

CITY OF WASHINGTON

ALEXANDRIA

POTOMAC RIVER

Bladensburg

Scale of Miles

AFFAIR OF
BLADENSBURG.
August 24th 1814.
Scale of Yards.

Plate VI.

Bladensburg

Potomac or East Branch

CHESAPEAKE

South R.

West R.

Herring Bay

Patuxent River

Queen Ann

London T.

Upper Marlboro

Nottingham

Lower Marlboro

Huntington

Prince Frederick

Benedict

Route of the Army to Washington.
Retreat of do.
Advance & retrograde of the
American Army, under
President Madison.

57

Map of Maj. Gen. Ross's Route, with the British Column, from Benedict, on the Patuxent River, to the City of Washington, August 1814

William James, Publisher
Engraving, 38.1 × 41.9 cm (15 × 16½ in.), 1818
The Albert H. Small/George Washington University
Collection, Washington, D.C.

The American defeat on August 24, 1814, at the Battle of Bladensburg, more aptly referred to as "the Bladensburg Races," was a humiliating failure that left Washington open to attack. The battle demonstrated the folly of depending too heavily on poorly trained militia with weak and inexperienced leaders. Secretary of War John Armstrong (cat. 69) insisted, right until the last moment, that the British would never attack the capital and therefore failed to make preparations for the city's defense. When the British did arrive at Bladensburg, just outside of Washington—which was already known as "dark and bloody grounds" for the many duels that took place there—all that stood between their army regulars and the capital was a mixed force consisting mainly of untrained and ill-equipped militia. The orderly advance and precision of the British army, led by General Robert Ross (cat. 58), supported by a frightening barrage of Congreve rockets (cat. 74), were too much for the militia, who quickly turned and ran. What followed was largely a frantic, haphazard retreat, with every man for himself and no intent to regroup. Officers' attempts to rally their men were ignored. Some regiments joined the general retreat before even entering the battle. Still, both British commanders, Ross and Admiral George Cockburn (cat. 61), experienced close calls near the American lines. A seaman and former slave serving under Commodore Joshua Barney confessed he could not help but admire the British officers, declaring Ross "one of the finest looking men that I ever saw on horseback."

RLP

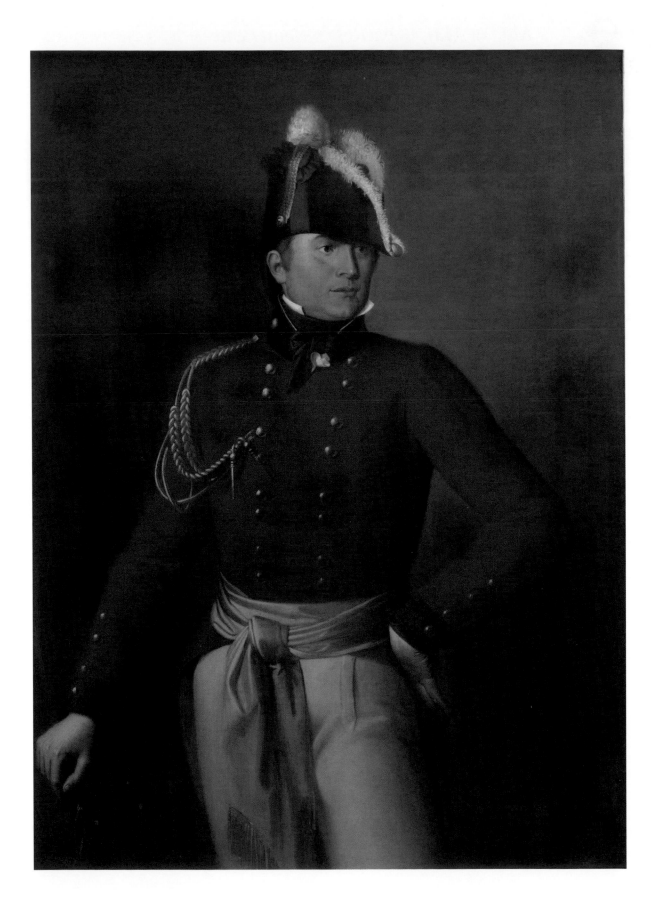

58

Robert Ross, 1766–1814

Unidentified artist
Oil on canvas,
170 × 130 cm (66¹⁵⁄₁₆ × 51³⁄₁₆ in.) framed, c. 1815
Stephen Campbell

Whereas the War of 1812 created new Americans heroes, the British army
suffered the loss of several of its brightest young stars: Isaac Brock (cat. 25)
in Canada, Edward Pakenham (cat. 79) at New Orleans, and Robert Ross
at North Point. A hardened veteran of far-flung battles in France, Egypt,
and Spain, Major General Ross arrived in America in August 1814 with the
"temporary inconvenience" of an unhealed neck wound he had sustained while
fighting the French in February. Ross was said to hold the "absolute love of
all who served under him, from the highest to the lowest" and commanded
his men to victory at the Battle of Bladensburg, followed by the capture and
burning of Washington. In both cases Ross was noted for his honorable
behavior toward prisoners, residents, and private property. Aboard the British
flagship *Tonnant* Ross encountered Francis Scott Key (cat. 75), who was there
to secure the release of an American prisoner. Proceeding toward Baltimore
on land, Ross was at his customary spot at the head of his troops at North
Point when he was killed by an American sharpshooter. Ross's death had a
profound effect on the unsuccessful attack on Baltimore, and Admiral Sir
George Cockburn (cat. 61), who was at Ross's side, mourned his friend's
death to Admiral Alexander Cochrane: "our country, sir, has lost in him one
of its best and bravest soldiers, and those who knew him, as I did, a friend
honored and beloved." The Prince Regent (cat. 16) bestowed the honorific
Ross of Bladensburg on the family name in recognition of Ross's success.
This portrait remains with the Ross family in Northern Ireland.

RLP

59

British Officer's Drawing of Bladensburg

Unidentified artist
Graphite and wash on paper,
26.7 × 33.7 cm (10½ × 13¼ in.), 1814
The Albert H. Small/George Washington University
Collection, Washington, D.C.

Although the Americans managed to inflict significant casualties on the British at Bladensburg, such was the rout that the numbers of killed and wounded on the American side did not reach one hundred, and few were captured. As Major General Robert Ross (cat. 58) noted dryly, "The rapid flight of the enemy . . . precluded the possibility of many prisoners being taken." Bladensburg would be the last time a sitting president would be present during battle; James Madison was so close that British officers witnessed him fleeing the field on horseback to avoid capture. The British casualties were largely caused by the 500 marines and seamen under the command of Commodore Joshua Barney, a salty Revolutionary War veteran who had been evading the British with his small flotilla in the Chesapeake Bay for months. Abandoned by all other units and out of ammunition (because the supply wagons had also fled), Barney waited until the last moment to order a retreat, just as he was shot. Immobilized, he was left on the field, and moments later the British converged on him. Ironically, Barney's naval foe, Admiral Sir George Cockburn (cat. 61), was also on land and was brought to his side, where Barney admitted, "Well, admiral, you have got hold of me at last." To Barney's surprise, after being attended by a British surgeon, Ross and Cockburn let him go. Barney later noted that the two men "behaved to me with most marked attention, respect and politeness." With both sides abandoning the field so rapidly, the bodies of the dead remained on the battlefield, some for as long as two weeks. They were eventually buried by the slaves of George and Rosalie Calvert. The Calverts were antiwar Federalists who owned the nearby Riversdale plantation.

RLP

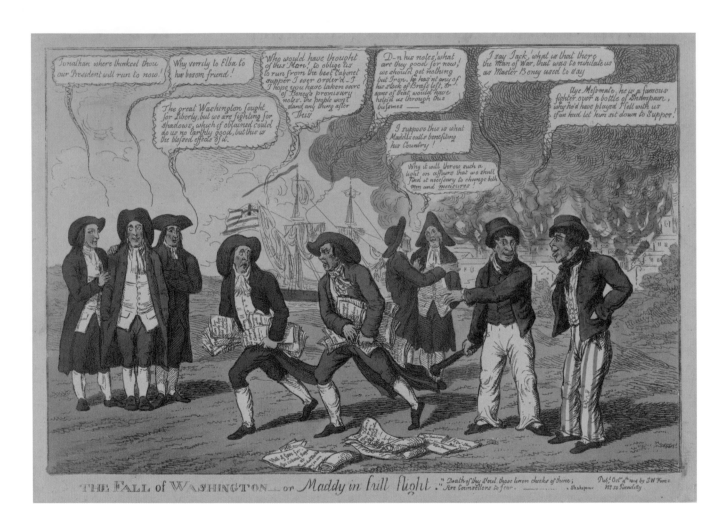

60

The Fall of Washington— or Maddy in full flight

Unidentified artist
Color engraving,
25.8 × 36.3 cm (10³/₁₆ × 14⁵/₁₆ in.), 1814
Prints and Photographs Division, Library of Congress,
Washington, D.C.

Published by S. W. Fores in Piccadilly, London, on October 4, 1814, this cartoon is a good indication of the English reaction to the burning of the American capital. President Madison (see also cats. 9 and 19) and probably Secretary of War John Armstrong (cat. 69) are depicted fleeing Washington with bundles of government documents. Madison, who had invited the members of his cabinet to supper at the President's House (the common name for the White House in the early nineteenth century) on the night of the attack, says, "best cabinet supper I ever ordered"; the paper on the ground reads, "Bill of fare for Cabinet supper at President Maddy's . . . August 24, 1814." The British view of the war is voiced by the three men at the left: the man at the far left asks Jonathan (an early nickname for America, although Uncle Sam was already coming into use), in the middle, where Madison "will run to now"; Jonathan responds, "Why verily to Elba to his bosom friend!" (Many in Britain believed that America aligned itself with Napoleon [cat. 14] in declaring war against Britain.) The third man sorrowfully contrasts the American Revolution to the War of 1812: "The Great Washington fought for Liberty, but we are fighting for shadows, which if obtained could do us no Earthly good." Most Britons regarded the destruction of Washington as deserved punishment for America's foolishness in starting a war without sufficient cause, a war the British—fully engaged in a war with Napoleon— did not want. Britain's burning of the public buildings in Washington was also a payback for American destruction of Canadian communities, including their capital, York (present-day Toronto).

SH

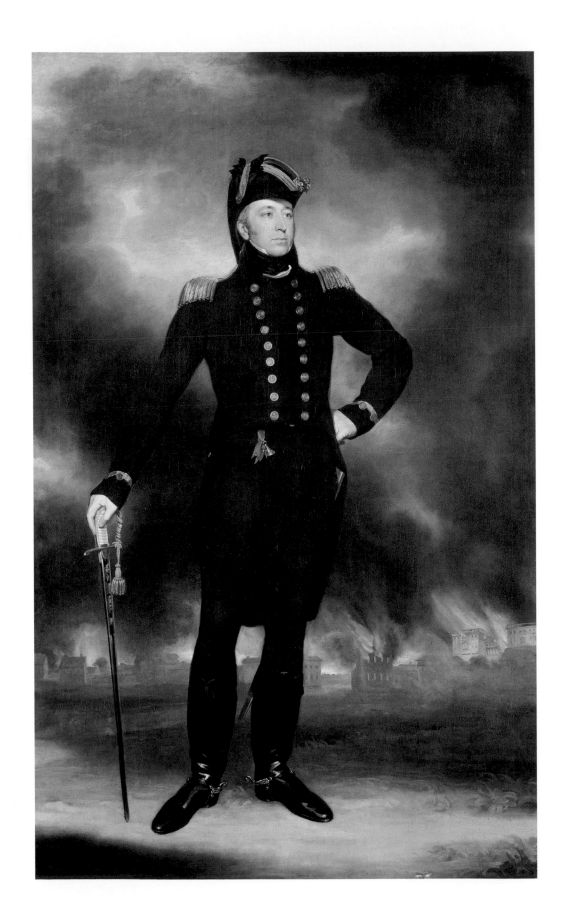

61

George Cockburn, 1772–1853

John James Halls (1776–1853)
Oil on canvas,
238.8 × 148.6 cm (94 × 58½ in.), c. 1817
National Maritime Museum, Greenwich, London

A career sailor, Sir George Cockburn went to sea as a boy and rose through the ranks to rear admiral; as governor of Saint Helena, he also guarded Napoleon in captivity. However, his greatest moment of glory, which he chose for this portrait, was the burning of Washington on August 24–25, 1814. Although a naval officer and therefore not in command on land, Cockburn was the driving force behind the operation, encouraging Major General Robert Ross (cat. 58) to continue into the city even after his superior, Vice Admiral Alexander Cochrane, recommended retreat. Cockburn was already a hated figure, infamous for his raids throughout the Chesapeake, particularly on Hampton. A $1,000 reward was offered for his head. News of his presence in the attack terrified Washingtonians. As a congressman reported, "Cockburn's name was on every tongue with various particulars of his incredibly coarse and blackguard misconduct." Although Cockburn stuck to Ross's strict prohibition on the destruction of private property, he made a notable exception in his personal vendetta against the *National Intelligencer*. An avid reader of American newspapers, Cockburn considered the *Intelligencer* to be the voice of the Madison administration and its profiles of him particularly unflattering. When ladies from neighboring houses pleaded that their homes not be destroyed by a spreading fire, Cockburn spared the newspaper office but ordered its contents destroyed, paying particular attention that all the C's from the type case were destroyed. Disdainful of President Madison's failure to defend his own capital, Cockburn was quick to answer when an angry citizen declared that they would not have dared to attack if George Washington had been alive. "No Sir," Cockburn replied, "If General Washington had been president we should never have thought of coming here."

RLP

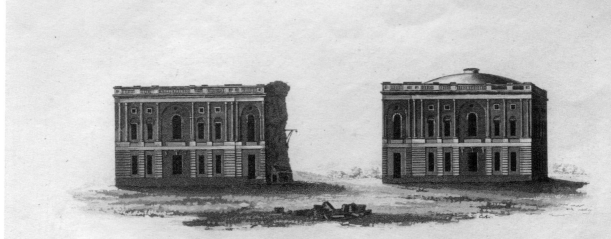

Flyglarna af Capitolen i Washington år 1819.

62

Flyglarna af Capitolen i Washington ar 1819 (Wings of the Capitol in Washington in 1819)

Axel L. Klinckowström, Stockholm, publisher
Aquatint, 13.3 × 21.6 cm (5¼ × 8½ in.), 1819
The Albert H. Small/George Washington University
Collection, Washington, D.C.

The British army entered Washington unopposed near Capitol Hill at dusk on August 24, with Major General Robert Ross (cat. 58) and Rear Admiral Sir George Cockburn (cat. 61) on horseback; Cockburn's white mare was trailed by her foal. A few blocks from the Capitol, shots rang out from the house of Treasury Secretary Albert Gallatin (cat. 86), killing Ross's horse from under him. (Gallatin was in Europe at the time.) This was the only hostile act the British encountered in the city, and although Ross had ordered that private property be left unharmed, the house was immediately set alight. Entering the unguarded Capitol, the soldiers were struck by their surroundings, not expecting the grandeur of the soaring ceilings and intricate marble carvings, including the immense stone eagle, with a wingspan of twelve feet, hanging in the House chamber. A junior officer expressed horror at the order to burn the "elegant Houses of Parliament." With curtains and furniture fueling massive bonfires, by ten o'clock the product of years of work overseen by Benjamin Latrobe (cat. 90) was fully in flames. In the time before electricity, residents were most struck by the brightness that engulfed the city that night as the Capitol, President's House, Treasury, and Navy Yard burned. "You never saw a drawing room so brilliantly lighted as the whole city was that night," one witness remembered. "Few thought of going to bed—they spent the night in gazing on the fires and lamenting the disgrace of the city."

RLP

Taken in President's room in the
Capitol, at the destruction of that
building by the British, on the
capture of Washington 24th August 1814
by Admiral Cockburn. & by him presented to
his Eldest Brother Sir James Cockburn of Langton Bart
Governor of Bermuda. —

And now, this 24th day of January, 1940,
after 126 years, restored to the
Library of Congress
by
A. S. W. Rosenbach

63

Rects & Expends US for 1810

Rare Book and Special Collections Division, Library of Congress, Washington, D.C.

The burning of the Capitol building also meant the loss of the nearly 3,000 volumes in the Library of Congress as well as most congressional papers. Luckily, many of the government's most important papers, such as the Constitution and the Declaration of Independence, had been spirited out of the city at the last minute. As a naval commander, Rear Admiral Sir George Cockburn (cat. 61) was not in command of the invading forces and was largely along for pleasure, eager to collect souvenirs. On entering the Capitol, he sought out the office used by the president, and from the desk he selected this green leather volume stamped "President of the U. States"—Madison's personal copy of *Rects & Expends US for 1810*, a government receipt book. Cockburn took the book as a souvenir, writing inside the cover, "Taken in President's room in the Capitol, at the destruction of that building by the British, on the Capture of Washington 24th August 1814." Cockburn later gave the book to his brother, and in 1940 it was returned to the Library of Congress, which was reborn less than a year after the fire, when Congress purchased Thomas Jefferson's personal library.

RLP

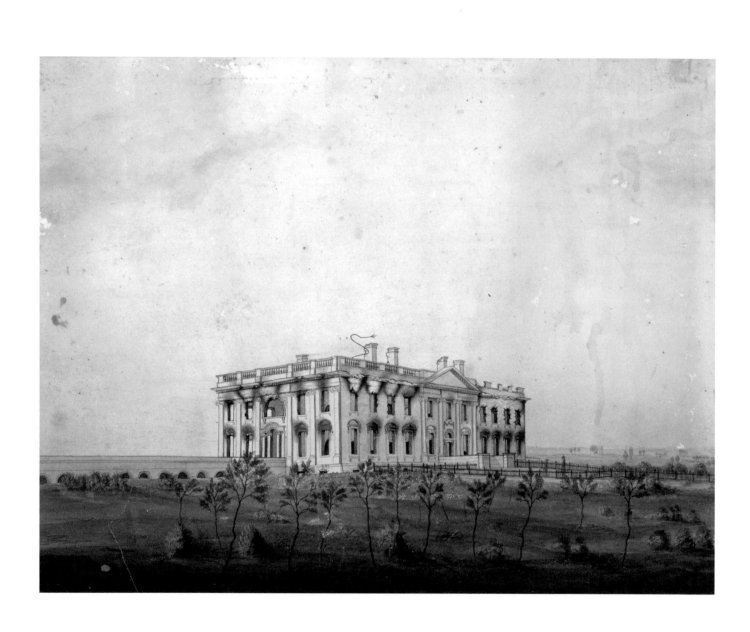

64

The President's House

George Munger (1781–1825)
Watercolor on paper,
30.2 × 39.8 cm (11⅞ × 15¹¹⁄₁₆ in.) sight, c. 1814
White House Historical Association (White House
Collection), Washington, D.C.

It was midnight on the evening of August 24, 1814, by the time the British arrived at the President's House, where they were met by a surprise: an elegant and elaborate dinner laid out as if for their arrival. One of the Madisons' servants, known as French John, had put forward a scheme to "spike the cannon at the gate and to lay a train of powder which would blow up the British should they enter the house." Dolley Madison (cat. 35) objected, saying that "all the advantages in war may not be taken." Tired and hungry after days of marching and the recent battle, Major General Robert Ross (cat. 58) reported that the dinner "intended for *Jonathan* was voraciously devoured by *John Bull*." Every account praised the quality of the president's excellent wine, used to toast the health of the Prince Regent. Spreading out through the house, the British helped themselves to souvenirs, some changing into clean clothes found in the bedrooms. They also claimed a portrait of Dolley to "exhibit her in London" before they set the house on fire. An aide to General Ross remembered, "I shall never forget the destructive majesty of the flames as the torches were applied to the beds, curtains, etc. Our sailors were artists at work." The Treasury Building next door soon joined the flames, completing the night's work for the British.

RLP

65

Dolley Madison's Red Velvet Dress, c. 1810–20

Greensboro Historical Museum, North Carolina

If Dolley Madison—or the War of 1812 for that matter—is remembered for one thing, it is the saving of Gilbert Stuart's portrait of George Washington from the White House. Despite the warnings of her husband and others, Dolley stayed in the Executive Mansion until the last moment, saving what she could of public property and leaving her own belongings to burn. Although stories vary about how the portrait was saved, all seem to agree it was Dolley's initiative. When the Madisons moved into the White House in 1809, James enlisted Benjamin Latrobe (cat. 90) to work with Dolley to carry out a massive redecoration of the state rooms for her grand entertaining. Ever the perfectionist, Latrobe had furniture custom built and used all the best materials, except in one case, where he was unable to acquire his desired cloth for the Oval Drawing Room curtains. Although Latrobe complained to Dolley of "The curtains! Oh the terrible velvet curtains," their effect was apparently striking, as guests often noted the "superb red silk velvet curtains." After the destruction of the White House in 1814, Dolley wrote to Latrobe's wife, Mary, describing the events: "Two hours before the enemy entered the city . . . I sent out the silver (nearly all) and velvet curtains and General Washington's picture." This documentation that the curtains were saved from the flames has led to the belief that this red velvet dress was later made from the material. Despite Dolley's poverty and debts later in life, this dress obviously held sentimental value, as she kept it until her death. Regardless of its origins, the gown characterizes Dolley as a daring and stunning fashion icon. As one admirer wrote, "Tis here the woman who adorns the dress, and not the dress that beautifies the woman."

RLP

The E.C.Perry Photograph Co.
S BROAD ST. PERMANENT PHILADELPHIA, PA.
473 PENN AVE. PHOTOGRAPHS WASHINGTON, D.C.

66

Paul Jennings, 1799–1874

The E. C. Perry Photograph Co. (active dates unknown)
Photograph, 1870s, after an 1850s photograph
Sylvia Jennings Alexander
[Object represented by a reproduction in exhibition]

A remarkable witness to the lives and events of his time, Paul Jennings recorded his memories in an 1865 memoir, *A Colored Man's Reminiscences of James Madison*. Seen here in the only known image of him, Jennings was born a slave at Montpelier and traveled to the capital with James and Dolley Madison as a teenager. He described Washington at the time as "always in an awful condition from either mud or dust. The city was a dreary place." When the British marched on Washington, Jennings stayed at the White House even after the Madisons had left and described a scene of confusion and looting by local residents. He also includes in his account the saving of George Washington's portrait, although he claims Dolley had already left by the time it was taken down. Jennings served as James Madison's "body servant," writing, "I was always with Mr. Madison till he died, and shaved him every other day for sixteen years." After Madison's death in 1836, Dolley returned to Washington and, despite the wishes of her husband, sold Jennings because of financial difficulties. Jennings had been attempting to buy his freedom and had already paid Dolley $200. Soon after, Senator Daniel Webster purchased Jennings and allowed him to work off his debt in exchange for his freedom. Near the end of her life, Dolley Madison was living in poverty, and Jennings gave her money, "though I had years before bought my freedom of her." Jennings was successful as a freedman: he held a job at the pension office, owned his own land, and is said to have participated in the *Pearl* incident, a failed attempt in 1848 to free twenty-six slaves. In 2009 his descendants gathered at the White House for the first time to view the portrait their ancestor had labored beneath.

RLP

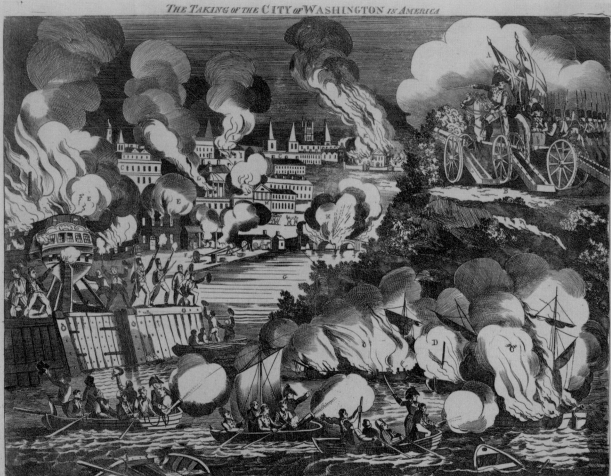

THE TAKING OF THE CITY OF WASHINGTON IN AMERICA

67

The Taking of the City of Washington in America

Unidentified artist
Wood engraving, 43 × 52.7 cm (16⅞ × 20¾ in.), 1814
Prints and Photographs Division, Library of Congress,
Washington, D.C.

Residents of Baltimore, only forty-five miles north of Washington but isolated from news of the British attack, watched in fear of the unknown. Wrote one witness, "We only know from the light during the night that the city was on fire." One of the fires that lit the night sky over Washington was not set by the British but was ordered by Thomas Tingey, commandant of the Navy Yard. Navy clerk Mordecai Booth had the task of insuring that the orders were carried out, including setting fire to the new frigate *Columbia* and sloop of war *Argus,* which were still sitting on their stocks. The British had already entered the city by the time the Americans—waiting until the last possible moment—set the Navy Yard on fire and quickly escaped across the Potomac. Looters soon descended, locals who took advantage of the power vacuum to raid the commandant's house and other private residences in the area. In contrast, when a British soldier was caught looting private homes near the White House, he was shot by his own officers. The destruction of public buildings across Washington continued on the next day but was cut short by a sudden storm that swept across the city, putting out fires yet also inflicting tremendous wind damage. Just after nightfall Major General Robert Ross (cat. 58) ordered the British army to withdraw from the city, which they did so stealthily that by morning most residents were not aware they were gone.

RLP

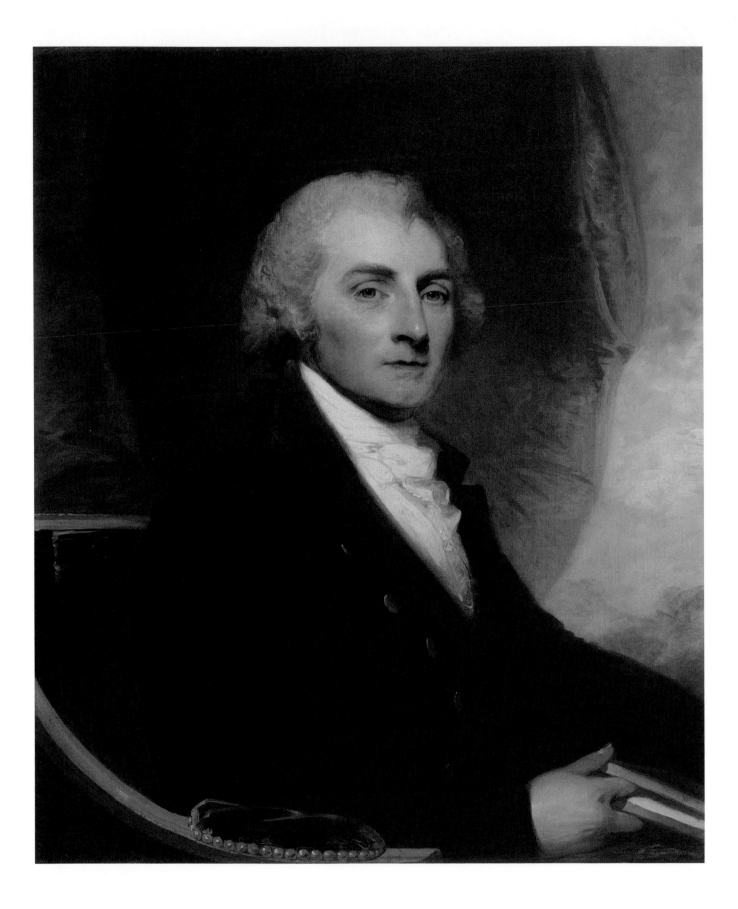

68

William Thornton, 1759–1828

Gilbert Stuart (1755–1828)
Oil on canvas, 73.2 × 61.9 cm (28¹³⁄₁₆ × 24⅜ in.), 1804
National Gallery of Art, Washington, D.C.; Andrew W.
Mellon Collection (1942.8.25)

Whereas Dolley Madison is remembered for rescuing George Washington's portrait from the White House during the burning of the city, William Thornton participated in a more confrontational act of heroism. Thornton was a man of many interests and talents: a doctor, an inventor, the architect of the Capitol building and the Octagon House, and the superintendent of patents. Housed along with the post office in a building at Seventh and F streets, NW, designed by James Hoban, the Patent Office contained the records of the roughly 2,000 patents issued up until that time as well as models of the proposed inventions. When the British entered the city, Thornton and his wife Anna Maria (cat. 36) took refuge at Tudor Place in Georgetown, and from this commanding view the couple "witnessed the conflagration of our poor undefended and devoted city," including the Capitol Thornton had designed. On the morning of August 25, 1814, Thornton heard that the British were marching on all public buildings, including the Patent Office. In a desperate attempt to save the patent models, records, and drawings housed inside, Thornton raced to the scene and pleaded his case to the British soldiers. He compared the building's destruction to that of the library at Alexandria, Egypt, and noted that the models were private, not public, property. Holding true to their defense of private property, the British relented. Ironically, Thornton's success in saving the Patent Office later brought him under suspicion, and he had to defend himself against accusations of dishonorable conduct in his negotiations with the British officers. Thornton continued to serve as superintendent of patents until his death. He did not live to see the Patent Office burn to the ground in 1836, destroying all of the records and models inside.

RLP

69 John Armstrong, 1758–1843

Attributed to John Wesley Jarvis (1781–1840)
Oil on wood, 76.2 × 61 cm (30 × 24 in.), c. 1812
National Portrait Gallery, Smithsonian Institution,
Washington, D.C.

Much of the blame for Washington's lack of defense fell rightly on the shoulders of Secretary of War John Armstrong. Armstrong's reckless dismissal of any British attack on the capital revealed his own views of the new city as a backwater. "They certainly will not come here!" he insisted to the head of the District militia. "What the devil will they do here? No! No! Baltimore is the place, Sir. That is of so much more consequence." Although a Revolutionary War veteran, diplomat, and U.S. senator, Armstrong was not well liked. Despite his experience and connections, he suffered from the reputation of "indolence and intrigue." It was said that his "nature and habits forbid him to speak well of any man." Armstrong's handling of the war so incensed William Henry Harrison (cat. 23), the hero of Tippecanoe and the Thames, that he resigned his commission in the army. In the days after the burning, Armstrong stubbornly refused to accept any responsibility for the outcome. When militia officers made it clear that they would rather resign than serve under him, Armstrong had a surprising confrontation with the "great little Madison," who rebuked the secretary for the city's demise. The secretary retired to Baltimore and then resigned, indignant. In a letter to the *Baltimore Patriot,* he lashed out at his attackers for turning the president against him, placing the blame for Washington's capture on the militia at Bladensburg. "It is obvious," Armstrong wrote, "that if all the troops assembled at Bladensburg had been faithful to themselves and to their country, the enemy would have been beaten and the capital saved."

RLP

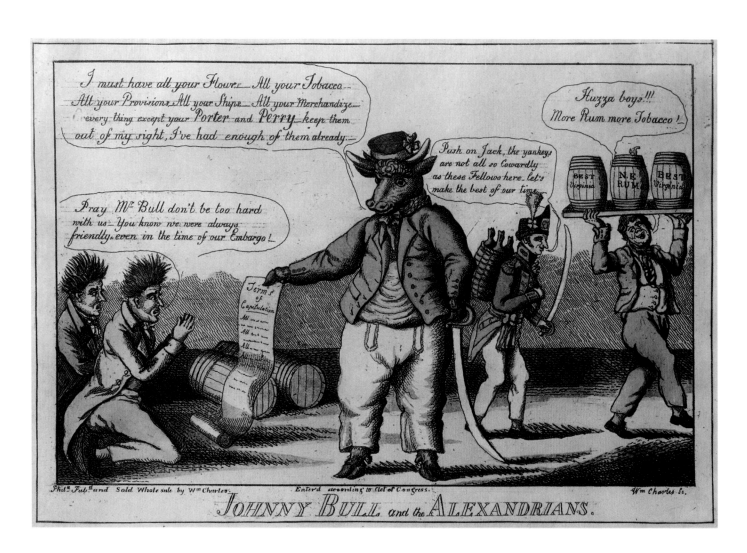

JOHNNY BULL and the ALEXANDRIANS.

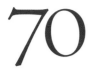

70 *Johnny Bull and the Alexandrians*

William Charles (1776–1820)
Colored etching, 24.1 × 33 cm (9½ × 13 in.), 1814
James M. Goode

While the British were burning Washington, a naval support force under Captain James Gordon sailed up the Potomac River. The ships met with resistance but reached Alexandria, an affluent Federalist port city one hundred miles upriver. The population numbered 7,227, including 1,488 slaves. The Alexandria militia had crossed the Potomac to aid in the defense of the capital, leaving the city helpless. For two years, the city had petitioned the Madison administration for help, to no avail. On August 28, 1814—with the Washington Navy Yard burning in sight across the Potomac—Mayor Charles Simms of Alexandria and a small party rowed under a flag of truce to meet the British squadron. The Alexandrians met with Gordon, reminding the captain of the British respect for private property in Washington, and of their Federalist, antiwar sympathies. Gordon, resenting such a lecture, angrily responded that he did not "want any prompting to do what is right." He stated that although he would not touch private homes and retail shops, he would seize nearby warehouses and vessels and that the Alexandrians would not be harmed as long as they cooperated fully. Seven British ships anchored off Alexandria, their guns pointing at the city. Gordon sent his conditions, giving the city one hour to respond. The town quickly surrendered, pleading it had acted "from the impulse of irresistible necessity and solely from a regard to the welfare of the town." For six days, the British plundered the docked vessels and warehouses along the riverbank.

William Charles's cartoon showing supine Alexandrians and the British plundering tobacco and rum expressed the shame and anger that many Americans felt. Dolley Madison commented to friends that the townspeople should have let their town be burned rather than to submit to Britain's humiliating terms.

SH

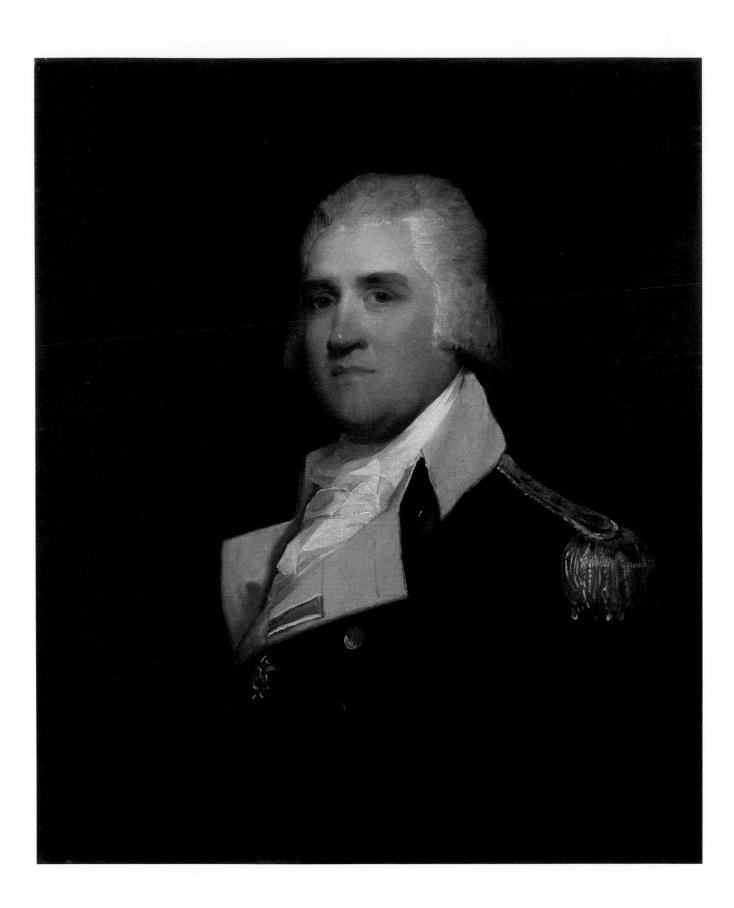

71 Samuel Smith, 1752–1839

Gilbert Stuart (1755–1828)
Oil on canvas, 72.4 × 58.4 cm (28½ × 23 in.), c. 1800
National Portrait Gallery, Smithsonian Institution,
Washington, D.C.; gift of Dr. and Mrs. B. Noland Carter
in memory of the Misses Mary Coles Carter and
Sally Randolph Carter

Samuel Smith was born into a wealthy mercantile family in Carlisle,
Pennsylvania, which relocated to Baltimore in 1760. Smith apprenticed
with his father's firm and spent several years abroad. He returned home
at the onset of the American Revolution, received a captain's commission,
distinguished himself in battle, and was promoted to lieutenant colonel.
In the 1780s and 1790s Smith had a successful mercantile and political
career. He won a seat in the Maryland House of Delegates and then the
U.S. Congress. In the 1790s, he broke with the Federalist Party, formed an
alliance with the new Jeffersonian party, and, using his mercantile and militia
connections, built a strong political machine in Maryland. Smith successfully
ran for the Senate in 1803, where he became a strong supporter of President
Jefferson. He became disillusioned with the president following the passage
of the Embargo Act, concluding that administration policy favored agrarian
interests. During Madison's presidency, Smith led a faction of Democratic-
Republicans that favored a strong navy and opposed the administration's
policies of commercial restrictions. When war was declared against Britain in
1812, Smith became commander of the Third Division of Maryland's militia.
He was present at the disastrous Battle of Bladensburg (August 1814) and
oversaw an orderly retreat of his command. To his lasting credit, Smith then
organized Baltimore's defenses against the expected British naval and land
attack. On September 11, 1814, Smith ordered militia troops under the
command of General John Stricker to block the British approach from North
Point. Although the militia was forced to retreat, the British suffered heavy
casualties, including Major General Robert Ross (cat. 58). The militia's
brave stand, followed by the failure of the attack on Fort McHenry, ended the
Chesapeake campaign by the British and made Smith a national hero.

SH

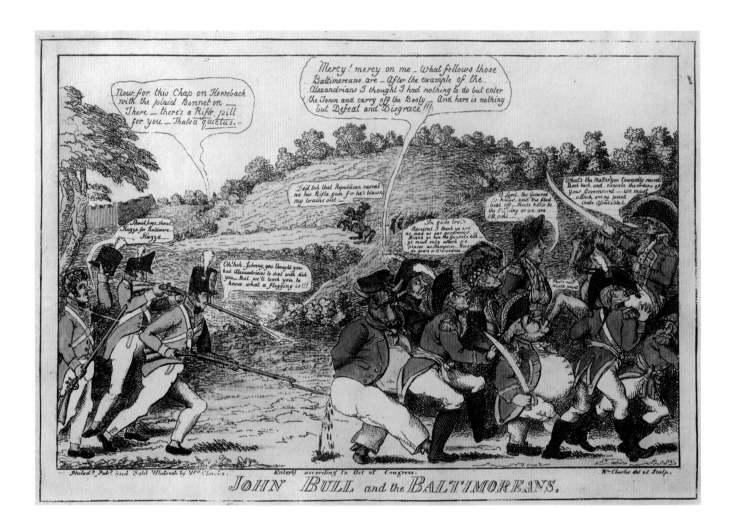

72 *John Bull and the Baltimoreans*

William Charles (1776–1820)
Colored etching, 24.1 × 33 cm (9½ × 13 in.), 1814
James M. Goode

During the second week of September 1814, the British followed up their raid on Washington with an attack on Baltimore, a prowar city with a busy commercial port that served as a base for American privateers. Unlike Washington, Baltimore had a well-organized militia of between 10,000 and 15,000 men and had every available citizen building earthworks. On September 12, Major General Robert Ross (cat. 58) landed with 4,500 men at North Point and began the fourteen-mile march to Baltimore. British naval ships prepared to bombard Fort McHenry. General John Stricker and 3,200 Baltimore militia met the British army about seven miles from the city. After an intense battle, the Baltimoreans retreated, but they had exacted a high cost from the British (340 casualties to 215 for the Americans). Especially devastating for the British was the loss of Ross. On approaching Baltimore, viewing the city's sturdy defenses, and realizing they did not have the expected naval support, they retreated on the morning of September 14.

In this cartoon, William Charles compares Baltimore's defense with the capitulation in Alexandria. An American soldier prodding John Bull exclaims, "Oh! Hoh!—Johnny you thought you had Alexandrians to deal with you— But we'll teach you to know what a flogging is!!!" John Bull cries: "Mercy! mercy on me—What fellows those Baltimoreans are." The small image of a British mounted officer is the mortally wounded Ross, who cries out, "Devil take the Republican rascal and his Rifle gun for he's blown my brains out." The mounted officer on the right, assuming command, urges the British on: "What's the Matter! You Cowardly rascals! . . . execute the orders of your Government."

SH

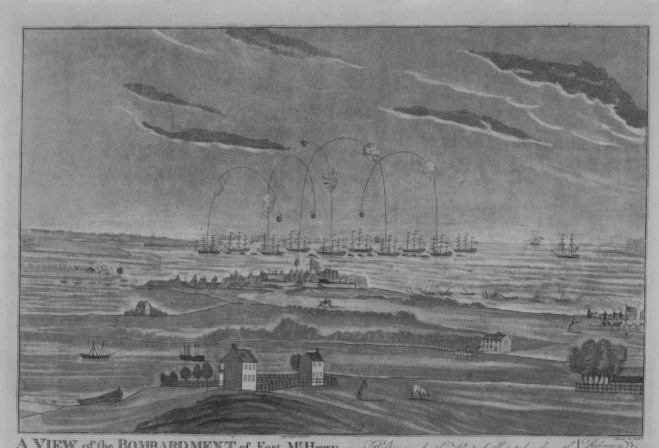

A VIEW of the BOMBARDMENT of Fort McHenry, *near Baltimore, by the British fleet, taken from the Observatory under the Command of Admirals Cochrane & Cockburn, on the morning of the 13th of Sepr 1814 which lasted 24 hours, & thrown from 1500 to 1800 shells in the Night attempted to land by forcing a passage up the ferry branch but were repulsed with great loss.*

References
A. *Fort McHenry*
B. *Lazaretto*
C. *Patapsco River*
D. *Admiral Ships & Shell Boats*
E. *Ferry and Fort*

73 *A View of the Bombardment of Fort McHenry*

John Bower (active 1810–19)
Hand-colored aquatint,
35.6 × 47.6 cm (14 × 18¾ in.), 1814
I. N. Phelps Stokes Collection of American Historical
Prints, Miriam and Ira D. Wallach Division of Art, Prints
and Photographs, The New York Public Library,
New York City; Astor, Lenox and Tilden Foundations

Located on the Northwest Branch of the Patapsco River, Fort McHenry
was built in the late 1790s to protect Baltimore's harbor. During the war of
1812, it was commanded by Major George Armistead and mounted twenty
guns. The British naval attack on Baltimore in September 1814, coordinated
with a land invasion originating from North Point, was led by Vice Admiral
Alexander Cochrane, who personally commanded the squadron of bomb and
rocket ships that threatened Fort McHenry. Cochrane, who was in charge of
the successful raid up the Potomac River in August, did not believe the fort
would give him much trouble. The plan called for him to reduce the fort and
then bring his lighter ships into Baltimore harbor to pound the American
defense lines. Cochrane ordered his ships to anchor at Whetstone Point,
two miles from Fort McHenry, out of range of the U.S. guns. At midday on
September 13, the British warships began to bombard the fort with their
powerful mortars, capable of firing 200-pound shells ("bombs bursting
in air") over 4,000 yards, and Congreve rockets ("the rockets' red glare").
The ships fired more than 1,500 rounds in twenty-four hours, hitting the
fort 400 times but causing minimal damage, killing only four Americans
and wounding twenty-four others. Cochrane tried slipping barges up the
Patapsco to threaten the fort from the rear, but they were driven back by
heavy American fire from the shore. The successful defense of Fort McHenry
secured Baltimore. The rebuff of the British ended their Chesapeake campaign
and was celebrated throughout the nation.

SH

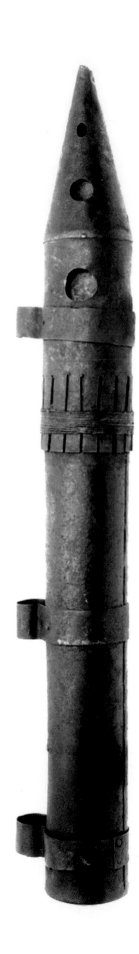

74 Congreve Rocket

Courtesy Smithsonian Institution, National Museum of
American History, Behring Center, Washington, D.C.
[Object represented by a reproduction in exhibition]

Already in use by Great Britain in the Napoleonic Wars, Congreve rockets
made their first appearance in the New World during the War of 1812. The
British Board of Ordnance became interested in rockets after learning of their
effective use in 1792 and 1799 against troops of the East India Company.
The Congreve rocket took its name from its inventor, Lieutenant William
Congreve (1772–1828). He initially developed a six-pound rocket that could
be fired up to 2,000 yards. In 1804 he produced a thirty-two-pound rocket
that was three-and-a-half feet long and four inches in diameter, with a fifteen-
foot stabilizing stick and a maximum range of 3,000 yards. Its warhead had
the explosive power of a ten-inch howitzer round, and great numbers of the
rockets could be fired at one time. The Royal Navy first used Congreve's
larger rocket on October 18, 1806, firing 200 of them into Boulogne Harbor.
A year later 2,500 rockets were fired at Copenhagen, setting the town on fire.
By January 1813, the Congreve rocket had become a staple of the Royal Navy.
Britain first used the rocket in America during its naval attack on Lewes,
Delaware, on April 6, 1813, followed by attacks on several other Atlantic
coast towns. Their first land use was at Lundy's Lane (July 25, 1814);
the stabilizing stick from one wounded U.S. commander Major General
Jacob Brown. The Royal Marines used them a month later at Bladensburg,
Maryland, and on September 13–14 at North Point, southeast of Baltimore.
Most famously, their red glare was immortalized in Francis Scott Key's poem
(cat. 76) about the Fort McHenry bombardment. Although the rockets could
initially frighten troops, they were notoriously inaccurate and—as in the
attack on Baltimore—did little damage.

SH

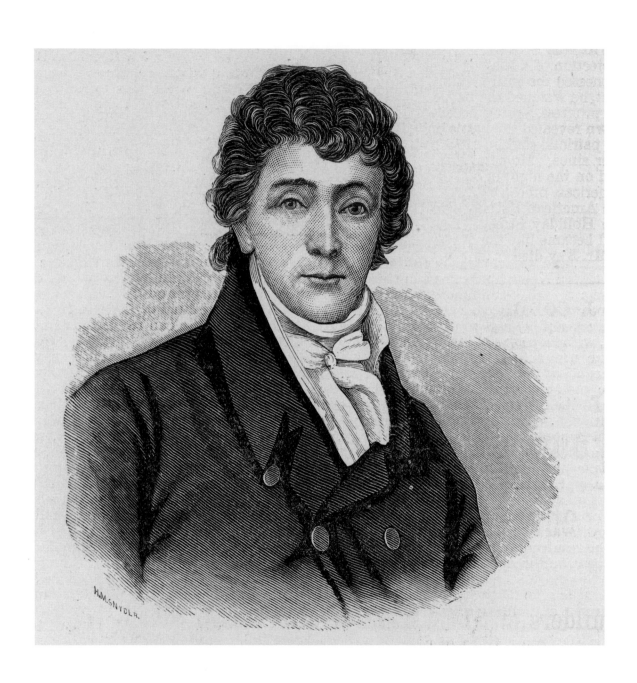

H.M. SNYDER.

75

Francis Scott Key, 1779–1843

Henry M. Snyder (active 1852–1871)
Lithograph, 21.6 × 14 cm (8½ × 5½ in.), not dated
National Portrait Gallery, Smithsonian Institution,
Washington, D.C.

Born in Frederick (now Carroll) County, Maryland, Francis Scott Key
attended St. John's College in Annapolis, studied law after he graduated,
and later moved to Georgetown, Washington, D.C., to begin his practice.
In the fall of 1814, after the British had raided Washington and were
making preparations for an attack on Baltimore, Key, perhaps because he
was a Federalist and was assumed to oppose the war, was asked to negotiate
the release of Maryland physician William Beanes, who was imprisoned
on a British ship. The British agreed to release Beanes but not until the
bombardment was over. Key spent the night on a truce ship with the main
British fleet, eight miles from Fort McHenry. Some have questioned whether
he could have seen the flag during the night by the light of the "rockets'
red glare" or the "bombs bursting," but Key's words imply that it was the
continued British bombardment through the night that "gave proof through
the night that our flag was still there." The published broadside containing
the poem, originally entitled "The Defence of Fort McHenry," explains that
Key "watched the flag at the Fort through the whole day with an anxiety that
can be better felt than described, until the night prevented him from seeing
it. In the night he watched the Bomb Shells, and at early dawn, his eye was
again greeted by the proudly waving flag of his country." According to an
account by one of Key's friends, Key composed the poem on his way to shore
and revised it in his hotel that evening.

SH

O say can you see ~~through~~ by the dawn's early light
What so proudly we hail'd at the twilight's last gleaming,
Whose broad stripes & bright stars through the perilous fight
O'er the ramparts we watch'd, were so gallantly streaming?
And the rocket's red glare, the bomb bursting in air,
Gave proof through the night that our flag was still there,
O say does that star spangled banner yet wave
O'er the land of the free & the home of the brave?

On the shore dimly seen through the mists of the deep,
Where the foe's haughty host in dread silence reposes,
What is that which the breeze, o'er the towering steep,
As it fitfully blows, half conceals, half discloses?
Now it catches the gleam of the morning's first beam,
In full glory reflected now shines in the stream,
'Tis the star-spangled banner — O long may it wave
O'er the land of the free & the home of the brave!

And where is that band who so vauntingly swore,
That the havoc of war & the battle's confusion
A home & a Country should leave us no more?
~~Their blood~~
Their blood has wash'd out their foul footstep's pollution.
No refuge could save the hireling & slave
From the terror of flight or the gloom of the grave,
And the star-spangled banner in triumph doth wave
O'er the land of the free & the home of the brave.

O thus be it ever when freemen shall stand
Between their lov'd home & the war's desolation!
Blest with vict'ry & peace may the heav'n rescued land
Praise the power that hath made & preserv'd us a nation!
Then conquer we must, when our cause it is just,
And this be our motto—"In God is our trust,"
And the star-spangled banner in triumph shall wave
O'er the land of the free & the home of the brave. —

COPYRIGHT 1906 BY J. E. HAROST

76

Original Manuscript of "The Star Spangled Banner," 1814

Photographed by Harris E. Ewing, 1914
Prints & Photographs Division,
Library of Congress, Washington, D.C.
Original manuscript in the collection of the Maryland
Historical Society

On September 13, 1814, Francis Scott Key (cat. 75) spent a restless night on the truce ship *President* while the British bombarded Fort McHenry, eight miles away. The bombardment came to an end at about 4:00 AM on September 14. At 9:00 AM Key, to his great relief, spotted the huge American flag going up over the fort and the British bomb and rocket ships moving downriver. Shortly thereafter, the British released his truce ship. As he sailed into Baltimore harbor, Key began writing a poem about the attack. He spent the night in Baltimore revising the poem. The next morning, Key showed his poem to a relative, Joseph H. Nicholson, who arranged for the poem's publication in the form of a handbill, "The Defence of Fort McHenry," and wrote a fourteen-line introduction explaining how it came to be written. Key's name was not on the poem. The words "Tune—Anacreon in Heaven" are inserted above the poem. Doubtless Key had this well-known English drinking song in mind when he wrote this poem, as he had used it for an earlier poem. The handbill was circulated throughout Baltimore and was picked up by newspapers. Key was soon identified as the author, and the poem began appearing as "The Star-Spangled Banner." The first public singing took place in Baltimore's Holiday Street Theater on October 19, 1814, and thereafter the song gained steadily in popularity. By the end of the nineteenth century it was being sung by the armed forces in their ceremonies. A bill designating "The Star-Spangled Banner" as the national anthem was signed into law by President Herbert Hoover on March 3, 1931.

SH

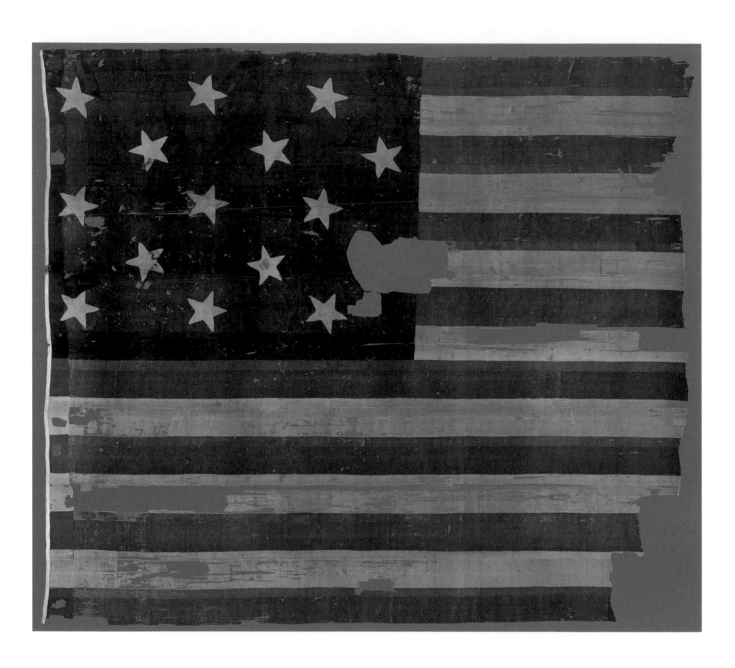

77 The "Star-Spangled Banner" Flag, 1813

Smithsonian Institution, National Museum of American History, Behring Center, Washington, D.C.
[Object represented by a reproduction in exhibition]

Francis Scott Key (cat. 75) spotted the flag that inspired him to write the poem that became America's national anthem over Fort McHenry after its bombardment by the British on the morning of September 14, 1814. A British naval officer wrote that as they sailed away in the early morning hours, the Americans "hoisted a most superb and splendid ensign on their battery." The star-spangled banner was commissioned during the summer of 1813 by the commander of Fort McHenry, Major George Armistead, who desired "to have a flag so large that the British will have no difficulty in seeing it from a distance." Baltimore flagmaker Mary Pickersgill, with the assistance of her entire household, made the flag in six weeks. At 30 × 42 feet, it certainly met Armistead's requirements for size. On the basis of an act of Congress in 1794, it had fifteen stars and fifteen stripes, although by this time there were eighteen states in the Union.

Armistead died of heart disease only three years after the bombardment, possibly aggravated by the stress from the twenty-four hour attack on the fort. The flag remained in his family, shrinking over time as fragments were given away as patriotic mementos. In 1912 Armistead's grandson, Eben Appleton, donated the flag to the Smithsonian Institution. Beginning in 1998 the flag underwent extensive restoration, and today it resides at the National Museum of American History.

RLP

THE BATTLE OF NEW ORLEANS

The Battle of New Orleans was the largest land battle of the War of 1812. It was fought after the peace treaty was signed at Ghent in December 1814 but before the news had reached Washington. As accounts of the victory radiated across the country, Americans reacted with celebrations. For the first time, including the American Revolution, an unaided American army in a major land battle beat Britain's best troops, many of whom were veterans of the Napoleonic Wars. The American army, on the other hand, was an assemblage of regulars, militia, volunteers, refugees from Haiti, freedmen, American slaves, Indians, and pirates, commanded by the brilliant, largely untrained, but fiercely determined Andrew Jackson (cats. 81 and 83), one of the best pure warriors in American history. The casualty figures show that this was one of the most lopsided battles in the war. The British lost 2,000 killed, wounded, or captured; the United States lost only 70. One of the most consequential results of the battle was the emergence of Andrew Jackson as a national hero. His popularity rapidly eclipsed George Washington's, and in many cities January 8 became a holiday equal in importance to July 4—a second day of American independence. Jackson would be the first of three military officers whose service in the war helped propel them into the presidency; the others were William Henry Harrison (cat. 23) and Zachary Taylor (cat. 97). More important, Jackson would both lead and come to symbolize the emerging nation after the war.

SH

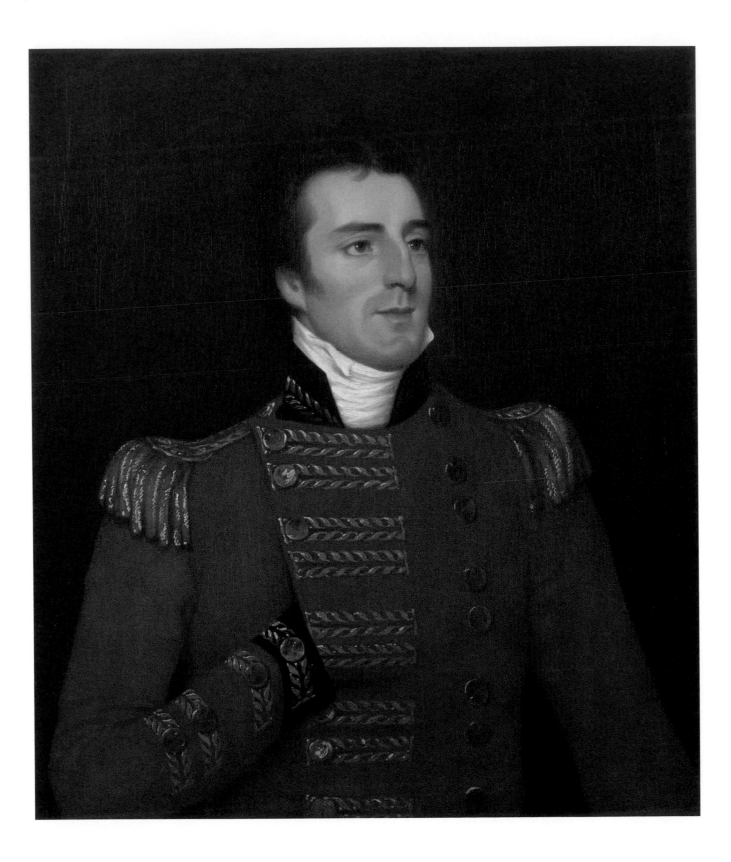

78 Arthur Wellesley, First Duke of Wellington, 1769–1852

Robert Home (1752–1834)
Oil on canvas, 74.9 × 62.2 cm (29½ × 24½ in.), 1804
National Portrait Gallery, London;
transferred from Tate Gallery, 1957

What if Arthur Wellesley, instead of Edward Pakenham (cat. 79), had come to America and faced Andrew Jackson at the Battle of New Orleans? If the Duke of Wellington had come to America, beaten Jackson, and taken the Mississippi River, the British would have likely backed out of the Treaty of Ghent and gone on to victory. Jackson would not have become president. Wellington would not have been at Waterloo to defeat Napoleon. Speculation is interesting but, in the end, pointless. The duke had paid little attention to the war with America, considering it a nuisance that diverted resources from his campaigns against Napoleon. However, with Napoleon's defeat and abdication in April 1814, British ministers turned their attention to the United States and sought to ride Wellington's popularity to victory in North America. The Iron Duke, however, was blunt in his assessment. In light of Oliver Hazard Perry's recent victory on Lake Erie (cat. 51), Wellington wrote, "I have told the Ministers repeatedly that a naval superiority on the lakes is a *sine qua non* of success in war on the frontier of Canada, even if our object should be solely defensive." Although many have claimed that Wellington refused the North American command, as a military officer he was hardly in the position to do so. Rather, he confessed, "I feel no objection to going to America, though I don't promise to myself much success there." Instead, the duke's brother-in-law, Pakenham, was sent, leaving Wellington in Europe after Napoleon escaped from Elba. Henry Clay (cat. 10), who later met Wellington in London, declared he wished the duke had come to America, that "had we beaten the Duke we should have gained immortal honor, whilst we should have lost none had we been defeated by the Conqueror of Napoleon."

RLP

79 Edward Pakenham, 1778–1815

Henry Bryan Ziegler (1798–1874)
Watercolor, 50 × 40 cm (19¹¹⁄₁₆ × 15¾ in.), 1820–60?
Thomas Pakenham

An acquaintance once wrote that "General Pakenham makes me now and then think there are some good men in this world." Although some also considered the thirty-six-year-old arrogant and overconfident, it was Edward Pakenham's sense of honor and duty that led to his death and his army's defeat at New Orleans. He arrived at New Orleans on Christmas Day, 1814, the day after the peace treaty had been signed at Ghent, to find that Vice Admiral Alexander Cochrane had landed the army in a swamp and that they had already been engaged in inconclusive combat two days before. Annoyed, but egged on by Cochrane, Pakenham made a frontal attack on the American line on January 8, 1815. With his army sustaining heavy casualties from the start, Pakenham rode to the front of the line in an effort to rally his fleeing troops, admonishing them to remember that they were British soldiers—the best in the world. Already shot in the arm, the general remounted multiple horses and continued in his efforts to rally the British line. He called for reinforcements moments before being shot again, this time fatally. In a letter to Pakenham's older brother, the Duke of Wellington (cat. 78) wrote, "We have one consolation, that he fell as he lived in the Honourable discharge of his Duty; and distinguished as a soldier and as a man. I cannot but regret however that he was ever employed on such a Service or with such a Colleague [Cochrane]." This watercolor of "Ned" remains with the Pakenham family in Ireland.

RLP

80

Jean Laffite(?), 1780?–1823?

Unidentified artist
Oil on canvas, 83.8 × 69.2 cm (33 × 27.25 in.),
early nineteenth century
Rosenberg Library, Galveston, Texas

A man of legend more than fact, Jean Laffite is remembered as the patriotic pirate who came to Andrew Jackson's rescue at New Orleans and, as a reward, was pardoned for his crimes. In reality, little can be said for certain about him. We do not know when or where he was born or how he died, although theories for each abound. The romanticized image of a mysterious rogue of the sea holds more appeal than the actual man, who was more a smuggler than a pirate and always dressed as a gentleman. At the height of his power, Laffite commanded a force of roughly 1,000 men based in Barataria Bay, near New Orleans. From there Laffite plundered ships in the Gulf of Mexico with no particular national loyalty, although he was thought to be French by birth. In 1814 the British approached Laffite, hoping for an alliance in their attack on New Orleans, offering a bribe of a captain's commission and the equivalent of about $2 million today. Yet for unknown reasons Laffite refused, instead turning over the information to officials in New Orleans and offering his services to Andrew Jackson. Having once called Laffite and his band "hellish banditti," Jackson hesitated, but desperate straits led him to accept Laffite's offer of men and ammunition. Laffite served as Jackson's unofficial aide-de-camp, and although he was not personally involved in the fighting for New Orleans, his men served as experienced artillerymen. Although President Madison pardoned Laffite, he returned to the sea from a new base in Galveston, Texas. He died either in a sea battle against the Spanish in 1823 or peacefully in Illinois in 1851. In 1889 this portrait was found buried in a box near Laffite's last known base in Galveston.

RLP

81

Andrew Jackson, 1767–1845

Cast after Clark Mills (1810–1883)
Zinc, 67.3 cm (26½ in.) height, with mount, 1855
National Portrait Gallery, Smithsonian Institution,
Washington, D.C.; gift of Mr. and Mrs. John L. Sanders in
memory of William Monroe Geer

South Carolina–born Andrew Jackson quit school at age thirteen to fight in
the American Revolution. He was captured by the British in 1781 and left
with scars on his head and fingers when a British officer struck him with
a sword because he refused to clean the officer's boots. During the winter
of 1812–13, Jackson, by then a major general in the Tennessee militia, was
ordered to New Orleans by the governor with his 2,070 volunteers. After
they marched 500 miles to Natchez, orders arrived to disband his army
and return to Nashville. Jackson angrily wrote the governor that they were
"abandoned in a strange country" and said he would not leave 150 of his men
who were sick. When the army doctor asked him what to do with only eleven
wagons, Jackson angrily responded, "To do, sir? You are not to leave a man on
the ground." Jackson had the officers give up their horses. "Not a man, sir,
must be left behind," Jackson declared as he handed over his own horse. "It
shall never be said," he wrote his wife Rachel, that "they have been abandoned
by their general." By the time the army arrived in Nashville, Jackson—as
unyielding as a hickory stick—was known as Old Hickory.

In the fall of 1813, Jackson was ordered to repulse attacks on the southern
frontier by the Creek Indians, who, aided by the Spanish and the British,
were taking advantage of the war to reclaim tribal lands. Jackson crushed
the Creek at the Battle of Horseshoe Bend (March 27, 1814), confiscating
twenty-three million acres of their land. He was a quick study in military
tactics and possessed what one of his biographers characterized as a "demonic
determination to defeat the enemy." He was rewarded by being made a major
general in the U.S. Army.

SH

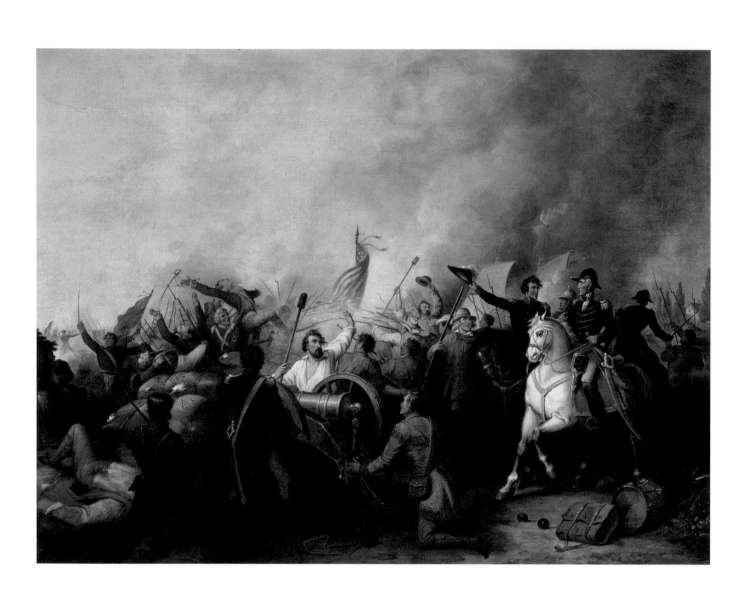

82 *Battle of New Orleans*

Dennis Malone Carter (1818–1881)
Oil on canvas, 46.4 × 62.2 cm (18¼ × 24½ in.), 1856
The Historic New Orleans Collection, Louisiana;
acc. no. 1960.22

Originally intended to take pressure off Canada, the Gulf Coast campaign
became a means for the British to either exert leverage in the peace talks
or annex important real estate that might be kept as a price for peace.
New Orleans's population of 25,000 made it the largest city west of the
Appalachians, and it was a valuable port. When Major General Andrew
Jackson arrived there on December 1, 1814, its citizens were reconciled to
surrender and had done little to prepare against an attack. Almost overnight,
Jackson's energy and determination changed the mood. In response to
Jackson's appeals, men joined his army: 850 Tennessee riflemen marched 135
miles in three days; free blacks, slaves, and refugees from Santo Domingo
enlisted, against objections by the governor of Louisiana and other whites;
even pirates led by Jean Laffite (cat. 80) joined in. The British ships reached
Cat Island, eighty miles from New Orleans, on December 13. The British
commander Edward Pakenham (cat. 79), an experienced and able soldier and
the Duke of Wellington's brother-in-law, arrived with additional troops on
Christmas Day. The Battle of New Orleans took place on January 8, 1815,
with Pakenham's force numbering 5,300 men advancing on Jackson's line,
defended by 4,700 men. When the fog covering the British lifted, the soldiers
were exposed to murderous fire as they advanced: at 500 yards from American
cannons, at 300 yards from American riflemen, and at 100 yards from musket
fire. The British fell back. Pakenham was killed trying to rally his men, and
the British broke off the attack, which had lasted less than an hour. The casualty
count was lopsided: 1,500 for the British and 70 for the United States.

SH

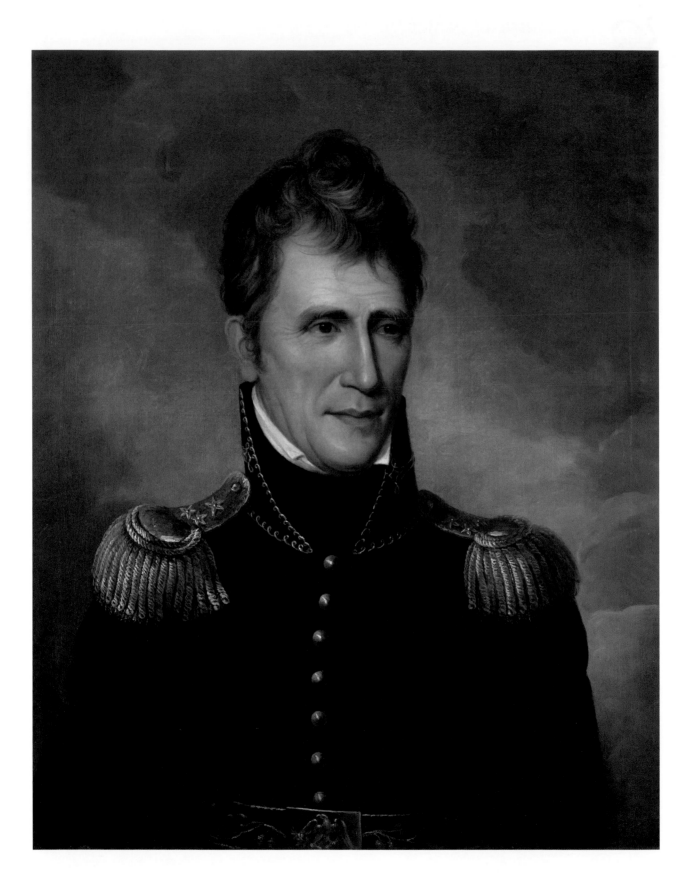

83 *Andrew Jackson, 1767–1845*

Charles Willson Peale (1741–1827)
Oil on canvas, 71.1 × 56.8 cm (28 × 22⅜ in.), 1819
The Masonic Library and Museum of Pennsylvania of the
Grand Lodge F.+ A.M. of Pennsylvania, Philadelphia

In January 1815 news of Andrew Jackson's brilliant victory in the Battle of New Orleans traveled across the country. In a war in which so much had gone wrong for America, the news that Jackson had decisively defeated the British army was cause for celebration. Americans held parades and banquets, and there was a tremendous popular outburst of national pride. Even Thomas Jefferson, who did not like Jackson, attended a celebration in Lynchburg, Virginia, and toasted the hero of New Orleans: "Honor and gratitude to those who have filled the measure of their country's honor."

When Charles Willson Peale painted this portrait in January 1819, Jackson was in Washington to answer questions in a congressional investigation of his military conduct in Florida. The Monroe administration had sent him to deal with the Seminole Indians, who were raiding Alabama and Georgia from Spanish Florida. Believing he had permission from Monroe to pursue the Seminoles into Florida and seize it from Spain, he invaded on March 15, 1818, captured St. Marks and Pensacola, and executed two British subjects he believed were instigating the Indian attacks. Many in the Monroe administration were shocked, believing that Jackson had greatly exceeded his authority.

Charles Willson Peale, seventy-six years old at the time of the sitting, had heard rumors that Jackson might challenge one of his critics to a duel. The artist "felt disposed" to give him a piece of advice. "He was fearful that he might as a military man, seek that abominable & too prevalent custom of settling injuries by duels." Jackson had a bad temper but was gentle with those he liked. He patiently explained to the elderly artist that duels could not be avoided in cases of honor, and he continued to sit for his portrait.

SH

THE TREATY OF GHENT

From almost the moment war was declared, President Madison directed envoys to reach out to Great Britain in an attempt to bring about a peaceful resolution. The tsar of Russia even offered to broker a deal between the two nations, a suggestion the British found insulting. By the time direct negotiations were under way in Ghent in August 1814, it was clear who had the upper hand. The United States had the advantage of having entrusted its future to some of the best minds it had to offer. In contrast, Great Britain, preoccupied with the forthcoming negotiations in Vienna after Napoleon's defeat and abdication, sent second-tier stand-ins who stalled with outrageous demands and were easily outmaneuvered. Negotiations dragged on for months. Meanwhile, across the Atlantic, New England Federalists from three states discussed secession at the Hartford Convention. Some even favored a separate peace with Great Britain. Finally, on the advice of the Duke of Wellington (cat. 78), Lord Castlereagh (cat. 13) directed his commissioners to make a deal. The Treaty of Ghent, signed on Christmas Eve 1814, restored status quo ante bellum between the two nations. Although ignoring the issues that ignited the conflict, the British ended interference with Native tribes and subsequently agreed to more favorable trade agreements between Great Britain and the United States. News of the treaty and Jackson's victory in New Orleans reached Washington at almost exactly the same time, leading many to mistakenly credit New Orleans with producing a favorable peace.

RLP

The Hartford Convention or *LEAP NO LEAP.*

84

The Hartford Convention or Leap No Leap

William Charles (1776–1820)
Etching and aquatint with watercolor,
28.1 × 42.3 cm (11⅛ × 16¹¹⁄₁₆ in.), c. 1814
Prints and Photographs Division, Library of Congress,
Washington, D.C.

On December 15, 1814, twenty-six delegates from Massachusetts, Connecticut, and Rhode Island (and four counties in Vermont and New Hampshire) met in Hartford to address the harm inflicted on New England by the war. New England's congressional delegations had voted unanimously in 1812 against the declaration of war, fearing its economic consequences and viewing it as a Democratic-Republican Party stratagem for dragging the nation into an alliance with Napoleon. Some called for secession. Moderates like George Cabot supported a convention as a means to control events; he commented to a friend that it would "keep you young hot-heads from getting into mischief." By the time of the meeting, the peace talks were going well, and moderates were able to block any move toward secession.

William Charles's cartoon shows Massachusetts pulling Connecticut and Rhode Island to the edge. Massachusetts says, "What a dangerous leap!!! but we must jump Brother Conn." Connecticut answers, "I cannot Brother Mass; let me pray and fast some time longer—little Rhode will jump the first." Rhode Island contends, "Poor little I, what will become of me? this leap is of frightful size—I sink into despondency." Meanwhile, George III calls: "O'tis my Yankey boys! jump in my fine fellows: plenty of molasses and Codfish; plenty of goods to Smuggle; Honours, titles and Nobility into the bargain." On his knees, Massachusetts congressman Timothy Pickering advocates secession: "I, Strongly and most fervently pray for the success of this great leap which will change my vulgar name into that of my Lord of Essex. God save the King." The medallion in the lower left corner contains the names of American war heroes (Perry, Macdonough, Hull, and others), and the ribbon reads, "This is the produce of the land they wish to abandon."

SH

J. Norman Sc.

His Exc.ᵗ CALEB STRONG, Esq.ᵣ LL.D.

Governor and Commander in chief, of the State of Massachusetts.

85

Caleb Strong, 1746/47–1819

John Norman (c. 1748–1817), after James B. Marston
Stipple engraving, 35.5 × 25 cm (14 × 9¹³⁄₁₆ in.), 1812
National Portrait Gallery, Smithsonian Institution,
Washington, D.C.; acquired through the generosity
of Sidney and Barbara Hart

Lawyer and politician Caleb Strong was born in Northampton,
Massachusetts, entered Harvard at age fifteen, and read law with Joseph
Hawley. During the Revolution he served on the Northampton Committee
of Safety and helped draft the Massachusetts Constitution of 1780.
In 1787, Strong was one of four Massachusetts representatives at the
Constitutional Convention, and he helped ensure the Constitution's adoption
and ratification. He served in the Senate from 1789 to 1796, associating
himself with the Federalist policies of the Washington administration. Strong
was elected governor of Massachusetts in 1801, counseling moderation to
those vociferously opposed to president-elect Thomas Jefferson, reminding
his fellow Federalists "that in a republic the majority must prevail." It was
advice he might have taken in 1812 when he returned to the governorship
and opposed the war, refusing to put the state's militia at the disposal of
the federal government. Some evidence suggests that Strong went even
further and may have participated in a plot to separate New England from
the United States and sign a separate peace treaty with Great Britain.
British correspondence indicates that Strong sent an agent to Halifax, Nova
Scotia, in November 1814 to enter into talks "of a very delicate nature"
with Lieutenant Governor Sir John Sherbrooke. The agent could not make
a "precise proposition" until after the Hartford Convention met but could
enter into discussions of a beneficial alliance between the two "countries."
Proposals for constitutional amendments and discussion of state nullification
of unconstitutional federal laws took place during the Hartford Convention,
but talk of secession was blocked by moderates. An American peace treaty
with Britain, signed on Christmas Eve 1814 and ratified on February 16,
1815, ended the war as well as the dispute between New England and the
Madison administration. Strong retired to private life in 1815.

SH

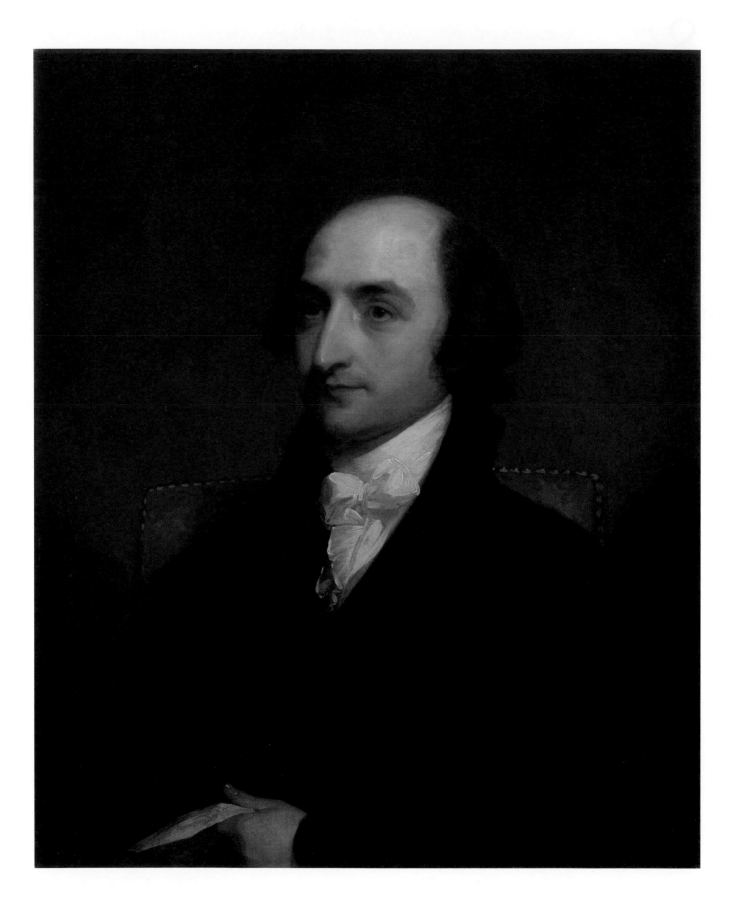

86

Albert Gallatin, 1761–1849

Gilbert Stuart (1755–1828)
Oil on canvas, 74.6 × 63.2 cm (29⅜ × 24⅞ in.), c. 1803
The Metropolitan Museum of Art, New York City; gift of
Frederic W. Stevens, 1908 (08.90)

A Swiss-born immigrant who never lost his French accent, Albert Gallatin
had all the ambition, talent, and success that could have made him
president. Arriving in America in 1780, Gallatin settled in Fayette County,
Pennsylvania, where he quickly became active in state and national politics.
Thomas Jefferson (cat. 4) named him secretary of the treasury in 1801,
and in that position Gallatin oversaw the nation's finances. He served as
secretary for twelve years, the longest tenure ever. In 1813 Gallatin requested
an appointment as a delegate to peace talks that Alexander I of Russia had
offered to mediate. When the British rejected the Russian offer, Gallatin
became part of the U.S. delegation in peace negotiations with Great Britain at
Ghent. He played the calm broker not only with the British but also between
the clashing personalities of his fellow delegates, Henry Clay (cat. 10) and
John Quincy Adams (cat. 87). After a time as minister to France, Gallatin
returned to America, where he served as president of the National Bank of
New York (which later became Gallatin National Bank) and was a founder of
New York University. Although Gallatin is largely forgotten today, a statue
honoring his influence can be seen in front of the Treasury Building on
Pennsylvania Avenue in Washington, D.C.

RLP

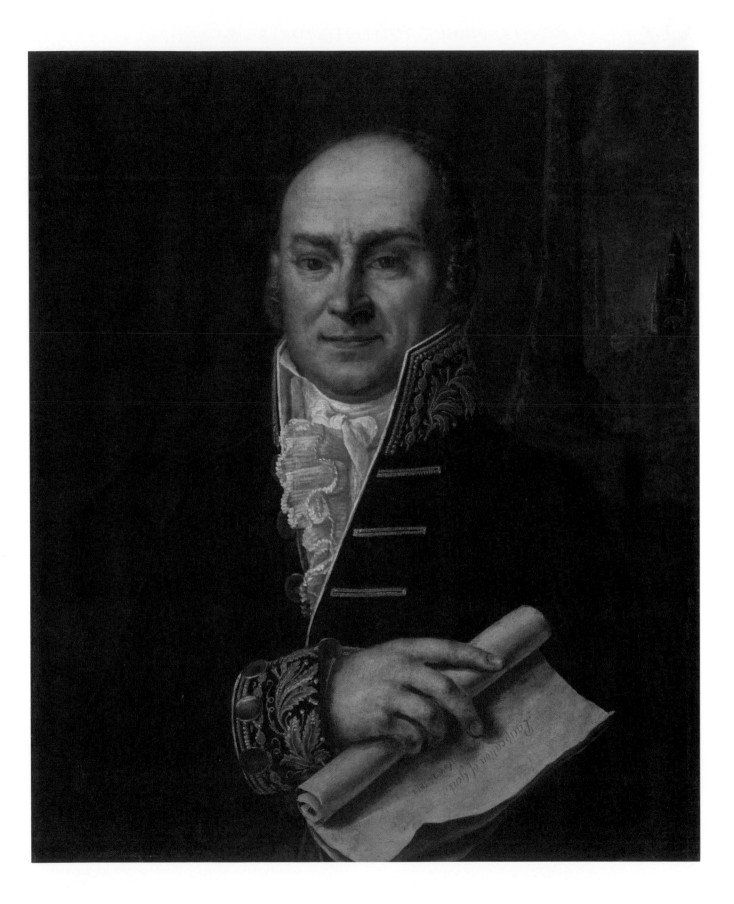

87 *John Quincy Adams, 1767–1848*

Pieter Van Huffel (1769–1844)
Oil on canvas, 61 × 50.8 cm (24 × 20 in.), 1815
National Portrait Gallery, Smithsonian Institution,
Washington, D.C.; gift of Mary Louisa Adams Clement in
memory of her mother, Louisa Catherine Adams Clement

As the son of John Adams, John Quincy Adams was raised partly in Europe and was groomed as a diplomat. By time Adams was twenty-six George Washington appointed him minister to the Netherlands and then Portugal. During his father's presidency, Adams served as minister to Prussia; President James Madison (cats. 9 and 19) appointed him America's first minister to Russia in 1809. Adams was still in Russia when he was appointed to the peace delegation to end the War of 1812 with Great Britain. The five commissioners lived together in Ghent to save money; however, this led to tension and frequent arguments, with Adams complaining constantly about the other commissioners' recreational activities, particularly Henry Clay's card parties lasting until 4:00 AM. **After the treaty was completed, the two men fought again over which of them would take the delegation's official papers back to Washington.** The election of 1824—the first post–Era of Good Feelings election following the War of 1812—pitted "**Johnny Q**," the diplomat, against Andrew Jackson (cats. 81 and 83), the war hero. Jackson won the popular vote. In an ironic twist, however, Adams's old nemesis Henry Clay gave him the majority of electoral votes to win the presidency. When President Adams appointed Clay as secretary of state, Jackson supporters were outraged and accused Clay and Adams of making a "corrupt bargain." Jackson campaigned against Adams for the next four years and ultimately defeated him for the presidency in 1828.

RLP

twenty fourth day of December one
thousand eight hundred and fourteen.

Gambier.

Henry Goulburn.

William Adams

John Quincy Adams.

J. A. Bayard

H. Clay

Jon. Russell

Albert Gallatin

88 Treaty of Ghent, 1814
National Archives, Washington, D.C.

Three British and five American plenipotentiaries took part in the peace negotiations at Ghent, with the Americans arriving in July of 1814. The negotiations were hampered initially by the demands of the British and later by the conflicting goals and personalities of the American commissioners, particularly John Quincy Adams (cat. 87) and Henry Clay (cat. 10). Albert Gallatin (cat. 86) served as the calming presence of the group, whereas the other commissioners, Jonathan Russell and James Bayard, played only minor roles. The first British proposal startled and dismayed the Americans, as it demanded American territory, the unilateral disarmament of the Great Lakes, and the creation of an Indian buffer state to control American expansionism. Such was the frustration experienced by the Americans that Adams is said to have proposed a toast to "Lawrence's last words," a reference to St. Lawrence, who was roasted to death as a martyr and admonished his tormentors, "turn me over, I'm done on this side." It was Clay, the noted gambler of the group, who thought the British were bluffing and might be willing to accept less. Clay's hunch proved correct. On December 24, 1814, the eleven articles of the final treaty established status quo ante bellum, a return to all laws, boundaries, and agreements that stood before the war as well as the exchange of prisoners of war. The impressment of American sailors was not addressed. The tenth article declared the slave trade "irreconcilable with the principles of humanity and Justice" and committed both sides to "promote its entire abolition." News of Jackson's victory at New Orleans on January 8, 1815, arrived in Washington almost simultaneously with the news of the treaty, contributing to the American public's feeling of national victory.

RLP

A Nation Emerges

For a small war that most people in Great Britain quickly forgot, the War of 1812 left Americans with lasting symbols and heroes: Uncle Sam (cat. 100), the Star-Spangled Banner (cat. 77), Old Ironsides (cat. 44), Andrew Jackson (cats. 81 and 83), Winfield Scott (cat. 29), Isaac Hull (cat. 43), and Oliver Hazard Perry (cat. 50). Contemporaries felt a resurgence of nationalism not evident since the winning of American independence. Although this nationalism was short-lived, it resumed in the personification of the greatest hero of the war, Andrew Jackson. Jackson's victory at New Orleans became the single most important manifestation of the nation's nationalism and independence from Great Britain. The war brought economic changes to the nation and accelerated those already under way. Restrictions on American trade gave manufacturing a boost. The number of cotton and flour mills, factory-made woolens, and even the production of gunpowder increased significantly. Perhaps the biggest growth was in transportation: turnpikes, roads, and canals. A second national bank—necessary to deal with the disturbed national finances, currency, and credit after the war—would not have been approved by Presidents Madison or Monroe, who doubted its constitutionality, if not for the war. The war stimulated American expansion. The defeat of the Indians on both frontiers and the removal of the British and Spanish presence opened much of the continent for American settlement and the fur trade, to the Rocky Mountains and south into Georgia, Alabama, and Florida. Noah Webster even gave Americans a dictionary with a vocabulary and spelling distinct from Great Britain's. It is impossible to imagine the same timeline of American growth, expansion, and national feeling if the United States had either not fought Great Britain or lost the war. The War of 1812 was indeed a little war with great consequences for America.

SH

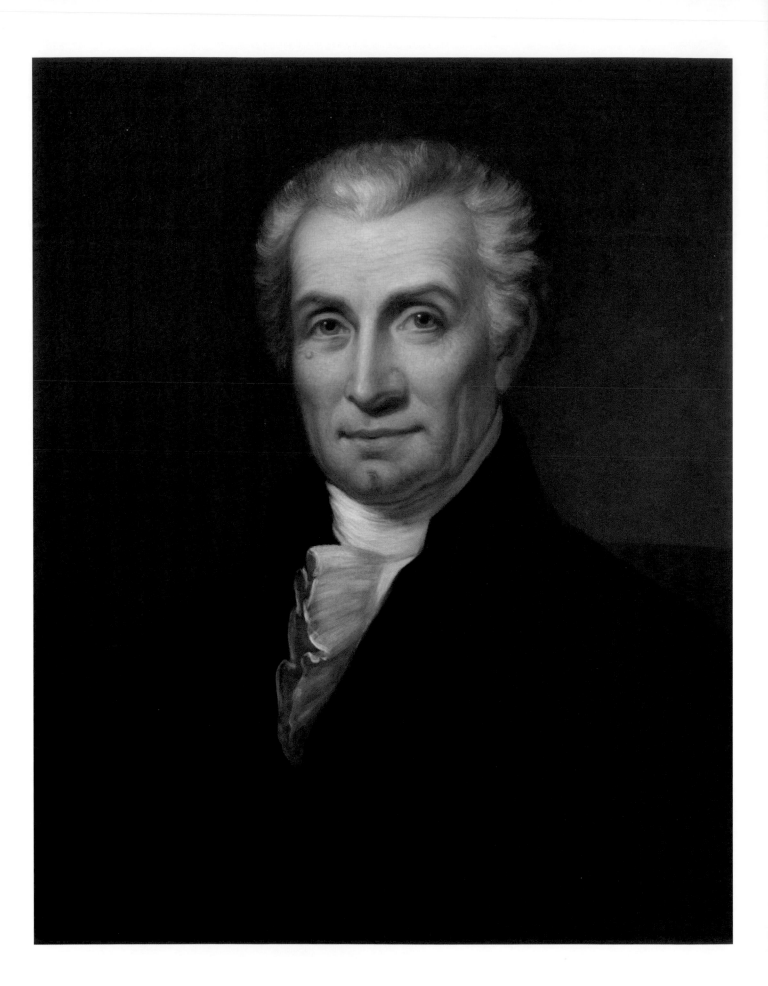

89

James Monroe, 1758–1831

Rembrandt Peale (1778–1860)
Oil on canvas, 73.7 × 60.3 cm (29 × 23¾ in.), 1817–25
James Monroe Museum and Memorial Library,
Fredericksburg, Virginia

When James Monroe was elected president in 1816, the United States "was for a brief while, genuinely at peace with itself." The ending of the War of 1812 left in its wake an Era of Good Feelings, a phrase coined by a Boston newspaperman. Although the Treaty of Ghent (1814) seemingly restored prewar relations between Great Britain and America, in reality, much had changed. The British no longer posed much of a threat on the northern border, and their alliances with the Indians ended. Albert Gallatin (cat. 86), a negotiator at Ghent and a perceptive observer, noted the reinvigoration of "national feelings" that had lessened since the Revolution. "The people," he said, "are more American; they feel and act more like a nation." Both Presidents Madison and Monroe adopted a more nationalistic and expansive tone. Madison's Seventh Annual Message in December 1815 endorsed policies previously labeled Federalist: a national bank, a tariff on manufactures, and internal improvements. In the 1816 presidential election, Monroe received 183 electoral votes to 34 for the Federalist candidate, Rufus King. In a letter to Andrew Jackson on December 16, 1816, Monroe wrote that "the existence of parties is not necessary to free government." This "shimmering illusion" of harmony lasted until the Panic of 1819. Caused by inflation, speculation in western lands, and the collapse of foreign markets, the panic led to a severe credit contraction, business failures, and hardships for debtors and farmers. That same year, however, Spain and the United States signed a treaty in which Spain ceded all claims to Florida and to the Pacific Northwest. A new national excitement was emerging around the figure of Andrew Jackson. The nationalism awakened by the War of 1812 would encounter strong sectional forces but held the republic together until the Civil War.

SH

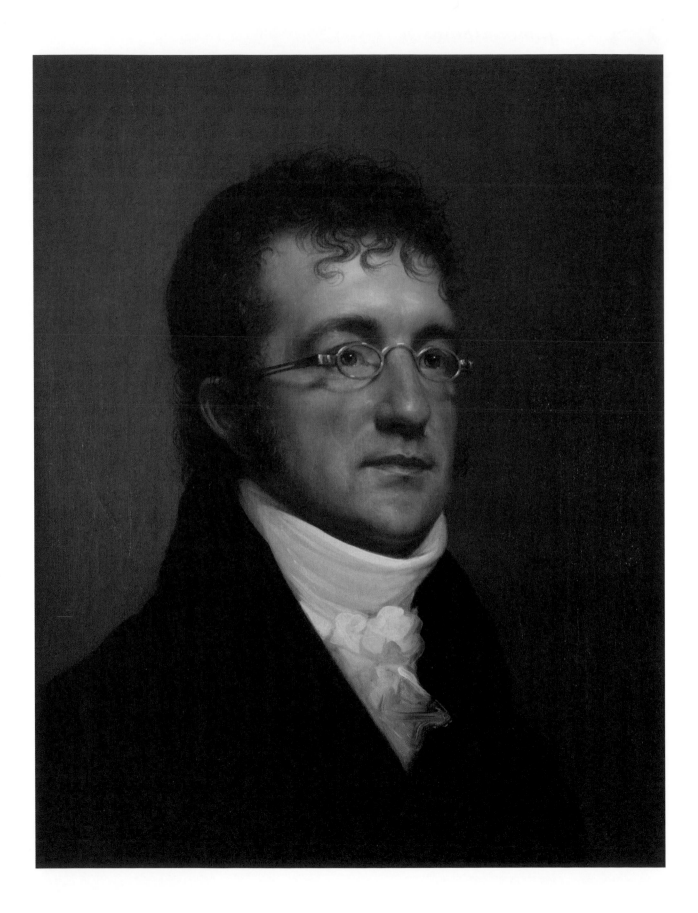

90

Benjamin Henry Latrobe, 1764–1820

Rembrandt Peale (1778–1860)
Oil on canvas, 58.4 × 48.3 cm (23 × 19 in.), c. 1815
Maryland Historical Society, Baltimore; gift of
Mrs. Gamble Latrobe

During his early career, the English-born Benjamin Henry Latrobe was
employed by several leading civil engineers and architects in London. He
immigrated to the United States in 1796, landing in Norfolk, Virginia, and
designed public and private buildings in that area and in Richmond, notably
Fort Nelson and the Virginia State Penitentiary. He relocated to Philadelphia
in 1798, where he created such noteworthy structures as the Bank of
Pennsylvania. He also collaborated with Thomas Jefferson (when the capital
was in Philadelphia) on designs for several federal buildings. In 1802 Latrobe
began his first Washington project, which President Jefferson commissioned:
a covered dry dock for the navy yard. On March 6, 1803, Jefferson made
Latrobe surveyor of public buildings and gave him primary responsibility
for completing the Capitol. Latrobe made several improvements and
modifications to its interiors from 1803 to 1807, including a beautiful
oval room in the House of Representatives lit by 100 skylights, which was
destroyed when the British burned the building on August 24, 1814. On
March 14, 1815, President Madison reappointed Latrobe as architect of the
Capitol. Latrobe redesigned the House chamber in the form of a hemicycle
(today the National Statuary Hall), enlarged the Senate chamber, and
designed a replacement center building. To provide abundant natural light for
the House and Senate chambers, Latrobe placed them under massive cupolas.
In collaboration with Jefferson, he also made significant contributions to
the Capitol's exterior, such as the wide east portico and stairway leading
to the rotunda. The two men also utilized American flora (corn, tobacco
leaf, and magnolia flowers) in their design to express American uniqueness
and separation from Europe. Reconstruction of the Capitol was still under
way when Latrobe resigned on November 20, 1817; some of his plans were
modified by his successor, Charles Bulfinch.

SH

91

The Old Brick Capitol

Unidentified artist
Albumen silver print,
23.5 × 35.6 cm (9¼ × 14 in.), c. 1862
The Albert H. Small/George Washington University
Collection, Washington, D.C.

In the aftermath of the burning of Washington, President Madison called an emergency session of Congress to meet in the Patent Office Building that William Thornton (cat. 68) had saved. With the Capitol building in ruins, the first order of business was to decide whether the seat of government should be removed to Philadelphia or New York (a plan strongly supported by the northerners) instead of incurring the costs to rebuild. Worried about property values and their livelihoods in the new city, prominent Washington citizens quickly promised to provide a building that would house the government until the Capitol could be rebuilt. The debate over moving the capital was fierce, with southern congressmen considering it humiliating to abandon the city. One congressman declared, "I would rather sit under canvas in the city than remove one mile out of it to a palace." Dolley Madison (cat. 35) also supported maintaining the capital in Washington by quickly returning and resuming her social gatherings in temporary presidential quarters at the Octagon House. In the end, the vote was 83 to 74, and Congress soon took up temporary residence in the Brick Capitol. Later the "Old Brick Capitol" served as a boarding house, where John C. Calhoun died in 1850, and then as a prison during the Civil War before being torn down. The site is now occupied by the Supreme Court.

RLP

92 *Pawtucket Bridge and Falls with Slater Mill, Pawtucket, Rhode Island*

Unidentified artist
Watercolor and ink on paper,
38.1 × 49.5 cm (15 × 19.5 in.), c. 1810
Rhode Island Historical Society, Providence (Rhi X5 22)

The measures restricting foreign trade during the Jefferson and Madison administrations and the War of 1812 encouraged manufacturing and internal trade in America. Earlier technological advances—the spinning jenny, carding machine, steam engine, automatic milling machinery, and standardized parts—prepared the way for a huge increase in American manufacturing. In 1805 American cotton mills operated 4,500 spindles; in 1815, they operated 130,000. The value of factory-made woolens went from $4 million in 1810 to $19 million in 1815. In 1816, Thomas Jefferson, once the apostle of an agrarian America, acknowledged that the country must manufacture its own goods and concluded, "We must now place the manufacturer by the side of the agriculturist."

By 1814 there were 243 cotton mills in the United States. Samuel Slater's mills in Pawtucket, Rhode Island, were among the most famous. Slater (1768–1835), born in England, was a factory supervisor in one of Richard Arkwright's water-powered mills before immigrating to America in 1789. He was lured to Rhode Island by newspaper advertisements placed by Moses Brown and William Almy, who were searching for English mechanics familiar with Arkwright's machines. Slater formed a partnership with Brown and Almy and, assisted by skilled American workers, built them machines "similar to those used in England" in return for one-half the net profits and one-half ownership of America's first water-powered cotton mill. In 1798, a second mill was opened in Massachusetts. By 1807, Slater was part of a group that created the first planned factory village in the United States: Slatersville, Rhode Island. Other mills and factories followed, and by 1833 Slater's wealth and fame even attracted the notice of President Andrew Jackson. While touring Old Slater Mill, the president turned and said to the old mechanic, "I understand you taught us how to spin."

SH

93

View of Erie Canal

John William Hill (1812–79)
Watercolor on paper, 24.8 × 35 cm (9¾ × 13¾ in.), 1829
I. N. Phelps Stokes Collection of American Historical
Prints, Miriam and Ira D. Wallach Division of Art, Prints
and Photographs, The New York Public Library,
New York City; Astor, Lenox and Tilden Foundations

Even before independence, Americans dreamed of roads and canals crossing
the barriers of mountains and wilderness, but not until after the War of
1812 did these dreams become reality. Foreign trade restrictions and the
war produced massive increases in internal trade, making evident the need
for a transportation network. The postwar nationalism also reinforced a
desire to connect the new territories to cities and ports. This idealism is
evident in President Madison's annual address to Congress in 1815, in which
he advocated that Congress establish "throughout the country the roads
and canals which can be best executed under national authority," even if it
meant amending the Constitution to give Congress such power. Madison
was supported not only by Henry Clay (cat. 10) from the West but also by
a powerful southern voice in Congress, John C. Calhoun (cat. 11): "Let us,
then, bind the republic together with a perfect system of roads and canals. Let
us conquer space." The rhetoric was not matched by reality on the national
level, but the states engaged in "a nation-wide craze for canal building." Only
about one hundred miles of canals existed in 1815, but there were numerous
plans to build more. The biggest envisioned connecting the Hudson River
at Albany with Lake Erie in Buffalo—364 miles through mostly unsettled
wilderness. New York governor DeWitt Clinton pushed a bill through
the state legislature. The Erie Canal would not only be the longest in the
world but would also encounter engineering problems more difficult than
any previous canal project. Many feared that "Clinton's Big Ditch" would
bankrupt the state. Sections were completed in 1819 and carried heavy traffic
that financed the canal's completion. From its completion in 1825—with
grand pageantry and patriotic oratory—traffic grew and revenues increased.
The transportation revolution in America had begun.

SH

Vig. IV.

Dessiné d'après nat. par Ch. Bodmer. Gravée par E. Willer.

WALD-ANSICHT AM TOBIHANNA. | FORÊT SUR LE TOBIHANNA.

Alleghany-Gebirge. | *Montagnes Alleghany.*

FOREST SCENE ON THE TOBIHANNA; ALLEGHANY MOUNTAINS.

Coblenz bei J.Hölscher. London published by Ackermann & C.º 96. Strand. 1ˢᵗ Jan.ʸ 1839. Paris, Arthus Bertrand, éditeur.

94

Forest Scene on the Tobihanna: Allegheny Mountains

Karl Bodmer (1809–93)
Hand-colored aquatint,
31.1 × 39.4 cm (12¼ × 15½ in.), 1839
Rare Books Division, Special Collections, J. Willard
Marriott Library, University of Utah, Salt Lake City

Notwithstanding the 1783 treaty signed with Great Britain recognizing American independence and granting Americans settlement rights west of the Allegheny Mountains, the nation's access to these lands was limited and embroiled in conflict until after the War of 1812. In the 1783 treaty, the British had agreed to turn over their garrisoned trading posts on the southern shores of the Great Lakes, but a mixture of political and economic motives delayed the transfer. The Indian tribes in the Northwest Territory, who relied on British protection from American settlement, and the Canadian fur traders, who sought to maintain their operations in the territory, successfully lobbied the British government to retain soldiers at the trading posts. Subsequent treaties, Greenville (1795) and Jay (1796), did not resolve the situation, which worsened as British ties with the Indian tribes strengthened under the leadership of Shawnee chief Tecumseh (cat. 27) and his half-brother, Tenskwatawa (cat. 22). In the War of 1812, most Indian tribes in the Northwest Territory fought alongside Britain, and they were an important factor in the battles in that area. After the war, the British severed their connections with their former Indian allies and no longer maintained a presence in the Northwest Territory, freeing the area for white settlement. Without their British protectors, the Indians suffered the loss of their land. A new boundary convention in 1818 extended the border between the United States and British North America from where it had been in 1783, at the Lake of the Woods in Minnesota, to the Rocky Mountains. The British accession to American expansion into the Northwest, followed by Spain's in the South and Southwest, were further indications of the rise of a powerful, emerging nation, one that Thomas Jefferson called an "empire for liberty."

SH

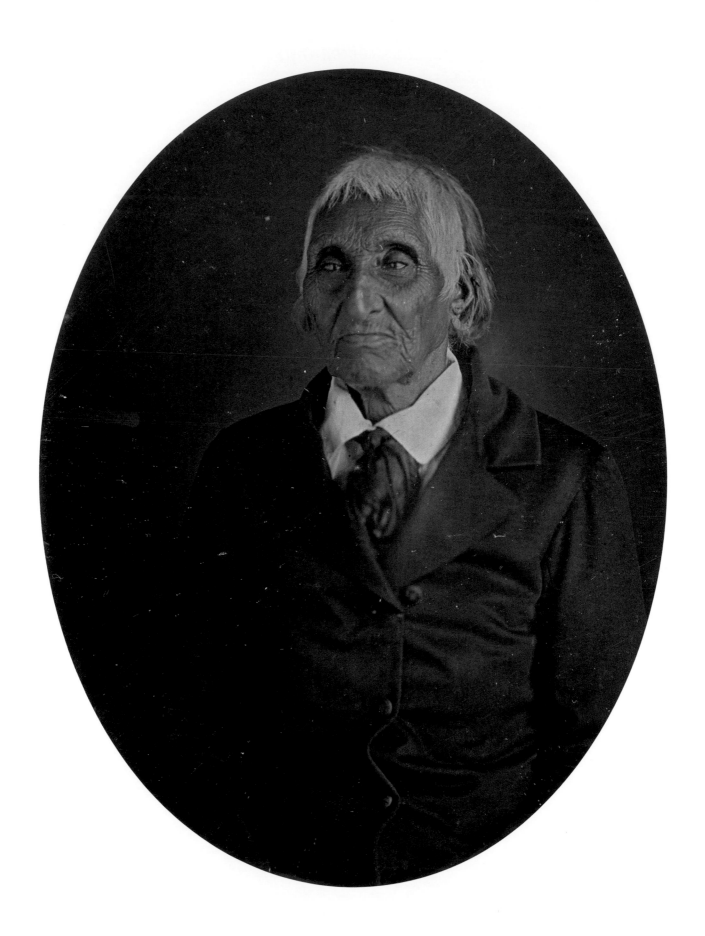

95

Blacksnake (Tha-o-hawyuth), 1753–1859

F. C. Flint (lifedates unknown)
Quarter-plate daguerreotype,
9 × 6.9 cm (3⁹⁄₁₆ × 2¹¹⁄₁₆ in.) sight, c. 1850
National Portrait Gallery, Smithsonian Institution,
Washington, D.C.

Governor Blacksnake, a Seneca/Six Nations chief and the nephew of the important Seneca chief Cornplanter (Kaintwakon), fought against the Americans in the Revolutionary War. When later told, however, that Britain had given his tribe's lands to the United States, he joined with Cornplanter to sign a treaty with America in which the Six Nations Iroquois retained most of their lands in New York. Although British agents continually encouraged the Six Nations to break the treaty, Cornplanter and Blacksnake, negotiating in Philadelphia with the Washington administration, were able to keep the peace. At the onset of the War of 1812, British agents tried to line up Indian allies all along the northern frontier. Although they were successful with many tribes, Cornplanter and Blacksnake enlisted Seneca warriors on the American side and fought in several battles on the Niagara frontier.

Although Seneca soldiers were honorably mustered out, the War of 1812 was a disaster for American Indians. Most sided with the British and depended on them to keep their lands secure. In the ninth article of the Treaty of Ghent, both nations promised to make peace with the Indians and "to restore to such tribes . . . all the possessions, rights, and privileges which they may have enjoyed, or been entitled to." No Indian leaders, however, were present at the negotiations, and the British abandoned their Indian allies. In the South, the Indians suffered a major defeat at Horseshoe Bend, and in the North, their most gifted leader, Tecumseh (cat. 27), was killed at the Battle of the Thames. The war was their last chance to resist an expanding America. The origins of the Indian Removal Act and confiscation of Indian lands in the 1830s under President Andrew Jackson can be traced to Indian defeats in the War of 1812.

SH

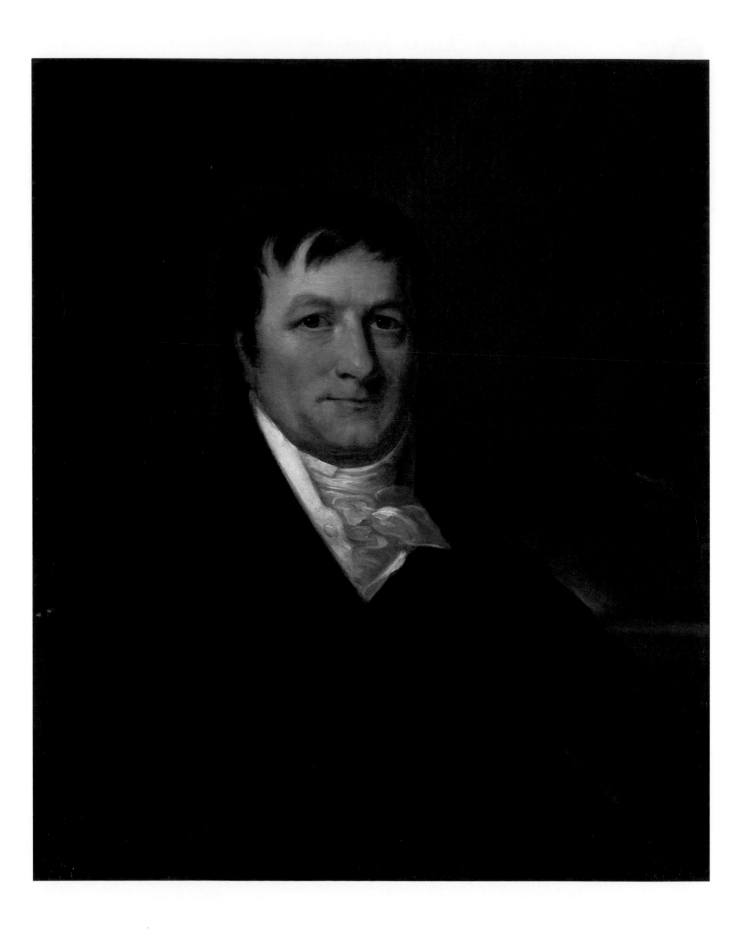

96

John Jacob Astor, 1763–1848

John Wesley Jarvis (1781–1840)
Oil on canvas, 76.2 × 61.6 cm (30 × 24¼ in.), c. 1825
National Portrait Gallery, Smithsonian Institution,
Washington, D.C.; gift of Susan Mary Alsop

Beaver Hat (Chapeau Bras)

Tweedy & Benedict (manufacturers), c. 1820–25
The New-York Historical Society, New York City (1952.325a)
[Not in exhibition]

An early herald of the American dream, John Jacob Astor was a German immigrant who still ranks as one of the wealthiest men in American history. He started out in the fur trade in the Great Lakes region, trading with Indians and French-Canadian trappers and making his fortune on the markup in shipping the furs to Europe. Although Astor also traded in bear, fox, otter, wolf, and seal, the greatest demand was for beaver, which was highly desirable for fashionable hats and coats. In 1811 he sent two expeditions, one by sea and one across country, to Oregon and founded the first American settlement on the Pacific coast, Astoria. The War of 1812 threatened his business, but Astor was politically astute, and in 1814 he successfully lobbied Congress to pass a law that allowed only U.S. citizens to trap on American soil. He was close friends with the Madisons, and sent Madeira to the president and furs to Dolley. After the war, Astor's American Fur Company established a trading post on Mackinac Island, in modern-day Michigan, which became the center of the booming fur trade. Astor also began to buy up real estate in Manhattan, predicting that it would become a major city. Upon his death in 1848 he was the wealthiest man in America.

This beaver hat represents the fashion that made Astor's furs so sought-after. It belonged to Caleb S. Woodhull, who would later be mayor of New York City.

RLP

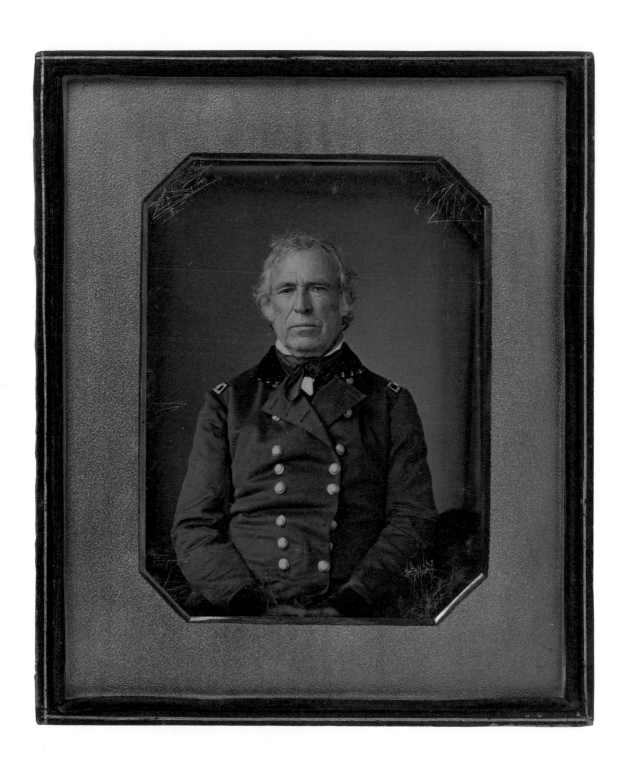

97 *Zachary Taylor, 1784–1850*

Attributed to James Maguire (1816–51)
Half-plate daguerreotype,
12 × 8.8 cm (4¾ × 3⁷⁄₁₆ in.), 1848
National Portrait Gallery, Smithsonian Institution,
Washington, D.C.

The War of 1812 was the first fighting opportunity for a new generation of soldiers and a launching pad for many long military careers. Young Zachary Taylor joined the army in 1808, before the war, and was assigned to western forts. After war was declared, he stayed in the West, fighting off Indian attacks, most notably at Fort Harrison (in present-day Indiana), where his sixteen able-bodied men fended off a large Native force. Although his service was not distinguished, Taylor was steadily promoted, and by the time the Mexican-American War began in 1846, Old Rough and Ready was second in rank only to Winfield Scott (cat. 29). The two had long been rivals: Scott had gained renown during 1812, and although two years younger, he was appointed general-in-chief over Taylor. Taylor's victory over Santa Anna at Buena Vista in 1847 made him a hero, and in the vein of Andrew Jackson after New Orleans, supporters rallied around Taylor as a presidential candidate, despite the fact that he seemed to have no political opinions. Although Scott had been his superior for thirty years, Taylor was swept into the White House, a goal that always eluded Scott. Although a slaveholder, Taylor was determined to fight against sectional interests and declared that as president he would personally lead the army against any secessionist rebellion. Taylor only served as president for sixteen months. He fell ill during the Fourth of July celebration at the yet-unfinished Washington Monument and died five days later.

RLP

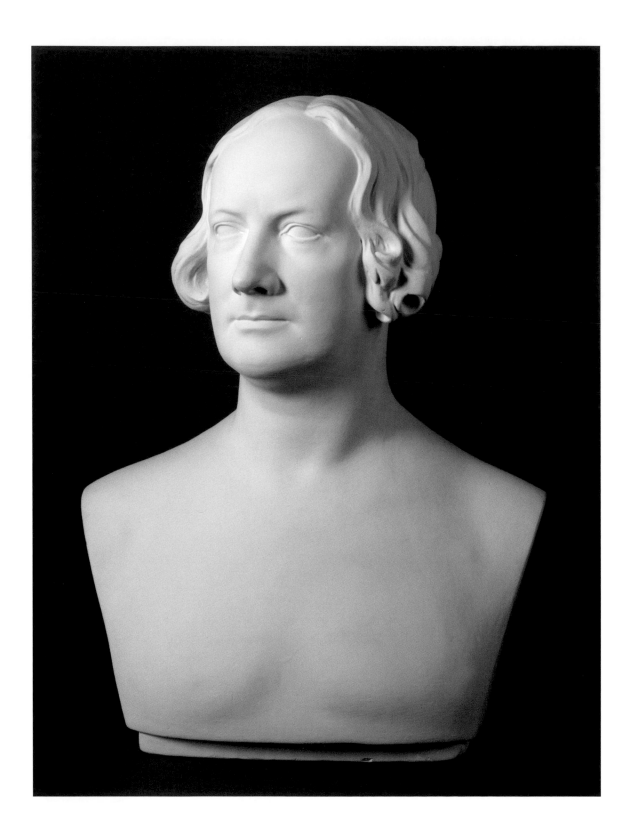

98 Nicholas Biddle, 1786–1844

Luigi Persico (1791–1860)
Plaster, 54.6 cm (21½ in.) height,
1838 cast after 1837 original
National Portrait Gallery, Smithsonian Institution,
Washington, D.C.; gift of Elizabeth Porter Fearing

The embargo and nonintercourse policies preceding the War of 1812 and
government expenditures during the conflict stimulated internal trade and
manufactures, leading to an increase in the number and size of banks in the
United States. In 1800 the nation had twenty-nine banks; in 1816 there were
246. But the war also revealed weaknesses in the nation's financial system.
After Congress refused to recharter the first Bank of the United States in
1811 and failed to provide an adequate national currency, large numbers of
state banks formed to fill the vacuum. The state banks issued notes, leading
to currency inflation. In addition, between March 1812 and March 1815,
Congress authorized the Treasury to borrow $80 million to pay for the
war. The government borrowing and currency expansion produced soaring
inflation. By the fall of 1814, state banks had suspended specie payments
but still issued depreciated currency. Wealthy merchants and bankers, such
as John Jacob Astor (cat. 96) and Stephen Girard, called for a new national
bank. Albert Gallatin (cat. 86) declared that the government must assume
leadership of the nation's finances or be "guilty of a continued breach of faith
towards our creditors, our soldiers, our seamen, our civil officers." Public
credit, private capital, and the value of property, he stated, were all on an
"uncertain basis." All these factors changed President Madison's previous
views opposing a national bank. Henry Clay (cat. 10), who also had opposed
it, was now convinced in "the lights of experience" that Congress had this
"constructive power." A bill chartering a second national bank was signed into
law on April 10, 1816.

Biddle, president of the Second National Bank from 1822 until 1836,
steered the economy through a period of growth and stability until President
Jackson vetoed the extension of the bank's charter.

SH

AN
AMERICAN DICTIONARY
OF THE
ENGLISH LANGUAGE:
INTENDED TO EXHIBIT,

I. The origin, affinities and primary signification of English words, as far as they have been ascertained.
II. The genuine orthography and pronunciation of words, according to general usage, or to just principles of analogy.
III. Accurate and discriminating definitions, with numerous authorities and illustrations.

TO WHICH ARE PREFIXED,

AN INTRODUCTORY DISSERTATION
ON THE
ORIGIN, HISTORY AND CONNECTION OF THE
LANGUAGES OF WESTERN ASIA AND OF EUROPE,
AND A CONCISE GRAMMAR
OF THE
ENGLISH LANGUAGE.

BY NOAH WEBSTER, LL. D.

IN TWO VOLUMES.
VOL. I.

He that wishes to be counted among the benefactors of posterity, must add, by his own toil, to the acquisitions of his ancestors.—*Rambler.*

NEW YORK:
PUBLISHED BY S. CONVERSE.
PRINTED BY HEZEKIAH HOWE—NEW HAVEN.
1828.

99

An American Dictionary of the English Language (New York: S. Converse, 1828)

Rare Book and Special Collections Division, Library of Congress, Washington, D.C.

Noah Webster believed that language was a tool for the development of a national identity and that the standardization of spellings and definitions would help eliminate regionalism. He also argued that public education centered on patriotism, rather than religion, would develop an intellectual nationalism in America. Webster spent more than twenty years researching and writing *An American Dictionary of the English Language*, learning twenty-six languages in his search for the most accurate etymology. However, when the massive first edition came out in 1828, it was not immediately popular. Some Americans still preferred the spelling that was standard in Great Britain. It was Webster who made the key transitions in spelling from the standard English to the Americanized versions we know today, such as switching *re* to *er* in theatre, dropping the *u* from colour and honour, and dropping the double *l* in traveller and the *k* from musick. Among the 70,000 entries were also some uniquely American words that had never before appeared in a dictionary: skunk, opossum, hickory, squash, and chowder. Webster was also an early crusader for copyright laws. He successfully lobbied his cousin Daniel Webster to extend the copyright law from fourteen to twenty-eight years. Today, the direct descendent of Webster's dictionary, *Merriam-Webster's Collegiate Dictionary*, is in its eleventh edition.

RLP

HŎN'EY-WÖRT, *n.* A plant of the genus Cerinthe.

HŎN'IED, *a.* [*Ill.* See *Honeyed.*]

HON'OR, *n.* on'or. [L. *honor, honos*; Fr. *honneur*; Sp. *honor*; Port. *honra*; It. *onore*; Arm. *enor*; Ir. *onoir.*]

1. The esteem due or paid to worth; high estimation.

A prophet is not without *honor*, except in his own country. Matt. xiii.

2. A testimony of esteem; any expression of respect or of high estimation by words or actions; as the *honors* of war; military *honors*; funeral *honors*; civil *honors*.

3. Dignity; exalted rank or place; distinction.

I have given thee riches and *honor*. 1 Kings iii.

Thou art clothed with *honor* and majesty. Ps. civ.

In doing a good thing, there is both *honor* and pleasure. *Franklin.*

4. Reverence; veneration; or any act by which reverence and submission are expressed, as worship paid to the Supreme Being.

5. Reputation; good name; as, his *honor* is unsullied.

6. True nobleness of mind; magnanimity; dignified respect for character, springing from probity, principle or moral rectitude; *a distinguishing trait in the character of good men.*

7. An assumed appearance of nobleness; scorn of meanness, springing from the fear of reproach, without regard to principle; as, shall I violate my trust? Forbid it, *honor.*

8. Any particular virtue much valued; as bravery in men, and chastity in females. *Shak.*

HIEROGLYPHICS of John Bull's overthrow: or A View of the Northern Expedition in Miniature.

DOLL, the Landlady. Split-Foot. Bonapart. John Bull. James War. Tom Patriot. John Adams. John Rogers:

Kill him Bona, kill him, 'tis what we've all after. Drive the business Split-foot, it's an ill wind that blows nobody down.

Doll, we'll win any way. Kill him Bona, I want to smoke him eternally.

Johnny, you old tyrant, I'll keep pace before by Boneks.

You old tyrant, I'll keep pace before by Boneks.

The little Corsican Serjeant, I'll give you a off hat.

Kill him Bona, kill him & I'll take Canada.

Kill him Bona, & I'll pay all damages.

Let me at him Bona, and I'll have him in the ears.

ON GOVERNMENTS.

From the creation of the world, down to the flood, including a term of 1656 years, and for several generations following, there was no civil government among men, which we have any account of, except patriarchal, which consisted in the authority that the head of a family had over his dependants. Consequently about one third part of the world's age ran down without any government, which the other two thirds have made such a buz about.

Nimrod the great grandson of Noah, had more ambition and address than his cotemporaries, by which means he established a supremacy over them. He was a mighty hunter before the Lord. He hunted men and reduced them to his will; and by force and fraud, turned the mild patriarchal governments into a consolidated, energetic monarchy, and fixed his residence at Babylon, several years before a like governanent was founded in Egypt.

On the first introduction of monarchy, the spirit ran with such velocity, that a king was found in almost every village. Joshua destroyed above 30 of them; and Adonibezek cut off the thumbs and great toes of 70 more.

In the midst of this rage for empire...

JOHN BULL in a pet.

I cannot get these impudent Yankees out of my head.——The Guerriere gone! The Macedonian taken! The Java sunk!——The Frolic and Peacock both sent to Davy Jones's locker! It is past all endurance!...

BATTLE OF QUEENSTOWN.

BUFFALO, October 30, 1812.

On Tuesday morning last, just before day light, in conformity to previous arrangements, Colonel Solomon Van Renslaer, aid-de-camp to Gen. Van Renslaer, at the head of 300 volunteer militia, from the 13th regiment, and Col. Chrystie, with 300 regular troops, the whole under the immediate command of Col. Van Renslaer, crossed the river at Lewiston in 13 boats, with the intent to storm the enemy's works on the heights or mountain above Queenston. The militia and regulars moved forward with the great...

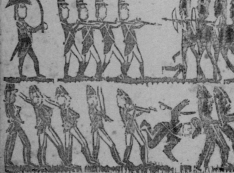

100

Hieroglyphics of John Bull's Overthrow: or A View of the Northern Expedition in Miniature

Lithograph, 51 × 62.9 cm (20 1/16 × 24 3/4 in.), 1812
Prints and Photographs Division, Library of Congress,
Washington, D.C.

The country's most patriotic symbols came out of the War of 1812 and have lasted over time because of the war's heightened nationalistic aims and outcomes. One of the greatest symbols came from Troy, New York, where a man named Samuel Wilson was known as Uncle Sam. Wilson supplied the army with meat packed in barrels stamped "U.S." Somehow, either in jest or by mistake, U.S. came to stand for Uncle Sam instead of United States, which morphed into Uncle Sam as a representation of the government. Soon Uncle Sam replaced Brother Jonathan and Lady Liberty as the American national personification, the rival to the British John Bull. As with any legend, it cannot be conclusively proven that Wilson was the basis for Uncle Sam, but Congress officially recognized the connection in 1961.

Uncle Sam is mentioned for the first time in an 1812 newspaper and appeared not long after in this broadside. "Bonapart" offers his services, "If uncle Sam needs, I'd be glad to assist him," as well as a warning: "But if Uncle Sam lives, they will all be Burgoyn'd," referring to the British general's Revolutionary War defeat. Not until 1832 did an image of Uncle Sam first appear, and cartoonist Thomas Nast perfected the caricature in the late nineteenth century. During World Wars I and II, the recruitment posters "I want you for the U.S. Army" by James Montgomery Flagg gave the most piercing and well-known images of Uncle Sam.

RLP

IOI

Independence Day Celebration in Centre Square

John Lewis Krimmel (1786–1821)
Watercolor and ink on paper,
31.3 × 46 cm (12⁵⁄₁₆ × 18⅛ in.), 1819
Historical Society of Pennsylvania, Philadelphia

"Who would not be an American?" Such was the feeling that swept the nation in the wake of Andrew Jackson's victory at New Orleans (cat. 82) and peace with Great Britain. The symbols and heroes of the War of 1812 did not soon fade, as seen here in a Fourth of July celebration in 1819. America still rested on the laurels of good feelings. Set in Philadelphia's Centre Square, in front of Benjamin Latrobe's Pump House, the watercolor shows two young military officers, one army, one navy, uniting with arms stretched wide in friendship. On one side, a banner venerates the Battle of New Orleans, and on the other the words of Captain James Lawrence (cats. 47 and 48)—"Don't give up the ship!"—are immortalized with a battle scene. So complete was the American sense of victory that even defeats, such as the battle where Lawrence was killed, were remembered in a heroic light. Although the "late war with Great Britain" took decades to fade from the American consciousness, "the American war" vanished almost instantly from the minds of most Britons. In the minds of the British public, the Napoleonic Wars reigned supreme. In 1854 an English writer came across a book on the war and confessed, "I read it carefully, with amazement at my own ignorance. I had scarcely heard of any such war!"

RLP

102 *We Owe Allegiance to No Crown*

John Archibald Woodside (1781–1852)
Oil on canvas,
149.9 × 134.6 cm (59 × 53 in.) framed, c. 1814
Nicholas S. West

Historian Henry Adams, the grandson of John Quincy Adams, reflected on the War of 1812 late in the century: "Many nations have gone to war in pure gayety of heart, but perhaps the United States were the first to force themselves into a war they dreaded, in the hope that the war itself might create the spirit they lacked." Regardless of the truth of this statement, many leaders took note of the new sense of national character that the war seemed to have created. "The war has renewed and reinstated the national feelings and character which the Revolution had given, and which were daily lessened," wrote Albert Gallatin. "The people now have more general objects of attachment with which their pride and political opinions are connected. They are more Americans; they feel and act more as a nation; and I hope that the permanency of the Union is thereby secured." The country now felt secure in its status as an independent nation—after all, Andrew Jackson had humbled the greatest soldiers in the world at the Battle of New Orleans (cat. 82). American commerce and trade, aided by new developments in transportation, fostered prosperity and opened the door to unlimited opportunities. The republican experiment was succeeding, although with a stronger central government than many intended. At the end of the War of 1812, the United States of America was for the first time truly a nation.

RLP

CHRONOLOGY

This is not intended to be a complete chronology but includes major events and individuals featured in the Catalogue section.

ABBREVIATIONS

USS	United States Ship
HMS	His Majesty's Ship
US	United States
GB	Great Britain
FR	France
ON	present-day Ontario
QC	Quebec

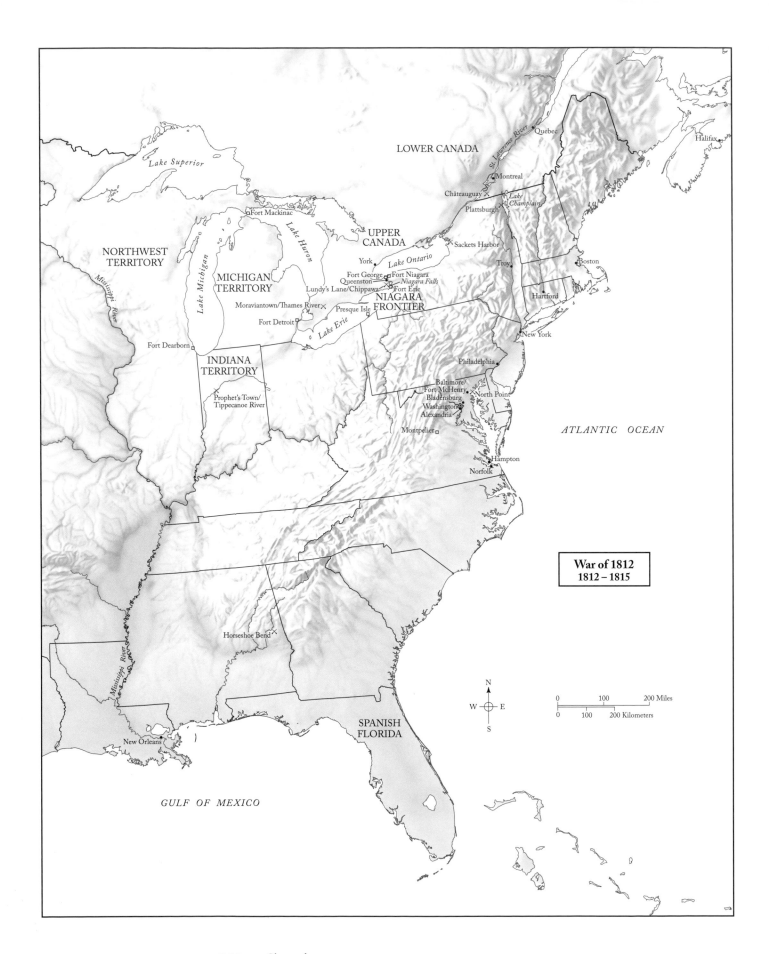

April 26	GB issues Orders in Council blockading ports under FR control
October 4	Spencer Perceval becomes prime minister of GB

1810

March 23	FR issues Rambouillet Decree, sequestering all US ships in FR-controlled ports
May 1	Macon's Bill No. 2 reopens US trade with GB and FR
August 5	FR sends Cadore letter to US, offering to rescind Continental System

1811

March 2	US adopts nonimportation law against GB
March 4	Henry Clay elected Speaker of the US House of Representatives
October 9	Isaac Brock appointed president and administrator of Upper Canada (ON)
October 21	George Prevost appointed captain-general and governor-in-chief of Canada
November 4	War Congress convenes in Washington
November 5	President Madison recommends military preparations
November 7	The Prophet attacks William Henry Harrison's troops in Indiana Territory at Battle of Tippecanoe
December 24	Congress enacts war preparations

1812

May 11	Prime Minister Spencer Perceval assassinated
June 1	President Madison sends war message to Congress
June 1	US House of Representatives adopts war bill
June 16	Lord Castlereagh announces GB's intention to suspend Orders in Council
June 17	US Senate adopts war bill
June 18	President Madison signs war bill into law (War of 1812 begins)
June 18–26	Concurrent with war declaration, US sends out peace feelers to GB

June 19	President Madison issues proclamation of war
June 22	Baltimore riots, Henry Lee injured
June 23	GB repeals Orders in Council
July 2	Connecticut refuses US request to call out militia
July 12	US invades Upper Canada across Detroit River (ON)
July 16–19	Escape of the USS *Constitution*, commanded by Isaac Hull
July 17	GB captures Fort Mackinac (Michigan)
August 5	Massachusetts refuses US request to call out militia
August 15	Fort Dearborn Massacre (Illinois)
August 16	William Hull surrenders to Isaac Brock at Detroit (Michigan)
August 19	USS *Constitution*, commanded by Isaac Hull, defeats HMS *Guerrière*
August 22	Rhode Island refuses US request to call out militia
October 13	Battle of Queenston Heights; Isaac Brock killed (ON)
October 25	USS *United States,* commanded by Stephen Decatur, captures HMS *Macedonian*
November 20	Battle of Lacolle Mill (QC)
December 2	President Madison reelected to a second term
December 29	USS *Constitution*, commanded by William Bainbridge, defeats HMS *Java*

1813

January 22	Battle of Frenchtown (Michigan)
January 23	River Raisin Massacre (Michigan)
February 6	GB proclaims blockade of Delaware and Chesapeake bays
April 27	US captures York (present-day Toronto); Zebulon Pike killed
May 1–9	First Siege of Fort Meigs (Ohio)
May 5	GB captures Kentucky relief force at Fort Meigs
May 5	US prisoners of war massacred near Fort Meigs
May 26	GB proclaims blockade of major ports in middle and southern US states
May 27	US captures Fort George (ON)

May 28	GB evacuates all posts along Niagara River in Upper Canada (ON)
May 29	Battle of Sackets Harbor (New York)
June 1	HMS *Shannon* captures USS *Chesapeake*; James Lawrence killed
June 5–6	Battle of Stoney Creek (ON)
June 6	*Chesapeake* enters Halifax under the command of Provo Wallis (ON)
June 22	Battle of Craney Island (Virginia)
June 24	Battle of Beaver Dams (ON)
June 25	Chasseurs Britannique (French prisoners of war in British service) commit atrocities at Hampton (Virginia)
July 21–28	Second Siege of Fort Meigs (Ohio)
August 1–2	Battle of Fort Stephenson (Ohio)
August 15	Repulsion of the British at Fort Erie (ON)
September 10	Battle of Lake Erie, US victory under Oliver Hazard Perry
October 5	Battle of the Thames; Tecumseh killed (ON)
October 26	Battle of Châteauguay (QC); British victory under Charles de Salaberry
November 11	Battle of Crysler's Farm (ON)
December 10	US evacuates Fort George and burns Newark (ON)
December 19	GB captures Fort Niagara (New York)
December 19–21	GB burns Lewiston, Youngstown, and Manchester (New York)
December 30	GB burns Buffalo and Black Rock (New York)

1814

January 10	British privateer *Hibernia* versus American privateer *Comet*, commanded by Thomas Boyle
March 27–28	Battle of Horseshoe Bend/Tohopeka (Alabama)
March 28	HMS *Phoebe* and HMS *Cherub* defeat USS *Essex*, commanded by David Porter
March 31	European allies enter Paris
April 6	Napoleon abdicates the French throne
April 25	GB proclaims blockade of New England

June 27	US drops its demand for the end of impressment as a condition for peace with GB
July	US commissioners arrive at Ghent for peace talks (Belgium)
July 3	US captures Fort Erie (ON)
July 5	Battle of Chippewa (ON)
July 11	GB captures Eastport (Maine)
July 25	Battle of Lundy's Lane; Winfield Scott injured (ON)
August 4	US attacks Fort Mackinac (Michigan)
August 8	Peace negotiations begin in Ghent
August 15	Battle of Fort Erie (ON)
August 24	Battle of Bladensburg (Maryland); British victory under Robert Ross
August 24–25	GB burns Washington under Robert Ross
August 27	Thomas Boyle of American privateer *Chasseur* proclaims mock blockade of GB
September 1–11	GB occupies 100 miles of US coast from Eastport to Castine (Maine)
September 11	Battle of Lake Champlain, US victory under Thomas Macdonough
September 12	Battle of North Point (Maryland); Robert Ross killed
September 13–14	GB under Alexander Cochrane bombards Fort McHenry (Maryland)
September 14	Francis Scott Key writes "The Star-Spangled Banner" (Maryland)
September 15– June 9, 1815	Congress of Vienna (Austria)
September 17	US sortie from Fort Erie (ON)
November 5	US evacuates Fort Erie
December 15	First meeting of the Hartford Convention (Connecticut)
December 24	US and GB sign Treaty of Ghent (present-day Belgium)
December 25	Edward Pakenham arrives at New Orleans
December 27	GB ratifies Treaty of Ghent

1815

January 8	Battle of New Orleans, US victory under Andrew Jackson; Edward Pakenham killed
January 15	British squadron captures USS *President*, commanded by Stephen Decatur
February 4	News of Battle of New Orleans reaches Washington
February 13	News of Treaty of Ghent reaches Washington
February 16	US Senate unanimously ratifies Treaty of Ghent
February 16	Madison signs Treaty of Ghent (War of 1812 officially ends)
February 20	USS *Constitution*, commanded by Charles Stewart, defeats HMS *Cyane* and HMS *Levant*
February 26	Napoleon escapes island of Elba
June 18	Duke of Wellington defeats Napoleon at the Battle of Waterloo (present-day Belgium)

1816

| December 4 | James Monroe elected president |

1817

| March 4 | President Monroe's inaugural address launches Era of Good Feelings |

1828

| December 3 | Andrew Jackson elected president |

CATALOGUE NOTES

Early America, 1800–1811

1. Georgetown and City of Washington: "Howling, malarious wilderness," quoted in Robert V. Remini, *The House—The History of the House of Representatives* (New York: Smithsonian Books, in association with HarperCollins, 2006), p. 66. "Bank of the Potowmac," "Negro Slaves," and "servants by day," *ibid.*, p. 66. "We only need houses," quoted in *ibid.*, p. 67.

3. Preparation for War: "Disunited from religious fellowship," quoted in Stephen Budiansky, *Perilous Fight: America's Intrepid War with Britain on the High Seas, 1812–1815* (New York: Alfred A. Knopf, 2010), p. 75. "No ship ever went to sea," quoted in *ibid.*, p. 81.

5. *Chesapeake* vs. *Leopard*: "Stop firing," quoted in Budiansky, *Perilous Fight*, p. 64. "To clear the ship for action," David S. Heidler and Jeanne T. Heidler, eds., *Encyclopedia of the War of 1812* (Annapolis, Md.: Naval Institute Press, 1997), p. 97.

6. An Old Philosopher: Allison M. Stagg identified the artist as Akin in "The Art of Wit: American Political Caricatures, 1787–1830" (Ph.D. thesis, University of London, 2010).

7. The First Great Western Empire: "Great and weighty matters," *Niles Weekly Register,* August 13, 1814, vol. 6, p. 405.

8. View of Montpelier: "Plain but grand appearance," Diaries of Mrs. William Thornton, vol. 1, September 5, 1802, Anna Maria Brodeau Thornton Papers, 1793–1861, MS 51862, Library of Congress, Washington, D.C.

Causes of War

Introduction: "A second struggle for our liberty," quoted in Donald R. Hickey, *Don't Give Up the Ship! Myths of the War of 1812* (Urbana: University of Illinois Press, 2006), p. 46.

10. Henry Clay: "Western Star," Robert V. Remini, *Henry Clay: Statesman for the Union* (New York: W. W. Norton, 1991), p. 79. "War calamitous as it generally is," *ibid.*, p. 77. "Influence and power," *ibid.*, p. 91. "The Great Compromiser," *ibid.*, p. 192.

11. John C. Calhoun: "Second struggle for our liberty," John C. Calhoun, May 6, 1812, *Congressional Reporter* 31, 12th Cong., p. 496. "I assert it with confidence," *ibid.* "The war will be a favorite," Alice Nobel Waring, "Letters of John C. Calhoun to Patrick Noble, 1812–1837," *Journal of Southern History* 16, no. 1 (1950), p. 65.

12. John Randolph: "We have heard but one word," Donald R. Hickey, *The War of 1812: A Forgotten Conflict*, Bicentennial edition (Urbana: University of Illinois Press, 2012), p. 72. "I admire his ingenuity," A. P. Peabody, ed., *Life of William Plumer* (Boston: Phillips, Sampson, 1856), p. 256. "Gentlemen, you have made war," Anthony S. Pitch, *The Burning of Washington: The British Invasion of 1814* (Annapolis: Naval Institute Press, 1998), p. 16. "The colonizing of the free people," Remini, *Henry Clay*, p. 179.

13. Lord Castlereagh: "Millstone of an American war," Hickey, *Don't Give Up the Ship*, p. 292.

14. *The Emperor Napoleon*: "Never enjoyed," quoted in Hickey, *War of 1812*, p. 9. "Nation of shopkeepers," quoted in Michael Orleans, "Napoleon," *Encyclopedia of World Biography*, 2nd ed. (New York: Gale, 1998), p. 309.

15. Pitcher: Sailor's Rights: "Almost ridiculous," quoted in Budiansky, *Perilous Fight,* p. 54.

16. King George IV: "A national scandal," Sir Arthur Bryant, *The Age of Elegance, 1812–1822* (New York: Harper, 1951), p. 109. "The worst man," Christopher Hibbert, *George IV, Regent and King, 1811–1830* (New York: Harper & Row, 1973), p. 310. "In his heart I fancied," Pitch, *Burning of Washington*, p. 149.

17. James Wilkinson: "Unprincipled imbecile," Hickey, *War of 1812*, p. 144. "Only man I ever saw," Henry Adams, *John Randolph* (Boston: Houghton, Mifflin, 1898), p. 219.

18. Henry Lee: "Without funds," Pitch, *Burning of Washington*, p. 1. "Black as a negro," *ibid.*, p. 12. "First in war, first in peace," *ibid.*, p. 10.

19. James Madison Peace Medal: "Ancient custom," quoted in Francis Paul Prucha, "Early Indian Peace Medals," *Wisconsin Magazine of History* 45, no. 4 (1962), p. 279.

20. By the President of the United States of America: "A state of war," quoted in J. C. A. Stagg, *Mr. Madison's War: Politics, Diplomacy, and Warfare in the Early American Republic* (Princeton, N.J.: Princeton University Press, 1983), p. 110.

Northern Battles and Indian Wars

Introduction: "A mere matter of marching," quoted in Hickey, *Don't Give Up the Ship*, p. 36.

24. William Hull: "Loud in his complaints" and "gasconading booby," A. J. Langguth, *Union 1812: The Americans Who Fought the Second War of Independence* (New York: Simon & Schuster, 2006), p. 198.

25. Isaac Brock: "Mere matter of marching," Hickey, *Don't Give Up the Ship*, p. 36. "Beyond my control," Langguth, *Union 1812*, p. 191. "Revenge the General!" *ibid.*, p. 217. "There was a long-continued," John S. D. Eisenhower, *Agent of Destiny: The Life and Times of Winfield Scott* (New York: Free Press, 1997), p. 44.

26. Zebulon Pike: "I believe no human being," Langguth, *Union 1812*, p. 122.

27. *Dying Tecumseh*: "Perhaps one of the finest-looking men," quoted in Langguth, *Union 1812*, p. 164. "One of those uncommon," quoted in Hickey, *Don't Give Up the Ship*, p. 180. "Sagacious," "gallant," and "Wellington of the Indians," quoted in *ibid.* "Every school boy," Alfred A. Cave, "The Shawnee Prophet, Tecumseh, and Tippecanoe: A Case Study of Historical Myth-Making," *Journal of the Early Republic* 22, no. 4 (2002), p. 637.

28. Richard Mentor Johnson: "To be idle during the recess," Mark O. Hatfield, *Vice Presidents of the United States, 1789–1993* (Washington, D.C.: Government Printing Office, 1997), p. 124. "The man who killed Tecumseh," Bil Gilbert, "The Object at Hand," *Smithsonian*, July 1995, http://www.smithsonianmag.com/history-archaeology/object_0795.html. "A lucky random shot," Hatfield, *Vice Presidents*, p. 121.

29. Winfield Scott: "God of War," John C. Fredriksen, *Officers of the War of 1812 with Portraits and Anecdotes* (Lewiston, N.Y.: Edwin Mellen Press, 1989), p. 50. "Shall war come at last," Eisenhower, *Agent of Destiny*, p. 21.

31. John Norton: "As perfect an Indian," William Reese Company, *Recent Acquisitions in Americana*, catalogue 272 (New Haven, Conn.: William Reese, 2010), p. 15. "A great intriguer," Hickey, *Don't Give Up the Ship*, p. 184. "Coolest and most undaunted," *ibid.*, p. 185.

33. *Repulsion . . . at Fort Erie:* "Give the Damned Yankee rascals," quoted in Hickey, *War of 1812,* p. 188.

The Republican Court

Introduction: "What a delightful thing," New York Genealogical and Biographical Society, *The New York Genealogical and Biographical Record,* vols. 11–13 (New York, 1880), p. 109.

35. **Dolley Dandridge Payne Todd Madison:** "Queen Dolley," Ethel Lewis, *The White House: An Informal History of its Architecture, Interiors and Gardens* (New York: Dodd, Mead, 1937), p. 63. "Her Majesty," *ibid.*, p. 72. "Squeezes," Catherine Allgor, *A Perfect Union: Dolley Madison and the Creation of the American Nation* (New York: Henry Holt, 2006), p. 189. "In her hands," Lewis, *White House*, p. 72. "She looks like an Amazon," Abraham Joseph Hasbrouck to Severyn Bruyn, January 29, 1814, in *Dolley Madison Digital Edition*, ed. Holly C. Shulman (Charlottesville: University of Virginia Press, 2009), http://rotunda.upress.virginia.edu/dmde/. "Everybody loves Mrs. Madison," Allgor, *Perfect Union*, p. 232.

36. **Anna Maria Brodeau Thornton:** "It is more difficult," Elinor Stearns and David N. Yerkes, *William Thornton: A Renaissance Man in the Federal City* (Washington, D.C.: American Institute of Architects, 1976), p. 16.

37. **Margaret Bayard Smith:** "Good humour and sprightliness," Allgor, *Perfect Union*, p. 44. "Accustoming us to see," *ibid.*, p. 177. "All I say is true," *ibid.,* p. 394.

38. **Anna Payne Cutts:** "A fine, portly, buxom dame," Allen C. Clark, *Life and Letters of Dolley Madison* (Washington, D.C.: W. F. Roberts, 1914), p. 115. "Sister-child," Allgor, *Perfect Union*, p. 106. "Let me hear from you directly," *ibid.*, p. 375.

39. **Madison Dinner Plate:** "More like a harvest-home supper," Richard N. Côté, *Strength and Honor: The Life of Dolley Madison* (Mount Pleasant, S.C.: Corinthian Books, 2005), p. 266. "Ice creams, macaroons, preserves," Josephine Seaton, *William Winston Seaton of the "National Intelligencer": A Biographical Sketch* (Boston: James R. Osgood, 1871), p. 85.

40. **Maria DeHart Mayo Scott:** "Not only beautiful," Eisenhower, *Agent of Destiny*, p. 109. "Although it has chanced me," Erasmus Darwin Keyes, *Fifty Years' Observations of Men and Events, Civil and Military* (New York: Charles Scribner's Sons, 1884), p. 29.

41. **Ann McCurdy Hart Hull:** "A sturdy, fat-looking fellow," Seaton, *William Winston Seaton,* p. 87. "It would be difficult to meet," New York Genealogical and Biographical Society, *New York Genealogical*, p. 109. "Command of the ship," William James Morgan, "Book Review: The Captain from Connecticut: The Life and Naval Times of Isaac Hull by Linda M. Maloney," *New England Quarterly* 60, no. 2 (1987), p. 313.

Naval Battles

43. **Isaac Hull:** "Keep yourself cool," quoted in Budiansky, *Perilous Fight,* p. 99. "Made of iron," quoted in Hickey, *Don't Give Up the Ship*, p. 107. "By God that vessel is ours," quoted in Budiansky, *Perilous Fight*, p. 143.

44. **Model of the *Constitution*:** "Uniquely embellished," description by Dana Wegner, curator of ship models, Department of the Navy, Naval Surface Warfare Center, "Navy Department 1:96 Scale Model of USS *Constitution*, ca. 1921; Navy Model Catalog Number 839" (handout), pp. 1–2. "Assassination model," verbal communications, Department of the Navy, Naval Surface Warfare Center.

45. **Stephen Decatur:** "Uncommonly handsome," Langguth, *Union 1812*, p. 207. "The most bold and daring," Heidler and Heidler, *Encyclopedia of the War of 1812*, p. 149. "Our country!" Alexander Slidell Mackenzie, *Life of Stephen Decatur, a Commodore in the Navy of the United States* (Boston: Charles C. Little and James Brown, 1846), p. 295.

49. **Provo William Parry Wallis:** "Every housetop," John George Brighton, *Admiral of the Fleet, Sir Provo W. P. Wallis: A Memoir* (London: Hutchinson & Co., 1892), p. 105.

50. **Oliver Hazard Perry:** "Most boisterous," quoted in Robert G. Baker, "Perry, Oliver Hazard," *American National Biography Online,* http://www.anb.org. "Misconduct," Theodore Roosevelt, *The Naval War of 1812*, 5th ed. (New York: G. P. Putnam's Sons, 1894), p. 264. "Characteristic bravery," quoted in *ibid*.

54. **Macdonough's Victory:** "Masterstroke" and "wind," Hickey, *Don't Give Up the Ship,* p. 133.

55. *12 at Midnight*: "So far succeeded," quoted in "Captain Thomas Boyle's Journal Account of the Action Between the Comet and the Hibernia," courtesy Arader Galleries, New York City, unpaginated. "Rendered almost unmanageable," quoted in *ibid*.

56. **1812 Seventeen-Star, Seventeen-Stripe Flag:** Information on the *Blockade* and *Charybdis* is from Harold D. Langley, "The American Privateer *Blockade* in the War of 1812" (Santa Cruz, CA: Fog Kist, 2010). Other information from curator James Ferrigan III, Zaricor Flag Collection.

The Burning of Washington and
the Defense of Baltimore

57. *Map of Maj. Gen. Ross's route*: "The Bladensburg Races," Hickey, *War of 1812*, p. 198. "Dark and bloody grounds," Pitch, *Burning of Washington*, p. 72. "One of the finest looking men," *ibid.*, p. 83.

58. Robert Ross: "Temporary inconvenience," George Lewis Smyth, *Biographical Illustrations of St. Paul's Cathedral* (London: Whittaker & Co., 1843), p. 69. "Absolute love," Pitch, *Burning of Washington*, p. 111. "Our country, sir," Irvin Molotsky, *The Flag, The Poet & The Song: The Story of the Star-Spangled Banner* (New York: Dutton, 2001), p. 107.

59. British Officer's Drawing of Bladensburg: "The rapid flight," Hickey, *War of 1812*, p. 198. "Well, admiral," Pitch, *Burning of Washington*, p. 149. "Behaved to me," ibid, p. 84.

61. George Cockburn: "Cockburn's name," Hickey, *War of 1812*, p. 153. "No Sir," *ibid.*, p. 133.

62. *Flyglarna af Capitolen i Washington ar 1819*: "Elegant Houses of Parliament," quoted in "Eyewitness Accounts of the Burning of the White House: They Were There," *White House History*, collection 1, vol. 4 (Fall 1998), p. 246. "You never saw a drawing room," Pitch, *Burning of Washington*, p. 124.

64. The President's House: "Spike the cannon," Dolley Madison, "The Burning of the White House in 1814," in *White House History*, collection 1, vol. 4 (Fall 1998), p. 232. "All the advantages," *ibid.* "Intended for *Jonathan*," John William Cole, *Memoirs of British Generals Distinguished during the Peninsular War*, vol. 2 (London: Richard Bentley, 1856), p. 315. "Exhibit her in London," Hickey, *War of 1812*, p. 118. "I shall never forget," "Eyewitness Accounts," p. 246.

65. Dolley Madison's Red Velvet Dress: "The curtains!" Côté, *Strength and Honor*, p. 266. "Superb red silk velvet curtains," Alexandra Alevizatos Kirtley, "Benjamin Henry Latrobe and the Furniture of John and Hugh Finlay," *Antiques,* December 2009, http://www.themagazineantiques.com/articles/benjamin-henry-latrobe-and-the-furniture-of-john-and-hugh-finlay/. "Two hours before the enemy," Madison, "Burning of the White House in 1814." p. 232. "Tis here the woman," Seaton, *William Winston Seaton*, p. 113.

66. Paul Jennings: "Always in an awful condition," Paul Jennings, *A Colored Man's Reminiscences of James Madison* (Brooklyn: George C. Beadle, 1865), p. 6. "Body servant," *ibid.*, p. iii. "I was always with Mr. Madison," *ibid.*, p. 18. "Though I had years before," *ibid.*, p. 5.

67. *Taking of the City of Washington in America*: "We only know from the light," Pitch, *Burning of Washington*, p. 126.

68. William Thornton: "Witnessed the conflagration," Pitch, *Burning of Washington*, p. 111.

69. John Armstrong: "They certainly will not," Pitch, *Burning of Washington*, p. 19. "Indolence and intrigue," Henry Adams, *History of the United States of America during the Administrations of James Madison* (New York: Literary Classics of the United States, 1986), p. 593. "Nature and habits forbid him," Pitch, *Burning of Washington*, p. 17. "Great little Madison," Côté, *Strength and Honor*, p. 109. "It is obvious," Pitch, *Burning of Washington*, p. 169.

70. Johnny Bull and the Alexandrians: "Want any prompting," quoted in Pitch, *Burning of Washington,* p. 170. "From the impulse," quoted in *ibid.*, p. 172.

77. The "Star-Spangled Banner" Flag: "Hoisted a most superb," Molotsky, *The Flag*, p. 90. "To have a flag so large," *ibid.*, p. 18.

The Battle of New Orleans

78. Arthur Wellesley: "I have told the Ministers," Walter R. Borneman, *1812: The War That Forged a Nation* (New York: HarperCollins, 2004), p. 214. "I feel no objection," Hickey, *Don't Give Up the Ship*, p. 151. "Had we beaten the Duke," Remini, *Henry Clay*, p. 125.

79. Edward Pakenham: "General Pakenham makes me now," Eliza Pakenham, *Tom, Ned and Kitty: An Intimate Portrait of an Irish Family* (London: Phoenix, 2008), p. 135. "We have one consolation," *ibid.*, p. 134.

80. Jean Laffite: "Hellish banditti," Winston Groom, *Patriotic Fire: Andrew Jackson and Jean Laffite at the Battle of New Orleans* (New York: Alfred A. Knopf, 2006), p. 88.

81. Andrew Jackson: "Abandoned in a strange country," "To do, sir?," and "It shall never be said," quoted in Jon Meacham, *American Lion: Andrew Jackson in the White House* (New York: Random House, 2008), pp. 28–29. "Demonic determination," quoted in Robert Remini, "Andrew Jackson," *American National Biography Online.*

83. Andrew Jackson: "Honor and gratitude," quoted in H. W. Brands, *Andrew Jackson: His Life and Times* (New York: Doubleday, 2005), p. 304. "Felt disposed" and "He was fearful," quoted in Lillian B. Miller, Sidney Hart, and David C. Ward, eds., *The Selected Papers of Charles Willson Peale and His Family* (New Haven, Conn.: Yale University Press, 1991), vol. 3, pp. 649–50.

The Treaty of Ghent

84. *The Hartford Convention or Leap No Leap*: "Keep you young hot-heads," quoted in Hickey, *War of 1812*, p. 275.

85. Caleb Strong: "That in a republic," quoted in David L. Sterling, "Caleb Strong," *American National Biography Online.* "Of a very delicate nature," "precise proposition," and "countries," quoted in *ibid.*

87. John Quincy Adams: "Johnny Q," Robert V. Remini, *John Quincy Adams* (New York: Henry Holt, 2002), p. 121. "Corrupt bargain," Richard R. Stenberg, "The 'Corrupt Bargain' Calumny," *Pennsylvania Magazine of History and Biography* 58, no. 1 (1934), p. 61.

88. Treaty of Ghent: "Lawrence's last words," George Dangerfield, *The Era of Good Feelings* (Gloucester, Mass.: Peter Smith, 1973), p. 66.

A Nation Emerges

89. James Monroe: "Was for a brief while," George Dangerfield, *The Awakening of American Nationalism, 1815–1828* (New York: Harper Torchbooks, 1965), pp. 2–3. "National feelings" and "the people," quoted in *ibid.*, pp. 3–4. "The existence of parties," quoted in *ibid.*, p. 24. "Shimmering illusion," *ibid.*, p. 30.

91. The Old Brick Capitol: "I would rather sit," Pitch, *Burning of Washington*, p. 224. "Old Brick Capitol," James W. Goode, *Capital Losses: A Cultural History of Washington's Destroyed Buildings* (Washington, D.C.: Smithsonian Institution Press, 1979), p. 290

92. *Pawtucket Bridge and Falls*: "We must now place," quoted in Gordon S. Wood, *Empire of Liberty: A History of the Early Republic, 1789–1815* (New York: Oxford University Press, 2009), p. 705. "Similar to those used in England," quoted in John R. Dichtl, "Samuel Slater," *American National Biography Online.* "I understand you taught," quoted in *ibid.*

93. *View of Erie Canal*: "Throughout the country," quoted in Dangerfield, *Awakening of American Nationalism*, p. 6. "Let us, then, bind," quoted in *ibid.*, p. 18. "A nation-wide craze," George Rogers Taylor, *The Transportation Revolution, 1815–1860*, The Economic History of the United States, vol. 4 (New York: M.E. Sharpe, 1951), p. 34. "Clinton's Big Ditch," quoted in *ibid.*, p. 33.

98. Nicholas Biddle: "Guilty of a continued," quoted in Dangerfield, *Awakening of American Nationalism*, p. 10. "The lights of experience," quoted in *ibid.*, p. 11.

101. Independence Day Celebration in Centre Square: "Who would not be an American?" Robert V. Remini, *The Battle of New Orleans: Andrew Jackson and America's First Military Victory* (New York: Penguin, 1999), p. 198. "Late war with Britain," Hickey, *Don't Give Up the Ship*, p. 364. "The American war," *ibid.*, p. 367. "I read it carefully," Brighton, *Admiral of the Fleet*, p. vii.

102. *We Owe Allegiance to No Crown*: "Many nations," Adams, *History of the United States*, p. 439. "The war has renewed," quoted in Borneman, *1812*, p. 304.

BIBLIOGRAPHY

Adams, Henry. *History of the United States of America during the Administrations of James Madison.* New York: Literary Classics of the United States, 1986.

Allgor, Catherine. *A Perfect Union: Dolley Madison and the Creation of the American Nation.* New York: Henry Holt, 2006.

Borneman, Walter R. *1812: The War That Forged a Nation.* New York: HarperCollins, 2004.

Budiansky, Stephen. *Perilous Fight: America's Intrepid War with Britain on the High Seas, 1812–1815.* New York: Alfred A. Knopf, 2010.

Côté, Richard N. *Strength and Honor: The Life of Dolley Madison.* Mount Pleasant, S.C.: Corinthian Books, 2005.

Dangerfield, George. *The Awakening of American Nationalism, 1815–1828.* New York: Harper Torchbooks, 1965.
The Era of Good Feelings. Gloucester, Mass.: Peter Smith, 1973.

Fredriksen, John C. *The War of 1812 in Person: Fifteen Accounts by United States Army Regulars, Volunteers and Militiamen.* Jefferson, N.C.: McFarland, 2010.

Groom, Winston. *Patriotic Fire: Andrew Jackson and Jean Laffite at the Battle of New Orleans.* New York: Alfred A. Knopf, 2006.

Heidler, David S., and Jeanne T. Heidler, eds. *Encyclopedia of the War of 1812.* Annapolis, Md.: Naval Institute Press, 1997.

Hickey, Donald R. *Don't Give Up the Ship! Myths of the War of 1812*. Urbana: University of Illinois Press, 2006.
 The Rockets' Red Glare: An Illustrated History of the War of 1812. Baltimore: Johns Hopkins University Press, 2011.
 The War of 1812: A Forgotten Conflict. Bicentennial ed. Urbana: University of Illinois Press, 2012.

Ketcham, Ralph. *James Madison: A Biography*. New York: Macmillan, 1971.

Ketchum, Alton. *Uncle Sam: The Man and the Legend*. New York: Hill and Wang, 1959.

Langguth, A. J. *Union 1812: The Americans Who Fought the Second War of Independence*. New York: Simon & Schuster, 2006.

Nettles, Curtis P. *The Emergence of a National Economy*. New York: Holt, Rinehart and Winston, 1962.

Pakenham, Eliza. *Tom, Ned and Kitty: An Intimate Portrait of an Irish Family*. London: Phoenix, 2008.

Pitch, Anthony S. *The Burning of Washington: The British Invasion of 1814.*. Annapolis, Md.: Naval Institute Press, 1998.

Remini, Robert V. *Andrew Jackson*. New York: Harper Perennial, 2001.
 The Battle of New Orleans: Andrew Jackson and America's First Military Victory. New York: Penguin, 1999.
 Henry Clay: Statesman for the Union. New York: W. W. Norton, 1991.

Roosevelt, Theodore. *The Naval War of 1812*. 5th ed. New York: G. P. Putnam's Sons, 1894.

Stagg, J. C. A. *Mr. Madison's War: Politics, Diplomacy, and Warfare in the Early America Republic*. Princeton, N.J.: Princeton University Press, 1983.
 The War of 1812: Conflict for a Continent. New York: Cambridge University Press, 2012.

Taylor, Alan. *The Civil War of 1812: American Citizens, British Subjects, Irish Rebels & Indian Allies*. New York: Knopf, 2010.

Taylor, George Rodgers. *The Transportation Revolution, 1815–1860.* The
 Economic History of the United States, vol. 4. White Plains, N.Y.:
 M. E. Sharpe, 1951.

Van Alstyne, Richard W. *The Rising American Empire.* Chicago: Quadrangle
 Paperbacks, 1960.

Wood, Gordon S. *Empire of Liberty: A History of the Early Republic, 1789–1815.*
 New York: Oxford University Press, 2009.

ACKNOWLEDGMENTS

The appearance of the catalogue and the exhibition *1812: A Nation Emerges* marks the culmination of years of effort and collaboration with people within and outside the National Portrait Gallery who believed that the work and expense of producing a bicentennial commemoration of the War of 1812 was justified by its significance in American history. By even contemporary standards of the Napoleonic Wars, of which the War of 1812 was a peripheral event, the War of 1812 was a small war fought by small armies with, blessedly, a small number of casualties. The historical ramifications, however, were not small. It is also fortunate, moreover, that the artwork inspired by this war was not small and insignificant, but often large and glorious. This book and accompanying exhibition provide fascinating images of the individuals—the politicians, the women of Dolley Madison's Republican Court, the soldiers and Indian warriors, the freedmen and pirates, and the diplomats—involved in this conflict. The younger American participants in the war comprised the first generation of leaders after the American Revolution, struggling to make their achievements equal to or greater than the generation that won the nation's independence.

Although readers and visitors will recognize the many fine portraits belonging to the National Portrait Gallery, this book and exhibition would not have been possible without participation from lending institutions and private owners from the United States, Canada, the United Kingdom, and Ireland. The War of 1812 was part of an international conflict, and it is only suitable that this commemoration reflects that reality. The credits following each entry reveal the scope and diversity of the lenders.

Libby O'Connell, chief historian and senior vice president for corporate outreach at HISTORY®, was the first person outside the National Portrait Gallery to support the exhibition. HISTORY's generous grant enabled us to arrange for the exhibition's loan and conservation costs and funded the customized map of War of 1812 sites on page 250. HISTORY produced a video that was shown in conjunction with the exhibition and provided video segments as part of the exhibition. This initial donation inspired others. Our

friends Peter and Isabel Malkin and Commissioners Jack Watson and Amy Meadows provided key support. We were pleased to have TD Bank Group from Canada join as a lead sponsor. Our two countries share a history with the War of 1812, and TD Bank's partnership helped to demonstrate that strong connection.

This exhibition would have been much narrower and reduced without the initial support of two people: Martin Sullivan, director of the National Portrait Gallery, a historian in his own right who believed in the significance of the War of 1812 and supported the vision of a large bicentennial exhibition, and Beverly Cox, former director of exhibitions and collections management for the National Portrait Gallery, who gave us the green light to locate the best works of art to borrow.

Beverly's successor, Claire Kelly, and her staff have vigorously supported this endeavor. Kristin Smith, exhibition and loan specialist, has worked tirelessly arranging national and international loans. Molly Grimsley, registrar for exhibitions and loans, made the complex arrangements for shipping and insuring the priceless works of art coming to the exhibition. John McMahon, chief registrar, brought the artwork into the National Portrait Gallery. Tibor Waldner, chief of design and production, and his staff are responsible for an exhibition design that had to meld historical alignment and aesthetic considerations, fitting all the artwork and items into the large but still limited space allotted. From the very onset the Office of Development and External Affairs wrestled with finding funding for this undertaking. The office is headed by Sherri Weil, who, with her deputy Charlotte Gaither, beat the bushes of corporate and individual giving to help fund the exhibition. A special thanks is owed to Elizabeth Perry for her work with HISTORY®. Bethany Bentley, public affairs specialist, had the challenging task of making this whole undertaking known to the public at large. Rebecca Kasemeyer, director of education, planned the programming that accompanies the exhibition. Our webmaster, Deborah Sisum, translated the real material objects into the virtual reality of a website. We would also like to thank John McCavitt and Eliza Chisholm for their timely aid in helping us to obtain loans for the portraits of Robert Ross and Edward Pakenham. Perry Colvin served as an intern during the research stage of the exhibition and provided insight into the military history of the war. Readers of the catalogue and the labels in the exhibition who might be tempted to attribute the fine style, flawless grammar, and concise sentences to the authors, must instead direct their compliments to the National Portrait Gallery's head of publications, Dru Dowdy.

Michael C. Quinn, president of The Montpelier Foundation, has been an enthusiastic supporter of this exhibition from its early planning stages. The foundation also contributed to the exhibition's opening event in June 2012.

This catalogue is enriched by the opening essays by Donald R. Hickey and J. C. A. Stagg, two preeminent scholars of the War of 1812 who agreed to condense their voluminous knowledge of the political, diplomatic, and military history of this episode into a very limited word count. Their essays provide the necessary context for the images and items of this exhibition. A special thanks is owed to Professor Hickey for reviewing our catalogue entries and contributing to the chronology.

Finally, I must acknowledge the assistant curator of this exhibition, Rachael L. Penman, who believed in *1812: A Nation Emerges* from the very beginning. Rachael immediately perceived the excitement and importance of the War of 1812 in American history and tirelessly tracked down the national and international portraits that grace the exhibition. Without her enthusiasm and energy, there would not have been an exhibition.

<div align="right">

Sidney Hart
Senior Historian, National Portrait Gallery

</div>

IMAGE CREDITS

Photographers

Erik Arnesen: cat. 102

Will Brown: cat. 39

Alex Jamison Photography: cats. 57, 59, 62, 91

Copyrights

© John Carter Brown Library, Brown University: cat. 3

© 2011 The States of Guernsey (Guernsey Museums and Galleries), Guernsey, UK: cat. 25

Image © The Metropolitan Museum of Art/Art Resource, New York: cats. 40, 86

Image courtesy National Gallery of Art, Washington, D.C.: cats. 14, 36, 53, 68

© National Portrait Gallery, London: cats. 13, 16, 78

© National Maritime Museum, Greenwich, UK: cat. 61

Photograph courtesy Wadsworth Atheneum Museum of Art/Art Resource, New York: cat. 41

© Nicholas S. West: cat 102

Photograph courtesy The White House Historical Association (White House Collection): cats. 35, 64

Photograph courtesy The White House Historical Association (White House Collection) © White House Historical Association: cat. 39

INDEX

Numbers in *italic* indicate pages with *illustrations*.